MW00344607

Lost Tea Rooms

OF DOWNTOWN

CINCINNATI

· · · · · · · · · · · · · · · *Reflections & Recipes*

CYNTHIA KUHN BEISCHEL

AMERICAN PALATE

Published by American Palate
A Division of The History Press
Charleston, SC
www.historypress.net

Front cover, top center: A woman disembarking the trolley. *Photograph by the author; courtesy of the Cincinnati Museum Center at Union Terminal.*
Back cover, top: Time for tea, a classic, elegant ritual. *Photograph by Rachel Schmid.*

First published 2016

ISBN 9781540201065

Library of Congress Control Number: 2016943915

This book is dedicated to all the girls and women in my life.

May all the wonderful memories that resurfaced and became a part of this book become the inspiration for a resurgence of polite manners, consideration and a sense of loyalty for others.

Contents

Flashback

Snapshot of the Past

It was such a different world. Downtown was really something. Downtown was a totally different environment than it is now. Downtown is gone. Those were the good old days. The pace was slower, more leisurely. It was more elegant. There was a sense of occasion to going downtown. It was a magical time to go to town.

These sentiments are typical of the comments expressed repeatedly during interviews. What was so different?

Consider that around 1930, almost a fifth of all the people who lived in Cincinnati walked by the intersection of Fifth and Vine Streets every day. Downtown in those days had a high volume of traffic and was described as a vibrant and interesting place to be in the 1930s, '40s and '50s. There was always a feeling of excitement about going downtown—there were so many things to see and do. Banks, doctors, pharmacies, lawyers, accountants, investment brokers, barbers, beauty shops, tailors, dressmakers and myriad other destinations, including the department stores, drew people to the city's business center. The era of looking at a shopping trip downtown as a destination continued into the early 1970s. There was a special spirit to those times. People made an effort to get all dressed up for these expeditions—doing so was part of the adventure.

Of course people got dressed up to go downtown. Downtown was where you would be seen and see others. Men wore business suits, and many wore fedoras; boys wore blazers and ties. Women never thought about wearing slacks (*pants* for those who are too young to recognize that word) before the 1970s and

certainly nothing resembling blue jeans. To do so would have been shocking! Disgraceful! To be properly dressed "as ladies," girls wore their Sunday best (including black patent-leather shoes, kept glossy with Vaseline) and women wore dresses or skirts, stockings (in some years with seams along the back of the leg and held up by girdles or garter belts), heels, perhaps a strand of pearls around the neck and, of course, hats and the ever-mentioned white cotton gloves that were required by etiquette and the fashion standards of the past. There were decades when gloves were worn throughout the day, except while eating (you would have slipped them into your purse after being seated) or to assess the feel of fabrics. While gloves continued to be popular, hats began to go out of favor with younger women in the 1960s, for the most part due to the new bouffant and beehive hairstyles. By the 1970s, people still got dressed up, but both hats and gloves were no longer in style.

The art of buying gloves was far more complex than just grabbing a pair marked small, medium or large from a rack. The salesladies were taught to perform a series of actions and steps to achieve a perfect fit for the customer. The customer placed her arm on the counter with her elbow bent and hand pointing upward. The saleslady would then size and fit the glove to her hand, smoothing the fabric down and around each finger.

Keeping white cotton gloves clean was a difficult task. On a trip downtown with your white gloves on and your ten- or fifteen-cent fare in hand, by the time you got on the streetcar, put your money in the box and held onto the pole or strap if no seats were available, your gloves would be soiled. This was especially true in the war years, when the factories were running around the clock and Cincinnati was a fairly filthy place. Even with the best attempts to carefully wash the gloves so as to always have clean, pretty, white pairs, many women stated that it was very difficult to remove that last little bit of dark stain out of the fingertips. Many found it convenient to have three or four pairs for rotation.

The hosiery department definitely offered a more elegant buying experience than the current way hose are sold. Silk stockings and nylons were kept behind glass counters in flat, thin boxes that would indicate the size and shade of color on the edge. A saleslady would use her long, polished fingernails to get underneath the lid, hook the box and slide it out from the stack on the shelf. She would then open up the box, unfold the tissue wrapper and slip her hand inside the top of the stocking, beyond the dark band, so the customer could see the actual color. Women wearing rings were not allowed to do that, for fear of snags. In contrast, on the bargain tables of nylons in the basements of some stores, the stockings were loose and all

mixed up. Customers picked through them, trying to match the stockings both in size and color, and flung the chosen ones over their shoulders to keep them separate from the pile. At least once, a woman was seen walking out of the store with a stocking or two still on her shoulder!

Until the early 1960s, elevators were not automatic, as they are now. Instead, they were run usually by women wearing uniforms with epaulets similar to those worn by hotel bellhops. When the elevators arrived on the main floor, an operator stood by the door with a pointer and tapped on the frame indicating that hers would be going up next. Inside the elevator, the operator stood to the side, just inside the door, although there was a fold-down seat for her use if she got tired of standing. First, she closed the folding metal "cage" gate and then the main door, before turning the dial or lever to make the elevator move. As each floor approached, she announced the floor number and what could be found on each level. "Third Floor—Ladies' Dresses and Coats, Lingerie, Girls' Clothing and Accessories, Infants' and Toddlers' Shop, Fashion Fabrics and Sewing Machines, Beauty Salon." The stops were usually a bit jerky, sometimes taking a few attempts at alignment. Hitting the exact spot required some practice and expertise.

Store hours were limited in the bygone days. Most department stores were open starting from 9:30 or 10:00 a.m. until 5:00 or 5:30 p.m., with Monday night hours stretching to 8:30 p.m. In the mid-1950s, many stores extended their hours to also include Thursday evenings. In general, most businesses were closed in the evenings, as they were on Sundays (remember when blue laws were in place and prohibited shopping on the Christian Sabbath?) and major holidays. On Good Fridays, everything was closed from noon to 3:00 p.m.

In some of the stores, cash and sales slips for purchases were sent through pneumatic tubes to the billing department and then returned to the sales desk with receipts and any change due. By the 1930s, customers had the opportunity to use Charga-Plates in several of the department stores. The small, embossed metal plate was placed in the bottom half of the imprint machine and then a lever handle was pressed down, making a carbon paper copy of the sale receipt.

When a piece of clothing was purchased, the salesperson was very careful about how she folded the item and wrapped it with tissue paper before putting it in a box. The customers ended up with bags full of boxes, or just boxes. Alternatively, the clerk might ask, "Do you want to take that with you or do you want it delivered?" There were days when stores' delivery truck

drivers had placed the packages at the customers' front doors before they arrived back home—and this service was usually at no extra charge.

Great importance was placed on customer appreciation and the concept of providing great service. The department stores were very different from what they are nowadays, in part because each department was staffed with a sufficient number of salesclerks to assist a large number of customers. And the larger companies definitely earned their title of "department" stores. A substantial variety of merchandise and services were conveniently provided under their roofs. Besides the popular clothing, shoe and jewelry options, customers were able to buy a plethora of other products. If household items were needed, china, glassware, silver, stainless and any manner of cookware were available, as well as mattresses, bedding and linens; furniture, rugs, paint and wall coverings; and window treatments. There were well-stocked book departments, greeting card and stationery departments and even an area furnished with desks and writing supplies, where one could sit down to write letters.

If toys, sports items, pet products, fabrics and sewing notions or lawn and garden equipment were needed, there were departments for those, too. Even expensive hobbies were considered and catered to in the areas that sold photographic equipment, as well as rare coins and stamps. Perhaps a vacation was in order—a person could buy luggage and then book the upcoming trip in the nearby travel agency department. Other services were pharmacy prescriptions and drug items, dry cleaning and alterations, watch repairs and check cashing. At the end of the shopping day, flowers, freshly made candy, baked goods, wine and other food products were available.

When the stores had enormous, storewide annual and semiannual sales, customers arrived in hordes, many of whom had traveled long distances. The crowds were mammoth; in some cases, streets were closed because of the number of people gathering outside, waiting for the doors to open. Those days were chaotic but fun—a very exciting time.

There was a lively atmosphere about downtown and shopping—busy sidewalks filled with people, sounds of traffic going in two directions on all the streets, attractive window displays, aromas from restaurants and food cart vendors. Memories abounded of warm roasted nuts and the man who stationed himself at Shillito Place and sold doughy pretzel sticks covered with coarse salt in small white bags. While downtown provided a real delight for all the senses year-round, during the holidays it was an especially wonderful and magical place to be. At Christmastime, the Tyler-Davidson fountain was festooned with lights, and all the stores sparkled with their holiday trees and

decorations. Ladies and their daughters enjoyed the special feeling of adding an extra decorative touch to their outfits as well, wearing beautiful Christmas corsages that came in a variety of colors and were trimmed with beautiful satin ribbons, as well as "sugared" bells and berries and little holiday figures.

Back in the good old days before the twenty-first century, stores honored Thanksgiving and closed for that national celebration, a custom that actually heightened the excitement of the next day. Thanksgiving was the turning point. Unlike now, when Christmas displays are set up alongside Halloween items and most purchases are made on the Internet, the Friday morning after Thanksgiving meant the holiday season had begun. Wonderfully dressed store windows featuring elaborate moving Christmas displays and animated scenes were unveiled. Both children and adults who were young at heart stood with their noses close to the glass or took multiple rides around the blocks in a car as slowly as possible. Similar to the big sale days, crowds filled the stores and customers were jostled attempting to get onto the escalator or squeeze into an elevator. Young children in that tight space often saw nothing beyond the waist of the woolen coat in front of them.

Speaking of children and the holidays, let's not forget Santa Claus. Though each family had a preference as to which store they would visit, every child knew that the Santa whose lap they sat on and related their wish list to was the "real Santa." Those who spoke with Santa at Pogue's received a special helium balloon souvenir, consisting of an interior snowman balloon with an exterior clear balloon painted with snowflakes. Even the children who were uncomfortable talking with Santa thoroughly enjoyed seeing the sights of his workshop and busy elves in Shillito's Toyland, the entrance to which was guarded by a giant toy soldier that was, in reality, a decorated structural support pole. Other holiday treats included stopping to listen to Mabley & Carew's seasonal concerts, walking through the Enchanted Forest in the Carew Tower arcade and talking with Pogue's animatronic reindeers, Pogie and Patter. Hearing carolers who were dressed in Dickensian costumes singing Christmas songs and viewing the train set in a miniature wonderland near Pogue's toy department were additional pleasures. Shillito's also offered "The Secret Gift Shop—for Little Shoppers Only," where staff accompanied children with their fistfuls of money and helped them shop for gifts for their families. Mothers and fathers were not allowed in the small, decorated cubbyhole that was stocked with reasonably priced items. For many years, Alms & Doepke also provided a full-sized carousel during the season. For a nickel, a child got a ride and a big, fat candy cane.

Transportation to the downtown stores was often mentioned in the interviews. Up through the mid- to late 1940s, a large percentage (40 percent or so) of households did not own cars, and it was very common for the families who did to have only one car. In that environment, trolley cars and buses were used by many people to get around the city. Even in the 1960s and '70s, when approximately 80 percent of all households had at least one car, public transportation was still commonly used by a wide range of people.

Riding on the streetcar or taking the bus was a big deal when youngsters were allowed to go downtown alone. Some were given permission to do so as early as nine years old, but more commonly as teenagers. High school girls saved up their allowances in order to go to a tea room every few weeks, planning ahead what they'd wear and what buses they would catch. Repeatedly, both women and men shared what fun they had taking a trolley or bus down to meet friends in the 1940s, '50s and '60s; parents had no concerns about their children going downtown alone. The interviewees felt very fortunate to have grown up in that era.

Going downtown to shop and lunch was an event for everyone who did it; however, the experience was even more of an adventure for residents living in outlying areas beyond the closer neighborhoods. Their trips were usually less frequent and not uncommonly taken on Greyhound buses or even trains. A trip from Glendale in the 1950s, for example, was likely on a bus originating from Hamilton, Ohio. Without all the stops of a regular city bus, the Greyhound bus was the faster choice. Even so, going all the way down Vine Street, through the bustling business areas at that time of Woodlawn, Wyoming, Hartwell, Carthage, Elmwood, St. Bernard and Corryville, could take well over an hour, because without the expressway Vine Street carried a huge amount of the traffic.

This was an era when venerable department stores had local roots and strong participation in the locale where they developed and grew. These stores carried the names of the prominent families who created, owned and governed them. Each establishment was the product of a family's efforts—efforts that were made not only for their own successful survival but also for the growth of the city and the good of the community. The stores participated in a variety of civic, cultural and charitable works. It was also a time when these locally owned stores truly understood their customers and the top executives knew their employees personally, taking care of them like family. In turn, employees were loyal and dedicated workers. The social mores of this atmosphere extended to women in a "family way." In the mid-1950s, women who became pregnant had to stop working in the stores when

they began to show, even those who worked in the hidden administrative offices off the merchandise floors. They were given the choice of quitting or taking a leave of absence, with the option of making up their minds whether or not to come back later. In the case of Shillito's, the store would call the new mother approximately two months after the baby was born and check to see what her plans were.

Before the mid-1950s, other than neighborhood groceries and small local stores, downtown Cincinnati was the center of retail activity, the only place to seriously shop. Malls did not exist. Accordingly, downtown was very popular. While the stores were busy every day, Thursday was popular with many women of a certain milieu. As interviewee Joan Baily recalled, her mother and mother-in-law went downtown every week on that day. Thursday was "maid's day out" for their full-time domestic help, and the ladies considered that an excellent "excuse" to get out of the house as well and go downtown to do their shopping, have fittings, get their hair done and take care of other errands. When Cincinnati's first shopping center, Swifton, came into existence, many people frowned upon it. If they needed socks, they went downtown and made an occasion of it as they had always done—meeting friends and having a wonderful lunch out and maybe even catching a stage show or seeing a movie in one of the many theaters before they went home. If you ate a little earlier or hurriedly, you could catch the one o'clock reduced-ticket movies at the Albee, Keith or Paramount theaters. Big bands, like Glenn Miller's and Tommy Dorsey's, came to the Albee, and the theater actually offered a combination of live shows and movies through the late 1950s. Such an outing was a full day—something to really look forward to.

In addition to a multitude of department stores, downtown Cincinnati offered a wealth of specialty stores for men's and women's clothing, jewelry, luggage and so forth. When interviewees discussed the topic of shopping, however, the street that stood out as the most impressive avenue for this experience was Fourth Street, compared by some to Fifth Avenue in New York. Further back in time, around 1900, the area near the corner of Fourth and Vine was known as "Ladies Square." The north side of Fourth was the elegant center of sophisticated shopping, an area busy with activity in all the upscale stores, where the prosperous people shopped. Women loved spending the day admiring and purchasing jewelry, watches, silver pieces and fine giftware displayed in the stores of the Loring Andrews Company, George H. Newstedt's (later merged with Loring Andrews) and the Frank Herschede Company.

The highest quality clothing merchandise could be found at any number of specialty stores, as well as Pogue's department store, which had been serving the carriage trade since 1863. For fine menswear, hats and other haberdashery articles, there was Burkhardt's. For luggage, Bankhardt's. Women, perhaps lured by the colorful, ornate Rookwood tile designs of fruits and flowers that surrounded the entrance of J.M. Gidding & Company or by the fragrance of Odalisque perfume that wafted over the sidewalk from a mister above its revolving doors, could select from the latest fashion styles while receiving exclusive attention from the entire staff. Other stores that had reputations for quality and personalized service were Jenny Co. (merged with Gidding's in 1962), Henry Harris, Todd Brothers and Closson's. Quality dining linens, blankets, hand-quilted items, fine monogramming, centerpieces or exotic items used in entertaining were found at Gattle's.

Cincinnati was home to a variety of department stores, including Shillito's, Pogue's, McAlpin's and Mabley & Carew, among others. Each store expressed its own distinctive character and, in turn, attracted its own devoted clientele. In a sense, it was as though the stores were teams, and they each had their staunch fans. A definite social hierarchy also became apparent during the interviews as to which stores people favored. More than once, sentiments were expressed that bordered on classism. For example, while some people praised McAlpin's as their favorite store because of its merchandise and reasonable prices, others said that their family and friends would not have been found there—Shillito's and Pogue's were the stores to shop. And others would go on to make it clear that of those two, Pogue's was the only one their families would patronize because of the excellent customer service and quality of merchandise. On the other hand, a large number of people described Pogue's as more elite, sometimes expressed as "uppity," and said that Shillito's had a larger, more diverse stock of merchandise—a thought summed up in the comment, "You could always find what you were looking for at Shillito's."

With a picture of the past still in our imaginations, let's experience some bygone tea rooms!

Painting a Picture of Bygone Tea Rooms

U p until the late 1960s, hosting an afternoon tea, known as an "at home" during earlier years, was how a sophisticated woman entertained her lady friends. Her guests were all dressed up, and she served them with her fancy tea service. Little tea sandwiches, pastries and cookies were the appropriate menu items of the day.

The beautifully appointed downtown tea rooms, with tables covered in white cloths and adorned with fresh flowers, small bowls of sugar cubes with tongs, heavy silverware and nice china, were certainly a part of that whole culture. So, too, were the dainty sandwiches (crusts cut off) of cream cheese and cucumber slices with fruit placed alongside and hot dishes brought out on plates covered with silver and, in some cases, white china domes to keep them warm. The difference was that anyone who wished to enjoy that pleasure had to be able to go and pay to have a tea experience. And for many ladies, the tea rooms became the perfect spot to celebrate birthdays, wedding and baby showers, bridge parties and even business meetings.

In certain social milieus, dressing in a hat and gloves and going downtown to the tea rooms was an integral part of a girl's upbringing, a rite of passage of sorts. The only question was what the destination would be. For many interviewees, the topic and questions revived great memories not only of the era but also of their mothers, grandmothers, aunts and sisters. The tea rooms provided an environment that united generations. Sharing lunch and shopping together was when they communicated. During this special one-on-one time, mothers and daughters talked about things not comfortably

discussed in front of brothers or fathers. These outings provided a chance for young girls to feel grown up and practice the "lady training" that they received at home and, for others, the lessons they had learned in the etiquette classes offered at Shillito's and McAlpin's. How to sit properly with your legs crossed at the ankles and how to sit up straight and keep elbows off the table were essential teachings. A sign of proper social etiquette was also to know the use of the different silverware pieces and how to spoon your soup in the bowl away from you, as well as the importance of chewing with one's mouth closed. Knowing how to say thank you when the waitress brought out your dish and how to let her know if the food was good was also significant. Benefits of the finishing school classes went beyond the dining room. Girls, usually between twelve and fourteen years of age, learned how to properly introduce people (first announcing the older person to the younger as an act of respect), how to apply and wear makeup and jewelry, how to pair colors and the finer points of fashion. The idea behind such instruction was that teaching appropriate behaviors and manners would benefit girls when they went out into society and the working world.

For other women, remembering their weekly rendezvous brought back fine memories about their girlfriends. The primary sentiment was that women considered such an occasion as a cheerful, sometimes celebratory, female event, a highlight of the week that was nothing like grabbing a quick bite to eat while running errands. The tea room experience was much more than that. An outing to town was considered special and important, a definite pleasure to be enjoyed.

Over time, the department store tea rooms became the venue for fashion shows in which models walked elegantly, showing off the current trends in clothing. Most stores had a group of models (usually young women, though occasionally older ladies) who worked primarily on weekdays during the lunch crowd and occasionally in the evening or on weekends. Sometimes, the outfits were presented as runway productions with a commentator on a staged area, culminating with bridal or formal wear, but more often shown informally with models walking through the room and stopping to interact with customers. The lovely models were paired, each working one side of the room and then switching to the other, casually approaching individual tables, sometimes with a tantalizing twirl, and talking about what they were wearing. Through the mid-1960s, models were required to wear hats and gloves. With tags carefully hidden, they answered any questions the customers might have about the garment, including the cost; allowed them to feel the fabric if

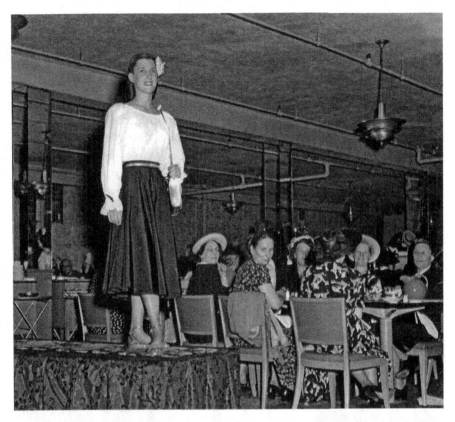

Fashion shows were frequent during department store tea room luncheons—this one took place in McAlpin's Tea Room. *Photo provided courtesy of the Gene Planck family. McAlpin's is a trademark of Dillard's Inc. The author thanks Dillard's for granting permission to use the McAlpin's name as well as the image included here.*

desired; and then told them where in the store they could find the item. They provided just enough to impress, intrigue and induce an "I have to have that!" purchase.

The restaurants' staff played a huge part in making the tea rooms as popular as they were as well. Outfitted in their solid color uniform dresses laundered by the store, crisply starched white aprons with pocket handkerchiefs and sometimes little caps on their heads, the waitresses were known to be very friendly and polite and to provide superlative service. The dining rooms that had waiters required them to dress in white coats and bow ties. The waitresses were often "old guard" who remembered names and, in many instances, the preferred menu items of frequent and loyal customers. Customers who were regulars had their favorite waitresses

and many times asked the elegant hostesses to be seated at one of their tables. In a similar fashion, like a family working together every day, a relaxed friendliness and intimacy developed among the people who were employed in the restaurants.

Waitresses at Shillito's in the 1940s had fifteen-minute morning meetings every day, during which they studied and memorized that day's menu. During their shifts, they collected and turned in comments (good and bad) that they'd heard during the day. The remarks were reviewed and acted upon accordingly by management. These waitresses, known as the Six-Minute Squad, exemplified Shillito service by serving meals in six minutes. According to an article in the October 16, 1940 issue of the *Shillito Enthusiast*, there was actually a time clock in the kitchen where they punched their order slips as they entered the kitchen and again when the food came out. And, as the readers were assured, "Each tray as it comes out is checked so that it's a sure thing your meal will be placed in front of you just as you ordered and looking its most attractive."

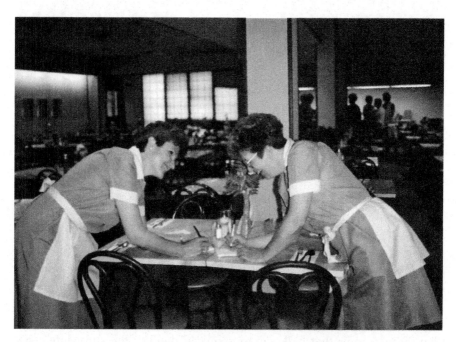

Restaurant staff members worked hard, but they had fun, too. *Photo provided courtesy of the Gene Planck family. McAlpin's is a trademark of Dillard's Inc. The author thanks Dillard's for granting permission to use the McAlpin's name as well as the image included here.*

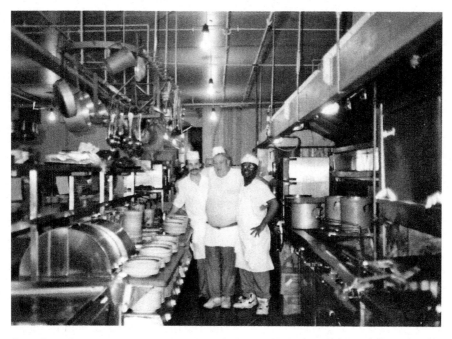

Chef Gene Planck stands proudly in the McAlpin's Tea Room kitchen with two of his helpers. *Photo provided courtesy of the Gene Planck family. McAlpin's is a trademark of Dillard's Inc. The author thanks Dillard's for granting permission to use the McAlpin's name as well as the image included here.*

Speed of service continued to be an important matter. As described in the January 10, 1942 issue of the *Shillito Enthusiast*, Shillito's Tea Room had just introduced the teleautograph system to Cincinnati. This electric device offered quick transmission of the food orders to the kitchen. Within a second of the dining room's operator writing the order on a metal plate with a special metal pencil, the order appeared in the kitchen and was immediately processed. The waitresses would pick up the order in the pantry, have the order slip stamped with the cost and serve the customers "all in a few moments. Besides saving time and steps, the new system lessen[ed] the chance of confusion of orders, and hasten[ed] quick, courteous service in the Shillito manner....How's that for efficient service?"

There was a lot of camaraderie in the kitchen also. Whereas the waitresses came in later and stayed later (from about 11:00 a.m. to 3:00 p.m. was typical), the kitchen staff arrived at around 6:00 or 7:00 a.m. and worked until about 1:00 p.m. Early jobs executed with ease and speed included peeling, squeezing, chopping and measuring the fresh ingredients for the basic menu

Large kitchens with huge stovetops and ovens that could bake 150 pies at a time were typical in the working side of the department-store tea rooms. Chef Planck at McAlpin's was a very loyal employee who worked there for forty-five years, commuting from New Richmond daily. When the weather forecast was bad, he would drive downtown and sleep in his car so that he'd be sure to get to work on time. Known as a wonderful cook, he had no formal training other than what he learned working on the job under his predecessor. Some of the items he fixed for the tea room were from his mother's recipe box.

and the specials of the day. Several former kitchen staff workers shared that while the operating conditions were sometimes strict (from making sure the glassware shined to how their hair was combed and their shoelaces were tied), they enjoyed a fun working environment in the very large kitchens that usually had lots of stoves, refrigerators and ovens and big counters or work islands. Dishwashers often preferred the "dirtier" job of loading the dishes rather than handling the very hot clean ones when unloading. While the chefs, for the most part, handled the entrées, other people were in charge of items such as salads, soups and desserts.

The tea rooms were considered a delightful part of the downtown shopping experience, popular for years because of the consistency in quality food for a reasonable price and, of course, the fact that the quiet atmosphere (which was sometimes enhanced by soft background music) provided a perfect setting to sit down, relax and enjoy conversations with family and friends. Each tea room had a different personality, and as such, their unique qualities served different purposes. They appealed to different needs and attracted different types of people. The following segments provide a glimpse into the character and background of some of Cincinnati's favorite downtown establishments

A Look at the Historical Personality of the Tea Rooms and Locations

THE WOMAN'S EXCHANGE

The Woman's Exchange of Cincinnati, the oldest of the tea rooms portrayed in this book, was founded in 1883 after a group of philanthropic women of means read a newspaper article about the success of such a venture in New York. The premise of the organization was to offer women who were not skilled in a profession and down on their luck a marketplace where they could sell items they were able to make at home. The Woman's Exchange was a true and profitable business based on benevolent charity, a place where privileged women helped other women help themselves and gain not only a paycheck but also their independence, dignity and self-respect.

The Woman's Exchange was created during the era when Cincinnati's grand emporiums had begun developing strong roots in the city. Shillito's, McAlpin's, Pogue's and Mabley & Carew, among other department stores, were established and provided merchandising models to emulate, albeit on a much smaller scale. The women who organized and administered the unpaid board of The Woman's Exchange came from the old, upper-crust Cincinnati families who made sure that everything was tiptop. Mrs. John A. Shillito and Mrs. George McAlpin were among the women who acted as managers of this charitable organization in its early days.

In January 1906, after existing at two other locations, The Woman's Exchange of Cincinnati found a new home at 113–15 West Fourth Street. The attractive bay window displayed samplings of the handiwork and

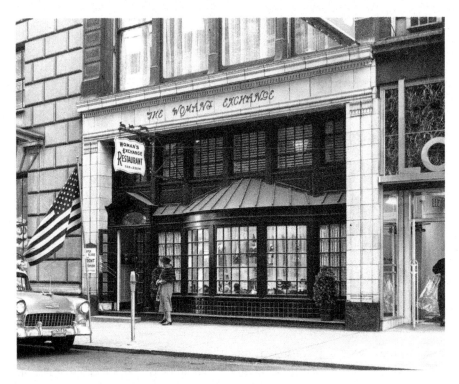

The Woman's Exchange tea room featured an elegant front bay window that displayed some of the wonderful handmade articles available inside. *Courtesy of Cincinnati Museum Center—Cincinnati History Library & Archives. Woman's Exchange Exterior (General Photos—Restaurants & Saloons).*

desirable homemade food items that could be found inside. This location, sometimes described as a WASPy environment and a place where the elders met, provided high-society women a convenient dining room and marketplace in a wonderful location near the center of elegant and upscale shopping. For over sixty years, these upper-class ladies, as well as professional and business people, were pleased to keep the organization alive and took delight in knowing that they were doing something good to help less fortunate women while they enjoyed themselves over luncheon and shopping.

Consignors, who first had to pass inspection by an examining board for approval regarding the quality of their work, produced beautiful, exclusive items that were sold in the specialty shop on the second floor. Knitted items such as hats, gloves, sweaters and blankets were very professional in appearance. Lovely ladies' blouses, lingerie and bed jackets were on display. Adorable layettes, cross-stitched and smocked infant and children's clothing

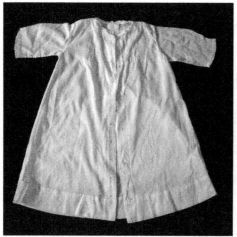
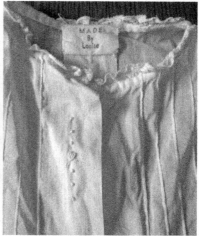

Left: This receiving gown made of fine cotton lawn fabric with exquisite hand stitching was bought at The Woman's Exchange. *Item photographed courtesy of Eunice Abel.*

Right: The inside back tag of the receiving gown indicates that the seamstress who made the garment was named Louise. *Item photographed courtesy of Eunice Abel.*

and soft dolls and doll clothes were always cherished items. Embroidered linens, tabletop and dresser scarves, doilies and decorative hand and tea towels added beauty to many home décors. Christmas tree ornaments and holiday decorations were very popular. Other unique offerings included reading book and telephone book covers, artwork, jewelry cases, purses, aprons, handkerchiefs and other accessories. The counters were filled with the handmade articles—all fancier and more expensive than what was normally used in many houses—which made wonderful gift items. The charming handiwork, a far cry from the mass-produced items of today, was a big draw and made The Woman's Exchange a preferred place to buy wedding and baby shower gifts.

Many people remembered "the wonderful birds," which were mobiles with five or six little colorful birds to hang from the ceiling above a crib, as an ideal baby present. A number of other women recalled taking a rickety elevator or walking across a wooden floor that squeaked as they went upstairs to be measured for their handmade dresses and pinafores, designed with the option of having their names embroidered at the waist.

Because the underlying purpose of the business was to assist women in need, occasionally expensive items, such as pieces of art, were accepted on consignment. The prices on all items were established by agreement.

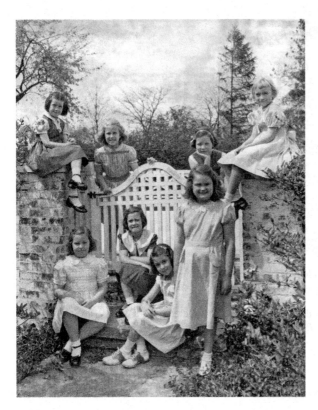

The children pictured here are wearing fashions from The Woman's Exchange that they modeled at a luncheon and fashion show sponsored by the Woman's Guild of the Presbyterian Church of Glendale. *Top row, left to right*: Louisa Egbert, Ann Muhlhauser, Rosemary Rogan and Betsy Whitesides. *Standing in front of gate*: Hydie Richardson. *Seated, left to right*: Jeannie Zimmerman, Heather Humphrey and Linda Cook. *The photo, courtesy of Jean Zimmerman Donaldson, was taken by David Tondow Sr. in the spring of 1951. Permission for its use was given courtesy of his son, Dr. David Tondow.*

The founders believed that providing a dining room would ensure a steady income to pay for overhead and help compensate losses in other departments. As such, an area to serve luncheons was created in their second year of operation. Their first menu offered an oyster stew and rolls served with tea or coffee. Later, desserts were added. The Woman's Exchange became a very popular and busy spot, not only because of the quality of the beautiful handcrafted articles but also because of the wonderfully prepared tea sandwiches, home-style meals and delicious desserts that were attractively served at a reasonable price. They offered a variety of beverages but, of course, no alcohol! Women who were talented bakers and candy and jam makers delivered delectable items that appealed to customers who had a sweet tooth—either to be enjoyed during their meal or as takeout purchases for home. Other ladies worked as tea room waitresses, cooks and kitchen helpers.

Those who spoke of going to the tea room remembered looking in the big front window as they approached and seeing the bustling activity of people being served. They described the restaurant on the first floor as a long and narrow room with a light, bright atmosphere, a lovely feminine place that

Winter Bill of Fare.

LUNCHEON SERVED TO LADIES AND GENTLEMEN FROM 11.30 A. M. TO 3 P. M.

SPECIAL DISHES.

Veal Chop, Tomato Sauce.. 10
Cherry Pudding... 10

SOUP.

Bouillon....................... 10 Vegetable..10

OYSTERS.

Fried, to order....... 25 Raw.......................15 Stewed, to order.....20

HOT MEATS.

Broiled Ham to order..........15 Beef Hash,....10
Roast Turkey..............................15

COLD MEATS.

Tongue................10 Ham.......................10 Veal Loaf................10

ENTREES.

Chicken Croquette........................10 Chicken Pie............................15
Sweetbreads, Cooked to Order..... 25

VEGETABLES.

Potatoes, Stewed..... 5 Turnips.................. 5 String Beans........... 5
Potatoes, Mashed..... 5 Spinach................. 5 Asparagus......... 8

SALADS.

Watercress.................................... 5 Lettuce..................................10
Potato..........................10 Cole Slaw,................................ 5
Chicken................................15

ROLLS AND BREAD.

Light Rolls............. 5 Cottage Rolls......... 5 Graham Bread........ 5
Bread, White.. 5 Finger Rolls........... 5 Sandwiches.............10
Bread, French......... 5 Graham Gems....... 5 Beaten Biscuit........ 5
Boston Bread.......... 5 Pocket Book Rolls... 5 Toast..................... 5
Potato Rolls................................. 5

EGGS—COOKED TO ORDER.

Eggs, fried............................10 Eggs, scrambled...................10
Eggs, boiled.........................10 Eggs, poached.....................10

SIDE DISHES.

Olives.................................... 5 Cottage Cheese..................... 5
Apple Sauce......... 5 Pickles........................ 5
Neufchatel Cheese and Crackers.. 5 Cheese................................... 5
Cranberries............................ 5 Strawberry Preserve............... 5
Stewed Prunes..................... 5 Celery 5

DESSERT.

Mince Pie............... 7 Pumpkin Pie.......... 5 Ice Cream..............15
Rice Pudding..........10 Cake............10 Lemon Pie............. 7

Milk.................................. 5 Cream.............15
Tea, Oolong....per cup 5, per pot 10 Coffee................................... 5
" Hyson..... " 5, " 10 Lemonade..............10
" English Breakfast...per cup 5 Cocoa....................................10
" " " ...per pot 10 Chocolate...............................10
Raspberry Vinegar...10 Sweet Cider............................ 5
Bowl of Milk and Bread................10 Buttermilk............................. 5

— 15 —

This menu page shows the items served during the winter season at The Woman's Exchange in the late nineteenth century. *Courtesy of Cincinnati Museum Center, Cincinnati History Library & Archives.*

reflected an outdoorsy garden feel; it was painted in pale yellow with green trim and latticework, with a gate-like structure where you entered. Many recalled the "long" way down an aisle, separated from the dining area by velvet roping that hung from poles, that led to the back of the room where you entered the seating area. Most of the tables, covered with tablecloths and crisp, white, starched napkins arranged next to nice, heavy silverware, sat four people. Some round tables in the center of the room could hold six, and there were a few smaller ones along the wall that were perfect for one or two people.

The Woman's Exchange Hand Book, published in 1898, contained membership information, annual reports and bills of fare. Most dishes remained the same throughout the year, but each season had specials, such as puree of pea soup, soft-shell crab, spring lamb with mint sauce, hamburger steak, roast beef, peas, cauliflower, lemon sherbet and a variety of fresh berries and fruits in the summer, as well as puree of turkey soup, fried chicken with cream sauce, fried pork tenderloin, spaghetti, spinach, stewed corn, oyster plant (an edible root, otherwise known as salsify, that has a taste similar to that of oysters), mince pie, pumpkin pie, baked custard and Brown Betty dessert in the autumn. (The spring bill of fare was not found.)

On the right side of the room was a somewhat plain, mid-twentieth-century rounded glass display case that held bakery items. Near the entrance was another display case with examples of what was for sale on the second floor, "all that little fussy stuff" (as recalled from the male perspective of Rick Donaldson). Very young boys were frequently taken to luncheon with their mothers and grandmothers, often dressed in little sailor suits, until they eventually rebelled and made it clear they no longer wanted to go to ladies' tea rooms. Another humorous male comment was shared by Polly Stein about her husband, Jacob, who liked to joke that when he went to The Woman's Exchange, he could never find a woman he wanted to exchange his wife for.

The overall impression of this predominantly ladies' place was garnered through such expressions as civilized (read as polite and well mannered); perfectly lovely, the ultimate old tea room–style ambiance; a quality place that attracted the higher side of society, "like bridge players"; and yet small, cozy and warm—comfortable for eating by oneself if not meeting friends.

By 1967, shopping downtown had lost most of its allure. The Woman's Exchange moved its gift shop to Hyde Park, where it ran until 1985, but the era of the tea room was over. The benevolent, philanthropic nature of this organization carries on through The Woman's Exchange of Cincinnati Fund, a part of the Greater Cincinnati Foundation.

McALPIN'S

Originally founded as Ellis, McAlpin & Co. in 1852, the establishment became the George W. McAlpin Company, a department dry goods store, in 1885. In 1880, the business bought the building on West Fourth Street that originally had been built for the John Shillito Company in 1857, and in 1892, McAlpin's "went retail," opening an elegant new department store on this site. By 1900, the adjacent six-story building had been purchased and the store space expanded. The department store was family owned and operated until 1916, when it was sold to the Mercantile Company, a retailer in New York that increased the store's size again in 1938 with the purchase of a third adjacent building.

In an advertisement from 1893, McAlpin's referred to itself as the "handsomest dry goods store in the city" with "styles, qualities and prices to suit all classes. We always have the latest." During the "modern" twentieth century, McAlpin's was acknowledged not only for carrying well-known name brands but also as the most moderately priced of the major department stores—"Small Profits Margin...Quality for Less"—and thus was the favorite and finest store in many people's eyes. The same sensible sentiment and fondness was shared about its restaurants: good, quality food for a reasonable price. A 1939 menu boasted, "For pleasant luncheons in the peaceful atmosphere of old Cincinnati...with fine food that upholds a tradition of more than three generations of restaurant service."

The precise date of McAlpin's first food service operation remains unknown. However, a *Cincinnati Enquirer* newspaper advertisement from April 1900 expressed, "Our Tea Rooms on fourth floor for Ladies and Gentleman are the talk of the town. The appointments are unsurpassed in the West. 'The best service' is our motto. Luncheon served from 10 to 5 o'clock. Ice cream from noon to 5 p.m." In another advertisement from that same month, afternoon tea was described as taking place from 3:00 to 5:30 p.m. A postcard from the early 1900s depicting "a family corner" promoted "Cincinnati's Most Elegant Moderate Priced Dining Rooms." "A la Carte Service" was offered from 8:30 a.m. to 5:30 p.m. and "Table d'Hote Service" from 11:00 a.m. to 3:00 p.m.

In September 1911, many ads appeared in the *Cincinnati Enquirer* celebrating the opening of the store's new tea rooms with a great storewide sale. The September 10 issue suggested, "Don't miss the wonderful opportunities Smiling Fortune now offers you. Sale starts promptly at 8:30 o'clock to-morrow morning." The week before, on September 3, a display

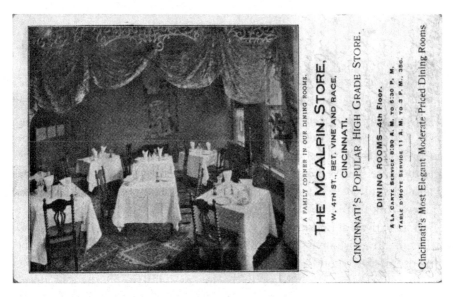

A FAMILY CORNER IN OUR DINING ROOMS.

THE McALPIN STORE,
W. 4TH ST., BET. VINE AND RACE,
CINCINNATI.
CINCINNATI'S POPULAR HIGH GRADE STORE.

DINING ROOMS—4th Floor.
A LA CARTE SERVICE 8:30 A. M. TO 5:30 P. M.
TABLE D'HOTE SERVICE 11 A. M. TO 3 P. M., 35c.

Cincinnati's Most Elegant Moderate Priced Dining Rooms

Above: McAlpin's was proud of the elegant, yet moderately priced, dining experience that was offered in its dining rooms. *Courtesy of the Collection of the Public Library of Cincinnati and Hamilton County.*

Left: In 1906, sheet music titled "McAlpin March" was written and published by the Cincinnati-based Dondero-DeLuisi Orchestra and Military Band. Copies of this music, featuring the dining room, were given as gifts to the tea room customers. *Courtesy of Cincinnati Museum Center, Cincinnati History Library & Archives.*

ad stated that the store would be closed all day in recognition of Labor Day but added the announcement that "Painters, Carpenters, Decorators have been at work for weeks making new Quarters ready on our Fifth Floor, New Building. Such a beautiful, airy, refined place these new Tea Rooms will be that, apart from an unequaled cuisine, you will find delight in the mere pleasure of such surroundings." In the updated restaurant, McAlpin's continued to serve its "celebrated 35¢ Luncheon," and on the morning of these sale days, it offered delicious club breakfasts from 8:00 to 10:00 a.m. for twenty-five to thirty cents. As it had done before in the old dining rooms, the "well-known" Villani's Orchestra played "delightful music" in the new tea rooms from 11:30 a.m. to 2:00 p.m.

Many arrangements had been put in place for the customers' convenience and entertainment, including an express elevator between the hours of 11:00 a.m. and 2:30 p.m. that ran directly up to the tea room without stops on the other floors. Two private tea rooms that could accommodate one hundred people for banquets and special parties (during daytimes, evenings and even night service by special arrangement) and a men's grill room where they could smoke had been added, along with "the most modern of kitchens," which patrons were invited to tour during scheduled hours.

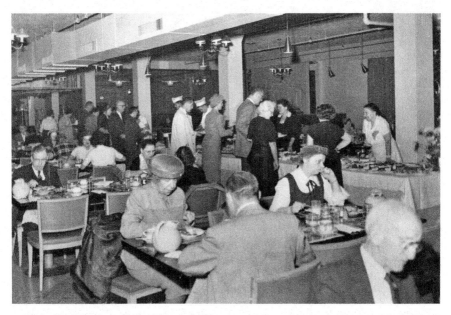

McAlpin's Tea Room offered waitress service at individual tables, as well as buffet service. *Photo courtesy of the Gene Planck family. McAlpin's is a trademark of Dillard's Inc. The author thanks Dillard's for granting permission to use the McAlpin's name as well as the image included here.*

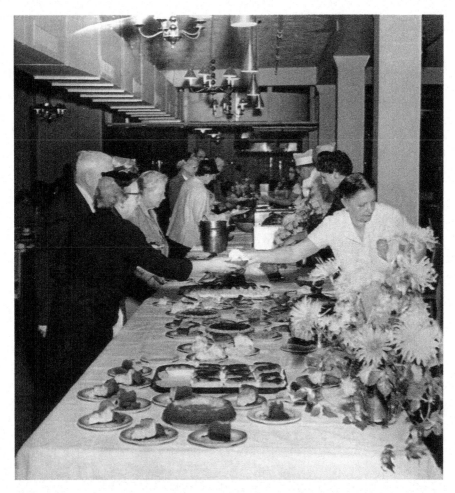

This meal ended with a tasty variety of pies, cheesecake and éclairs for dessert options. *Photo courtesy of the Gene Planck family. McAlpin's is a trademark of Dillard's Inc. The author thanks Dillard's for granting permission to use the McAlpin's name as well as the image included here.*

By 1949, the main dining room, which accommodated two hundred people, was located next to the Turn-Style, a quick on-the-go buffet targeting working women who wanted to both eat and shop during their lunch break, and the Men's Grill.

Many interviewees remembered McAlpin's large tea room, decorated with little flower arrangements on the tables, as a very nice place to eat that provided faster service than some of the other restaurants. To accommodate busy schedules, the store continued to provide an express elevator from the first floor to the fifth, where the dining room was located. Businessmen, in

particular, liked that they never had to wait in line at McAlpin's. The staff kept things moving quickly, which was much appreciated by people who didn't have the afternoon to spare.

While the men were especially pleased with the speed of the luncheon hour, women had cause to really enjoy the McAlpin's Tea Room in the mornings during the 1960s. Every weekday, approximately fifty lucky people—almost always women—sat in the audience of the *Good Morning Show*, a live program that was aired from there. Sometimes, a single organization filled the whole audience area. Tickets were apportioned. They were mailed out at no cost, but no one could get in without one.

The morning show was fashioned after the famous *Don McNeal Breakfast Club* in Chicago, a live audience participation show that became a network program. The managers at WLW in Cincinnati thought they could do a similar program with Bob Braun as the host. Nick Clooney explained that the show had been on the air for almost three years by the time he was hired in 1966 to take over because they were grooming Bob for the *Ruth Lyons 50-50 Club*.

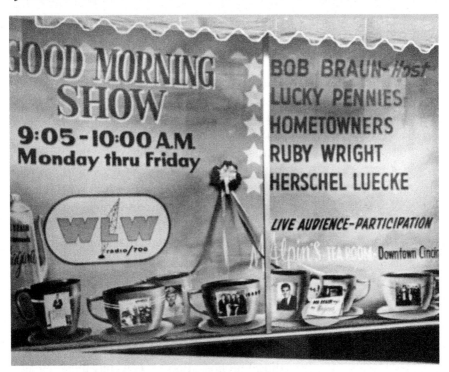

McAlpin's store windows showed the *Good Morning Show*'s roster and souvenir items that were for sale. *Courtesy Mark Magistrelli and Media Heritage Inc.*

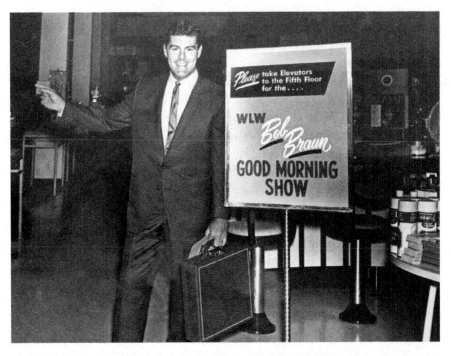

Bob Braun was happy to show the way to the tea room from which his radio program was broadcast. *Courtesy Mark Magistrelli and Media Heritage Inc.*

For a fun step back in time online, I highly suggest that you key in the words "Good Morning Show, November 22, 1963, Bob Braun" on your favorite search engine. You will get to hear the WLW-Radio broadcast from that day's show!

WLW radio and WLW-TV had an impressive array of musicians, such as the Cliff Lash Band, the Bruce Brownfield group and country music players, including the Hometowners, with accordionist Buddy Ross and headed by Kenny Price. They also had a wonderful variety of singers, including Marianne Spellman, Ruby Wright and Colleen Sharp. Because all of them took turns on this morning radio show, every day the audience was treated to live entertainment on the tiny stage on risers in the McAlpin's Tea Room. Nick stated, "It was always a show. The performers had some very specific little showpieces that they would do trying to embarrass the audience, and often did. The host, Bob or I, would meander out among the people, interview them, of course,

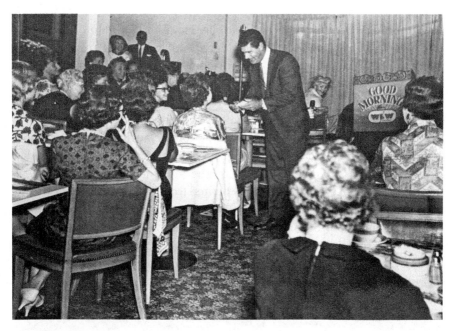

Bob Braun speaks with one of the ladies in the audience at the *Good Morning Show*. *Courtesy Mark Magistrelli and Media Heritage Inc.*

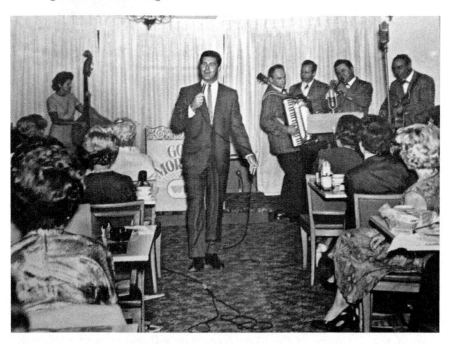

Bob Braun entertains the *Good Morning Show* audience with a song. *Courtesy Mark Magistrelli and Media Heritage Inc.*

and find out what was going on, and play games." If a man occasionally showed up, the host made a star of him and walked him all around the tea room. The entertainment was light, friendly and a lot of fun. Everyone had a good time.

The audience enjoyed breakfast rolls and doughnuts with tea or coffee. The emcees had items from their sponsors to give away as prizes. Commercials were live, and the audience often participated. The show was from 9:05 to 10:00 a.m., ending just before the tea room prepared for luncheon business. No doubt many of the audience members stayed to shop and eat there. McAlpin's also benefited from the fact that it was being mentioned as a sponsor on a fifty-thousand-watt radio station for an hour every day, and the program let people know the tea room was located in the store on Fourth Street.

"They would sometimes—and this would puzzle me—have fashion shows on radio," Nick added. He emceed those. "There would be a young woman, the fashion coordinator for the store, with me, and she would describe what

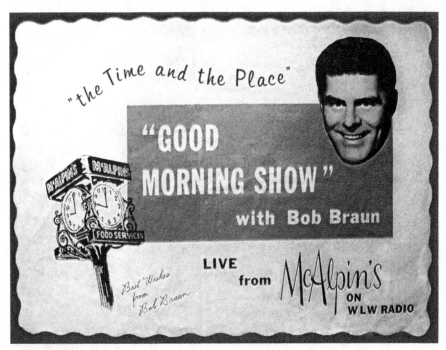

Lunch tray covers advertising Bob Braun's radio program, the *Good Morning Show*, were used for the audiences' pastries and beverages. *Courtesy of Dennis Hasty, Cincinnati TV & Radio History. McAlpin's is a trademark of Dillard's Inc. The author thanks Dillard's for granting permission to use the McAlpin's name as well as the copyrighted image included here.*

was going on. And I thought that it was odd to have a fashion show on radio, and then I thought about Edgar Bergen and Charlie McCarthy—he was a ventriloquist on radio! That didn't make a lot of sense either. So, I guess the fashion show was fine. It was fun."

In addition to the radio program and fashion shows, there were teen dance party shows, Cincinnati's version of Dick Clark's *American Bandstand*, broadcast on both radio and television. Records were played for the high school students who came from many schools around town, and the teens' dancing was actually the entertainment. Sometimes rock-and-roll artists came to town, and they often pantomimed their songs or gave an interview, talking about their current big hit. Hosting so many broadcasts from McAlpin's was definitely a savvy merchandising plan.

McAlpin's Tea Room also catered to the younger set in the event meals that took place for Christmas, Easter and Halloween. According to Martha Hinkel, the dining room's head hostess

Shopping bags with Bob Braun on the cover were provided to audience members at the *Good Morning Show*, WLW's radio program broadcast from the McAlpin's Tea Room in the early 1960s. *Photo provided by Mike Martini; courtesy of Media Heritage Inc. McAlpin's is a trademark of Dillard's Inc. The author thanks Dillard's for granting permission to use the McAlpin's name as well as the copyrighted image included here.*

from 1977 until the store closed in 1999, each of the Santa Claus breakfasts, which served "a good couple hundred people," sold out every time. "For Christmas, we had the shows (with Wayne Martin as puppeteer) from the day after Thanksgiving up to and including Christmas Eve day—weekdays and weekends. As it got closer to Christmas, we would have breakfast in the morning and a dinner at night—you would eat and then see a show, and then Santa Claus would come at the end. Oh, we had great Santa Clauses in the years I worked there!" For a couple of weeks before Easter, on weekdays and weekends, the Easter Bunny visited; and for a week or so before Halloween, a happy witch, not a scary one, entertained the children. In all cases, the characters went from table to table and talked with the kids.

The holiday show in 1976 was Martin's first of twenty consecutive years of performances that included Breakfast with Santa, Breakfast with the Easter Bunny and Breakfast with the Witch at McAlpin's main downtown Cincinnati store tea room. In addition, he also performed during Lunch and Dinner with Santa and often did lunches and dinners with the Easter Bunny and the Witch as well. During the Christmas season, these promotions would draw over seventy-five thousand people each year.

Of course the Easter Bunny didn't talk but handed out goodies. Wayne also recalled, "In addition to these annual holiday promotions, I occasionally did back to school dinners at the downtown location."

"There used to be ladies who played cards," added Martha. "They would come around 1:00 and have lunch and could stay and play until the store closed, but they usually left at 4:00 or 4:30. It wasn't unusual to have maybe thirty ladies playing cards, especially on Thursdays." Saturdays were also popular for the card players after the crowd had thinned out, and the tables were ready for those who had called ahead.

All in all, McAlpin's Tea Room took great efforts to become a successful, popular and famous spot. When the dining room closed, it had been the longest-running restaurant in Cincinnati.

Children loved having their own menus, making the grown-up tea room experience even more special. When opened, each menu had a little seasonal poem on the left side and the featured menu on the right. The Easter and Halloween offerings included a fruit cup, fruit juice or soup du jour, along with a miniature chicken pie or vegetable plate and a choice of chocolate or plain milk, followed by either a gelatin dessert, ice cream or pudding. The featured meal for Thanksgiving, of course, had roasted Tom Turkey with sage dressing, cranberry sauce, snowflake potatoes and giblet gravy. Some of the Christmas menus showed the turkey meal repeated, while another version showed the added choice of filet of sole or a jumbo hamburger. These meals cost forty-five cents.

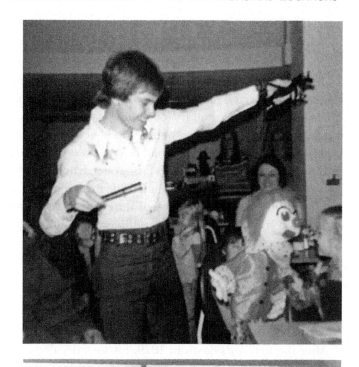

Top: Puppeteer
Wayne Martin with
McAlpin's audience
member, December
1976. *Photo copyright
© Wayne Martin
Puppets™ All Rights
Reserved.*

Right: Puppeteer
Wayne Martin
performing Frosty
the Snowman
at McAlpin's
Breakfast with
Santa, December
1993. *Photo copyright
© Wayne Martin
Puppets™ All Rights
Reserved.*

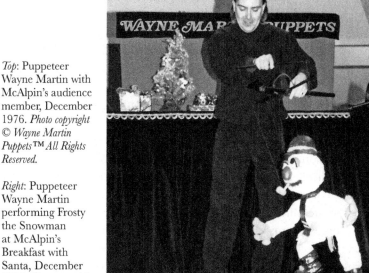

SHILLITO'S

John Shillito & Company was founded in 1830, a period in Cincinnati's history that reflected rapid growth, and became the city's first department store. John Shillito started the company as a modest dry goods store, and it eventually grew into an emporium, modeled after Bon Marché in Paris, France. The "uptown" Seventh and Race Streets location was built in 1877. At that time, it was the country's largest department store under one roof, "devoted to the wholesale and retail trade in all manner…of articles useful and beautiful from all the markets of the civilized and semi-civilized world" and staffed by "its army of over a thousand employees." With electrical lights, "swift running" steam-operated elevators and a seven-story atrium rising 120 feet to a 60-foot-diameter hexagonal glass sky-lit rotunda, the full-line department store became known at the time as one of the major sights to be seen in Cincinnati. This carriage-trade establishment gained the city's widespread respect because of John Shillito's high standards, integrity and fair dealing.

After the founder's death in 1879, his sons decided to rethink how they would purchase merchandise. Gordon moved to Paris and bought goods for the store in Europe, which he shipped to his elder brother, Wallace, who moved to New York. Wallace's responsibilities included receiving merchandise that came in through the port of New York, and he also made purchases for the store from places on the East Coast. All items were then sent to Stewart, the youngest brother, who remained in Cincinnati and was president of the store. This plan for running the operation allowed them to have the finest quality of materials and items.

In 1928, the Shillito family decided to sell the controlling interest of the store to the F.&R. Lazarus Company of Columbus, Ohio. As shared by Stewart Shillito Maxwell, Fred Lazarus Jr. was "the mastermind in acquiring the John Shillito Company.…He felt that the Shillito name was worth as much as the store itself, given the family's popularity, charitable efforts, civic leadership and national/international connections." Therefore, he was willing to double the purchase price in order to continue using the Shillito name on the store—because he felt that would ensure customer loyalty. It was suggested that because of the Great Depression, followed by World War II, the Lazarus group might have been more interested in providing value to its customers and more mass merchandising. Mr. Maxwell further explained that Mr. Lazarus, a man "in the forefront of retail merchandising and hailed as the 'world's greatest retailer,'" was also the person who conceived the

idea for Federated Department Stores. "He was a genius. Fred Lazarus Jr. believed that all these large department stores, even though their customer bases were totally different—a Shillito's customer was different from the Lazarus customer, who was different from the Bloomingdale customer or the Filene's customer or the Abraham & Straus customer—shared certain purchases, whether it be thread, underwear or maybe a certain type of carpeting. Whatever it was, there was a common denominator, and he felt that if the company could buy them in bulk, they would get a much better price for it." Fred Lazarus Jr. created the stores' motto, "The customer is always right," and extended this to extraordinary lengths. Under the new leadership, plans for tremendous expansion took place.

The Shillito family tried to have everything under one roof, and stories have been handed down through former employees that Shillito's was the first department store in Cincinnati to provide food for its customers. A food-related book, *Shillito's Every-Day Cook-Book*, by Edna Neil, was published expressly for the store in 1905, and an advertisement appeared in the *Cincinnati Enquirer* on July 10, 1912, for Instant Postum (a caffeine-free coffee substitute made from roasted grains) being served in the Shillito's Tea Room; no other information was found about the department store's original eatery prior to the Lazarus family taking over the organization.

The Shillito's Tea Room on the sixth floor was very much in the tradition of ladies' tea parties, complete with linen tablecloths and napkins and fresh flower arrangements, although men were certainly welcome and served there. The large, square room with two levels was described over the years as very open and airy, sunny and appealing, classic and elegant and a bit more cosmopolitan than the other downtown tea rooms, as people from different walks of life were seen there, including the top management personnel. The room's grandness was due in part to its spaciousness and tall ceiling, but certainly the big, beautiful, high windows above the banquettes on three walls of the room made the area bright. The Art Deco design added to the overall impression.

For many, Shillito's Tea Room was considered the "in" place to have luncheon and was very much a destination spot where "the girls" met in the era when people dressed up to go shopping. The tea room, later known as The Dining Room, had the obvious convenience factor (as did the other department store tea rooms) of eating in a very nice restaurant and not leaving the store. Eating there was a relaxing event in itself, not like the modern refueling in a food court, and often there was the additional treat of seeing celebrities who were visiting the city to appear on a show or at an

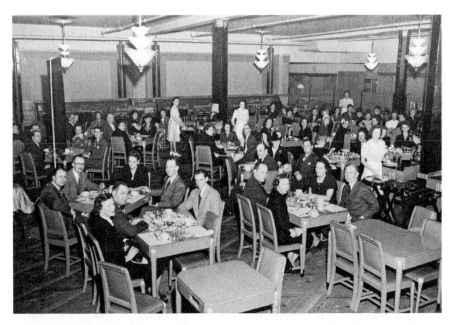

Above: Shillito's sales and service associates attending a meeting in the tea room—the tablecloths were not being used at this time. This photo appeared in the *Shillito's Enthusiast*, an in-house publication. *Courtesy of Cincinnati Museum Center, Cincinnati History Library & Archives. Lazarus Tea Room Meeting (General photos—Shillito's Employee Dinners). Shillito's is a trademark of Macy's Inc. The author thanks Macy's for allowing the use of the Shillito's name as well as the copyrighted image included here.*

Opposite: This photo was printed in the in-house publication *Shillito's Enthusiast, 125th Anniversary Issue, 1830–1955,* compiled by Richard Arms and Jeffrey Lazarus, president of the John Shillito Co. *Research courtesy of Steve Lazarus and image courtesy of Cincinnati Museum Center, Cincinnati History Library & Archives. Shillito's is a trademark of Macy's Inc. The author thanks Macy's for allowing the use of the Shillito's name as well as the copyrighted image included here.*

event. Because of the restaurant's popularity, customers usually spent time sitting in the waiting area or standing in a long line unless they had been wise enough to make a reservation ahead of time.

As mentioned, the tea room was also a lunch spot for businessmen. Regulars reserved tables, and there was also a private dining room available for business meeting lunches. Shillito's offered other accommodations as well. Several people mentioned that a place was provided where they could check their packages while eating and that there was a women's activity room used by women's groups and card clubs. Because the activity room was next to the tea room, the members and participants often ate in the restaurant.

Shillito's promoted the restaurant with this 1955 description:

Shillito's sixth floor Tea Room welcomes customers wishing to dine in an uncrowded gracious atmosphere. Shoppers, businessmen and business women find the neat, functional Tea Room a delightful place for luncheon. Children's menus offer particular appeal to parents shopping with their youngsters. Luncheons are served daily, and Shillito's Candlelight Dinner is an "occasion" when the store is open evenings.

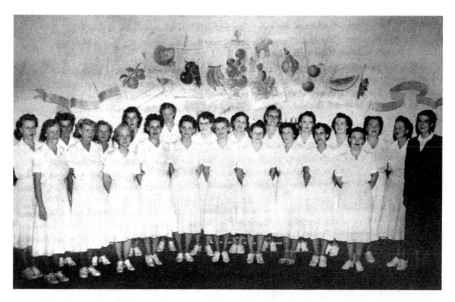

The Shillito's waitresses in their uniforms are ready to serve! *This photo, provided courtesy of Eva Carstens, appeared in the in-house publication* Shillito's Enthusiast—*exact date unknown, but thought to be from the mid-1950s. Shillito's is a trademark of Macy's Inc. The author thanks Macy's for allowing the use of the Shillito's name as well as the copyrighted image included here.*

One interviewee, Helen Dickhoner, contributed a very amusing story. In the 1940s, her mother was part of a bridge club that met at Shillito's Tea Room. One time she went downtown with her mother, who was meeting friends for the afternoon. As they were walking out the door of their home, her mother said, "Wait a minute, I forgot my cough medicine." "Cough medicine?" Helen questioned, knowing that her mother was perfectly healthy. Helen eventually discovered that at each meeting the women brought small medicine bottles filled with whiskey. "The routine was to have lunch and then play bridge after they finished eating. Around 2:00 p.m., they would order some Cokes and flavor it with their whiskey."

In the 1950s and '60s, probably every woman in Cincinnati knew of Ruth Lyons and her *50-50 Club* program on WLW-TV. Colleen Sharp Murray, a featured singer on the *Paul Dixon Show* and the *Bob Braun Show* (which replaced Ruth's when she retired), explained that much of "the food shown on Ruth's show was prepared at the Shillito's Tea Room. Everyone thought Elsa Sule, Ruth's right-hand gal, prepared the food made from the products sold on the show, but not so. And actually, when the Shillito's kitchen staff did not make the dishes, Elsa's husband did the cooking at their house!" Mickey Fisher;

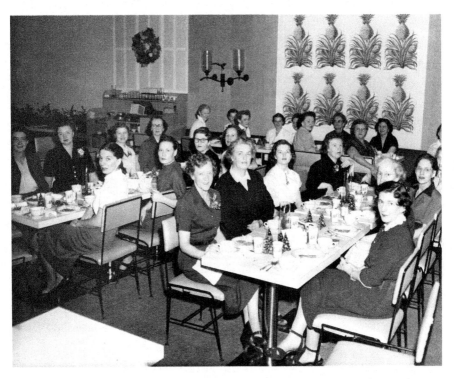

In their civilian clothes, waitresses who worked in the Shillito's Tea Room celebrate the 1953 Christmas holiday at their own after-hours gathering in the tea room. *Photo by Thomas Austin, owner of Ken Rarich Photographers Inc. Permission for its use was granted by his daughters, Carla Austin and Karen Austin. Photo provided courtesy of Eva Carstens, daughter of Trude Pfeiffer, the woman seated in the bottom-right corner.*

Ruth's secretary; and Dick Murgatroyd, Bob Braun's producer, revealed additional information, explaining that on a weekly basis the show provided the ingredients (based on the sponsors' products), and the kitchen staff came up with ideas for what to do with them. Occasionally, Elsa sent an actual recipe, but more often the chefs had to work from a list of items that were featured during the week, and each daily menu had to correspond with the food products that were advertised on a given day. According to Mickey, the most popular concoction appeared to be "peanut butter pie, when Skippy peanut butter was a sponsor." Glenn "Bud" Callaway, the certified executive chef in charge of the central kitchen, the production bakery and the candy kitchen during the 1980s and '90s, explained that WLW had a "runner" who picked up the finished products for the studio and, on the following day, returned the used dishes when picking up the new day's features. "We used to go to the electronics department once in a while to see how the items

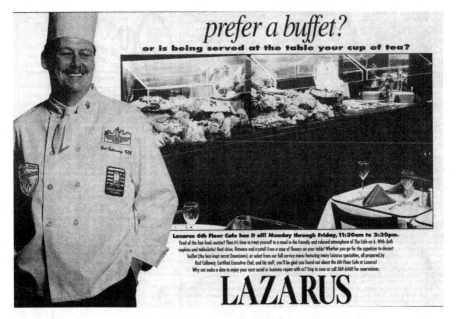

prefer a buffet?
or is being served at the table your cup of tea?

Lazarus 6th Floor Cafe has it all! Monday through Friday, 11:30am to 2:30pm.
Tired of the fast-food routine? Then it's time to treat yourself to a meal in the friendly and relaxed atmosphere of The Cafe on 6. With cloth napkins and tablecloths! Real china, flatware and crystal! Even a vase of flowers on your table! Whether you go for the appetizer-to-dessert buffet (the best-kept secret Downtown), or select from our full-service menu featuring many Lazarus specialties, all prepared by Bud Callaway, Certified Executive Chef, and his staff, you'll be glad you found out about the 6th Floor Cafe at Lazarus! Why not make a date to enjoy your next social or business repast with us? Stop in soon or call 369-6460 for reservations.

LAZARUS

When Chef Glenn "Bud" Callaway posed for this advertisement, the "Shillito's Tea Room" had been renamed the 6th Floor Café in Lazarus. *This image, which appeared on February 14, 1995, in the* Downtowner *newspaper, was provided courtesy of Bud Callaway. Lazarus is a trademark of Macy's Inc. The author thanks Macy's for allowing the use of the Lazarus name as well as the image above.*

we had prepared looked on TV." No doubt the dishes were much more appealing after color television was introduced.

By the time Chef Callaway was in charge, the tea room was in its third incarnation, at first changed to The Dining Room and then renamed the 6th Floor Café. "It was a nice dining room up there," he stated, explaining that it was frequented by people who had a little more money to spend than would be spent at a lunch counter and who didn't have to rush, mainly shoppers taking a break. He also proudly added that in 1982, the café won the *Cincinnati Magazine* award for the best salad bar in town.

MULLANE'S

William and Mary Mullane's business began as a small candy company on Valentine's Day in 1848. A century later, the family's efforts were recognized by the chamber of commerce for not only being among the companies

located in Cincinnati that had existed and thrived for over one hundred years but also, as stated in the *Times Star* on February 13, 1948, "for typifying business enterprise of the best American tradition, and for contributing to the development of Cincinnati as a distinctive American city."

The Mullanes' son John had gone to Quebec, Canada, to study under a master confectioner and returned with the knowledge and craftsmanship that was used throughout all the years of operation. Over the decades, the business grew and expanded in multiple locations. As time went on, Mullane's stores, with handsome wooden cases and tile floors, added soda fountains with marble counters and created ice cream parlors with round tables surrounded by chairs with curved wrought-iron backs. In 1933, Mullane's officially joined the ranks of tea rooms by opening its Tea Room and New Confectionery in the Carew Tower with both a Vine Street and an arcade entrance. During the mid-1930s, a division of the business took place among family members that caused confusion for customers as to the difference between the John Mullane Company and Mullane's Taffy

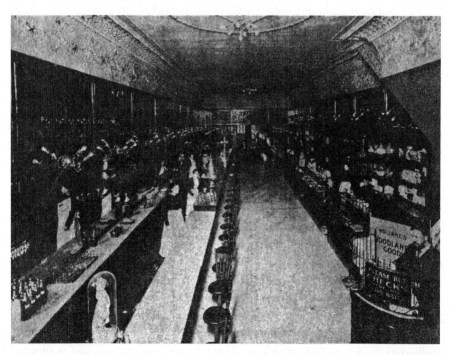

The photo above appeared under the title of "Turning Back the Clock" in the *Cincinnati Times Star* newspaper on February 17, 1948, "courtesy of William Castellini, Enquirer Building." *Courtesy of the Cincinnati Museum Center, Cincinnati History Library & Archives. Permission for its use is courtesy of the Castellini family.*

As written in the *Times Star*:

This picture of Mullane's was taken almost exactly halfway in the company's 100-year history at a location on West Fourth Street popularly known as "No. 4 Ladies Square." It combined then, as today, an ice cream "parlor" and confectionery store, but then electric lights were a novel feature. Decorations were of bronze, and a glass-covered figure in the lower left of the picture was the latest thing, combining statuary with a miniature fountain which played over the figure. The bottles at extreme lower left did not contain what is found on back bars today, but the flavors which went to make the "soda water," advertised in the sign at lower right. Shown at the cashier's cage is John Mullane, son of the founder of the Mullane Candy Co., in whose honor the present John Mullane Co. is named. John Mullane originated the slogan "Candies Made with Loving Care." The business was founded in 1848. Its quarters were then at Court and Baymiller Streets.

Company. In 1958, George and Marilu Case, local radio personalities, bought Mullane's Taffy Company. In 1963, they bought the John Mullane Company, thus once again reuniting the Mullane name on all the restaurant and candy operations.

"Meet me at Mullane's" became a frequent expression among friends who were going downtown, because they considered the shop to be a good place for a tasty and nutritious lunch at a reasonable price. The Carew Tower location offered additional evening service up to 11:30 p.m. for dinners and after-theater meals.

Although many stories were shared about adult women stopping in to meet friends for a soda and sandwich while shopping, Mullane's friendly and more casual atmosphere (as well as the ice cream sundaes and fountain specialties) was often reported as attracting a younger crowd. Children were thrilled to accompany their elders, but by the time they'd reached their teen years, they could take the bus or get a lift downtown in a friend's car. In earlier years, as shared by Mary Jane Schmuelling, this might have included sitting in a rumble seat. Mullane's was where high school girlfriends and

Fountain Menu

ICE CREAMS

Vanilla	.20
Chocolate	.20
Strawberry	.20
Peach	.20
Peppermint Candy	.20

FRUIT ICES

Raspberry	.15
Orange	.15

ICE CREAM SODAS

Nectar	.20
Chocolate	.20
Double Chocolate	.20
Chocolate Peppermint	.20
Vanilla	.20
Broadway	.20
Coffee	.20
Maple	.20

SUNDAES

Chocolate	.25
Double Chocolate	.25
Maple	.25
Chocolate Marshmallow	.30
Butterscotch	.30

Crushed Nuts 5c extra

SPECIALTIES

Frappes	.17
Fresh Fruit Frappe	.20

BEVERAGES

Coca-Cola	.05 and .10
Vichy .05 Gingerale	.10
Tomato Juice	.10 and .15
Grapefruit Juice	.10
Phosphates	.10

HOT DRINKS

Coffee	.10
Tea	.10

Try MULLANE'S MILK SHERBETS

Vanilla	.17
Orange	.17
Pineapple	.17
Apricot	.17
Lemon	.17
Lime	.17

Not an Ice Cream .15
Not a Fruit Ice .15
(Made with fresh whole milk)
It's deliciously different!

Apricot	.15
Pineapple	.15

Combination of any two flavors. .20

(originated by The John Mullane Co.)

Cherry	.20
Creme de Menthe	.20
Gingerale	.20
Lemon	.20
Lime	.20
Orange	.20
Raspberry	.20
Pineapple	.20

Caramel	.30
Bittersweet	.30
Hot Fudge (Fall & Winter)	.30
Milk Chocolate Fudge	.30
Fresh Strawberry	.30
Heavy Syrup	.45

Malted Milk (Any Flavor)	.20
Egg Malted Milk	.25

Milk	.10
Buttermilk Creamed	.10
Chocolate Milk	.10
Iced Coffee	.10
Iced Tea	.10

No 5c drink served on Balcony Tearoom except with luncheon

Postum	.10

Chocolate	.15
Malted Milk	.20

Sandwiches

with White, Rye or Whole Wheat Bread

SINGLE — Not Toasted Toasted 5c extra

MEAT
Minced Ham	.20
Chicken Liver	.20
Sliced Ham and Lettuce	.25
Tongue	.25

EGG
Deviled Egg	.20
Sliced Egg	.20

CHEESE
Swiss Cheese	.20
American Cheese	.20
Pimento Cheese	.20
Cheese Roll, Toasted	.20
Hot Melted Cheese on Toast	.30
Cream Cheese, Olive and Brown Bread	.25
Philadelphia Cream Cheese and Jelly	.25

CHICKEN and MEAT
Bacon	.35
Bacon and Tomato	.30
Chicken and Bacon	.50
Sliced Chicken (White-Dark)	.45
Sliced Chicken (All White Meat)	.50
Open Club Sandwich	.65

ASSORTED
Peanut Butter	.15
Lettuce Sandwich	.15
Peanut Butter and Jelly	.20
Sliced Tomato	.20
Peanut Butter and Bacon	.30
Ribbon Sandwiches (with Salad Center)	.35

Salmon Salad Sandwich .30

DOUBLE DECKER
Ham and Tomato	.40
Ham and Deviled Egg	.40
Deviled Egg and Tomato	.35
Sliced Egg and Tomato	.35
Bacon and Tomato	.40
Chicken Salad, Bacon and Tomato	.65

Potato Chips .05 Bread or Rolls and Butter .10 Buttered Toast .10 Cinnamon Toast .15

Salad Bar Suggestions

All Salads served with Ry-Krisp, Wafers, or Roll and Butter

SLENDERELLA SALAD BOWL: Crisp Garden Vegetables, Cottage Cheese, Julienne of Chicken or Ham (with or without Roquefort Cheese) .60

CHICKEN SALAD
Chicken Salad in Tomato Cup	.65
Tomato Aspic Ring with White Meat Chicken Salad	.65
All White Meat Chicken Salad in Lettuce Cup with Toasted Cheese Roll	.75

FRUIT SALADS
Assorted Fruits with Cottage Cheese Center	.40
Waldorf Salad with Whipped Cream Topping	.45
Frozen Fruit Salad with Whipped Cream	.50
Fresh Fruits in Lettuce Cup	.50
Club Fruit Plate with Frozen Salad Center	.60
Combination Fruit and Chicken Salad Plate	.65
with Fresh Fruit	.70

VEGETABLE SALADS
Potato Salad with Mayonnaise Dressing	.35
Cottage Cheese — Plain	.35
Cottage Cheese Aspic or in Tomato Cup	.35
Lettuce Hearts with Choice of Dressing	.25
with Roquefort Cheese Dressing	.40
Tomatoes Sliced, with Choice of Dressing	.30
Tomato Aspic, Molded Plain	.30
Cole Slaw20; with Tomato Aspic	.35
Tomato, Egg, Asparagus and Celery Salad	.50

SEAFOOD SALADS
Shrimp Cocktail	.35
Salmon Salad with Toasted Cheese Roll	.50
Shrimp Salad .50; in Tomato Cup	.60

Assorted Salad Plate — Four Individual Salads garnished with Tomatoes and Celery .50

All prices are our selling prices or below. The ceiling is based on prices charged by us from April 4 to 10, 1943. Our menus for this week are here for your inspection.

The Mullane's menu offered a variety of sandwiches, salads and a large selection of tasty treats and specialties made with ice cream and sherbets. *Courtesy of Ron Case.*

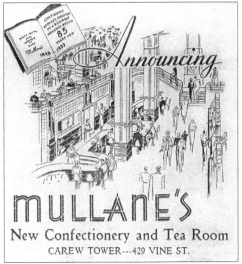

MULLANE'S

New Confectionery and Tea Room
CAREW TOWER---429 VINE ST.

Above: Mullane's served many delicious ice cream sodas in its sterling silver–based soda glasses, circa 1905. *Courtesy of David Conzett, curator, historical objects and fine art, Geier Collections & Research Center (Cincinnati Museum Center).*

Right: This advertisement illustration appeared in the *Times Star* on May 9, 1933, showing a glimpse of the Mullane's Tea Room in the Carew Tower. *Courtesy of the Cincinnati Museum Center, Cincinnati History Library & Archives.*

young adults wanted to go for lunch or after school on Friday afternoons. Some of them reported that they ate there "almost religiously" every week because it was *the* central place for meeting friends on Saturday afternoons after a movie or shopping. At the Carew Tower destination, they climbed up to the balcony and ordered ice cream sodas and milkshakes and made plans for the weekend, laughing and giggling as they discussed boys and whether or not the ones they liked would call.

Beyond the social aspect, Mullane's was well known (and in some cases remembered more) for its candy and the delightful fragrance of the store. From the beginning, starting with an old-fashioned molasses candy, all the Mullane products lived up to the company's slogan, "Candies Made with Loving Care." The popularity of its famous confections—opera creams, assorted chocolates, caramels, almond paste fruits and fancy floral wafers among them—generated purchase orders from all parts of the country. Mullane's saltwater taffies, which had also been made since the company's beginning, were perhaps the most renowned. People were always pleased to receive an assortment of the taffy pieces individually wrapped in wax paper with twisted ends. To ensure the freshness of orders that were sent overseas during World War II, the candies were advertised as "scientifically wrapped." Among the memorable flavors offered were lemon, orange, cinnamon,

Ron Case, the last owner of the candy division of Mullane's business, turned down offers from people who planned to keep the candy molds and machines in private collections, on display or stored in museums. His decision to sell them to candy maker Greg Cohen was based on his preference that the machines stay in use making candy. This type of equipment is no longer used because there are definitely easier ways to make candy nowadays, but Mr. Cohen fell in love with the technology of Victorian candy machines. "It's ancient, but it's still modern in certain ways." He added that he thought the press and rollers had another two or three hundred years of life in them. "Candy is very soft; metal is very hard."

The very rare and uniquely designed rollers have been restored and are currently being used in production at Lofty Pursuits in Tallahassee, Florida. Four sets of rollers purchased were custom-made for Mullane's candy store, one embossed with the name of the store and another with John Mullane's signature.

Along with the equipment, and after swearing Mr. Cohen to secrecy, Mr. Case also provided the secret recipe for the Mullane's nectar drops, which had not been made since the late 1980s. Thus, the old-fashioned hard candies using the over one-hundred-year-old recipe are once again available.

Would you like to see some candy being made using John Mullane's original machinery? To view the process in action online, key in the phrase "nectar drop candy being made on vintage equipment"—it's amazing!

licorice, butterscotch, chocolate, vanilla, maple and nectar. Small hard candies were also popular in many of the same flavors when you could get them—a good number had to be discontinued during the summer months before air conditioning was introduced because they would stick together.

According to a 1918 color-illustrated sales booklet titled *Mullane's Candies Made with Loving Care*, Woodland Goodies, an amber-colored candy

cluster of nine varieties of nuts, was an original signature piece that was "the most widely imitated confection in America." The name given to this confection was chosen from several thousand entries submitted during a contest for the "most distinctive appellation." For her suggestion in 1891, Mrs. Virginia Howell of Covington, Kentucky, won a $20 gold piece (current value would be approximately $550). Also offered in the candy store were the "Throat-Ease Gumdrops" that many Cincinnati physicians recommended to patients because of their soothing qualities. They came in four flavors: vanilla-glycerine, menthol-glycerine, eucalyptus and licorice-flaxseed-horehound.

MABLEY & CAREW

In 1877, Christopher R. Mabley and his business associate, Joseph T. Carew, were delayed in Cincinnati on their trip to Memphis, Tennessee, where they planned to choose a location for a men's clothing store. During their twenty-four-hour layover, they strolled around downtown. Among the sights, they saw a "For Rent" sign on the northeast corner of Fifth and Vine and decided that Cincinnati would be a better location for "Mabley's Mammoth Clothing House," which later was named the Mabley & Carew Company.

Early advertisements stated Mr. Mabley's pricing policy: all merchandise was to be marked "in plain figures, from which there [would] be no deviation." This approach was counter to the common protocol of bargaining and haggling over the cost of items. Following the "Rule of Three" (one price, one principle and one profit) that this successful clothing merchant had used in Detroit, the store grew at a steady pace and became one of the city's successful businesses. By 1890, the store had added women's ready-to-wear clothing to its merchandise, as well as household goods and china.

On a Saturday evening in July 1907, the Mabley & Carew store initiated an ongoing magnificent visual experience for people in Cincinnati when it created one of the city's not-to-be-missed sights. Seven thousand incandescent electric lights were placed about a foot apart to outline every window, doorway, cornice and awning, not only elaborately illuminating the exterior of the building from sidewalk to roof, but also lighting up the surrounding area on Fifth and Vine Streets from dark until midnight as if it was daytime. According to the August 14, 1907 publication of *Boot and Shoe Recorder*, the "illumination [was at that time] greater than that of any other

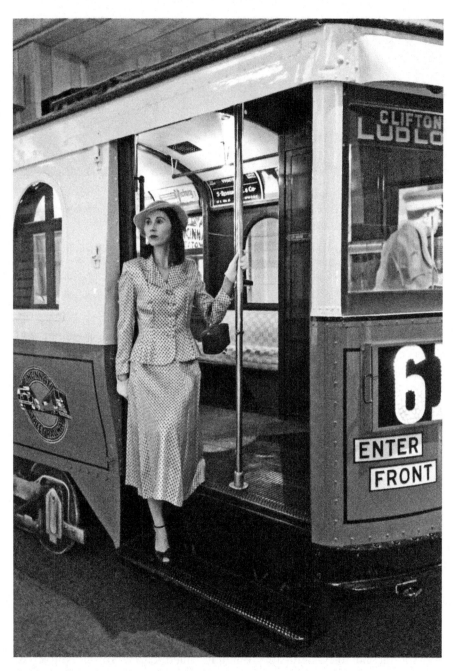

This attractive suit, a 1940s fashion worn by the young woman stepping off the No. 61 Clifton Ludlow Avenue trolley, was manufactured by and sold at Mabley & Carew. *Author's vintage outfit; photographed courtesy of the Cincinnati Museum Center at Union Terminal.*

Left: A close-up of the 1940s suit's label. *Mabley & Carew is a trademark of Bon-Ton Stores Inc. The author thanks Bon-Ton Stores Inc. for granting permission to use the Mabley & Carew name as well as the copyrighted image included here.*

Right: The French Room label on the hatbox promoted the store's image of a fashion store. *Courtesy of the Village Players of Fort Thomas, KY. Mabley & Carew is a trademark of Bon-Ton Stores Inc. The author thanks Bon-Ton Stores Inc. for granting permission to use the Mabley & Carew name as well as the copyrighted image included here.*

structure of any sort, with the exception of the amusement pavilions and towers of Coney Island, N.Y."

Mabley & Carew instituted another program that was a gift to the city. Beginning in 1911, each year on Arbor Day the store provided seedlings to students in area schools. By 1950, more than 4,280,000 shrubs and trees had been distributed and planted in an effort to beautify Cincinnati.

An advertising article by the Liquid Carbonic Company in the *Dry Goods Reporter* of January 1912 stated that Mabley & Carew had also successfully used a merchandising venture that was beneficial to increasing the store's sales and offered new, special services for its customers: a marble-topped soda fountain department and separate lunchroom where light meals were featured. "They [could] seat 40 people at the stools and tables on the main floor and 40 more in the balcony [lunchroom]. They [used] 25 to 50 gallons of ice cream a day and on Saturdays, as high as 80 gallons. By 11:30 on almost any day, every stool and seat at twelve tables [was] taken. By 11:45 people [were] standing two deep waiting for seats."

After fifty-three years at the original location, the business moved to a different home and became the primary retail tenant in the brand-new and spectacular forty-eight-story building called Carew Tower. Mabley & Carew set up operation on the first five floors, as well as in the basement and subbasement. In a *Cincinnati Enquirer* article on December 8, 1929, the store's president, Bolton S. Armstrong, stated, "Moreover, we feel a peculiar

The attractive blue cover of Mabley & Carew's Fountain Room menu, illustrated in a minimal realism style reminiscent of Charlie Harper's work, highlighted the nearby Tyler-Davidson fountain on Fountain Square.

Items found on the menu included chopped chicken liver appetizers, the Queen City Salad Bowl, the Waverly Fair Fruit Plate, the Skyscraper Club Sandwich, homemade chicken croquettes with gravy, shirred eggs with sausage and steamship round of beef.

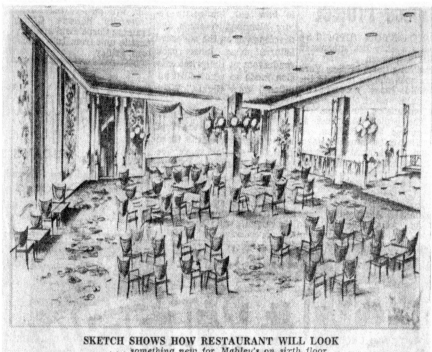

SKETCH SHOWS HOW RESTAURANT WILL LOOK
. . . *something new for Mabley's on sixth floor*

The sketch of Mabley & Carew's Fountain Room tea room, as depicted under the heading of "Features of Mabley's $4 Million Store" in the November 8, 1962 *Cincinnati Post & Times-Star* newspaper, illustrates fashion and style in dining. *Courtesy of the Cincinnati Museum Center, Cincinnati History Library & Archives. Mabley & Carew is a trademark of Bon-Ton Stores Inc. The author thanks Bon-Ton Stores Inc. for granting permission to use the Mabley & Carew name as well as the copyrighted image included here.*

appropriateness in this move to the site of the old Carew Building, inasmuch as Joseph T. Carew, the creator of the Mabley & Carew Company, had this location in mind when he erected the original Carew Building in 1890."

In the 1950s, Mabley & Carew's executives claimed that there was no other store in the United States exactly like it and attributed the store's success to an employee-stockholder idea conceived by Mr. Armstrong, who believed that people working with a common interest and goal was the key. The company was in the unique position of being owned by forty-eight of its employees, of having stockholders from all levels of management (such as buyers, managers and supervisors) and of having the board of directors also made up of company employees.

In 1962, when Mabley & Carew relocated to a new structure built on the site of the former Rollman's department store, the store's color scheme was the glittering "Mabley Wedgewood Blue." The store's image was that of a fashion store focused on clothing and accessories with departments on each floor presented as "specialty shops," and it became one of the largest of that type in the Midwest. That same year, the lovely Fountain Room tea room, which was described as a "quality in-store restaurant" with a large, beautiful space and elegant, private feel, was introduced on the sixth floor.

POGUE'S

Henry and Samuel Pogue, who were Irish immigrants, established the H.&S. Pogue Company in 1863. Numerous stories about the industrious and frugal family reveal both their work ethic and their ingenuity. During the founding days, in order to survive economically, the five Pogue brothers took turns sleeping on cots to save the expense of hiring night watchmen; their mother and sisters handled alterations work at home to eliminate paying a seamstress. Upon moving into their third store building, which was at the time larger than necessary for their stock, they cleverly filled the shelves behind the counters high to the top with saved empty boxes. The appearance of a huge inventory, which worked well unless a clerk mistakenly chose one of the staged boxes to open, in time became a reality. Their frugality, however, did not extend to their employees. Whereas it was quite common in the late nineteenth century to pay women working in such retail stores significantly less because the environment was considered conducive to meeting wealthy prospective husbands, the Pogue family's ethics did not allow such a practice.

As the enterprise grew and flourished into a full department store, the brothers continued to follow the operating concepts that they had used from the start. Samuel Pogue, speaking of his ancestors, stated in a *Cincinnati Enquirer* article on October 29, 1984, that from the beginning, "They all took a great deal of personal interest—bought all the merchandise, knew and waited on customers, saw they had special treatment, ordering…gloves from France, or shawls from England, assuring packages were delivered, sometimes personally, in time for Christmas.…They were very solicitous." For generations, the family realized that by offering services that were better, greater or otherwise different from their competition, their store could attract and build a strong bond with the people in Cincinnati.

The Pogue Company's credo was well taught to every family member and all hired employees from the carriage-trade days forward: each customer was to feel that his or her needs were of genuine concern and that all efforts toward meeting them would be made. By the late nineteenth century, the Pogue family's reputation for both carrying only high-quality, reliable and dependable merchandise and their outstanding customer service had become very well known. The exceptional reputation continued throughout the one hundred years that the family owned and operated the store. Employees would be admonished if they weren't dressed correctly, and as Susan Heil recalled, they'd be pulled off the floor and spoken to if they turned their back on a customer. "You always faced your customer. If you had to leave, you backed away—the customer was queen or king." All the rules put in place were part of the dream the Pogue family had to make the customer happy.

As late as the 1960s, the store provided an escort service, wherein a store representative met customers at the door, took their coats and then, offering his arm, walked them to the different departments, showing merchandise of interest and handling the purchases with the salesclerks. Very few people made use of this service, but there were some "little old ladies" who did. Tom Stewart, one of the escorts, remembered that their chauffeurs would bring them up to the door. They would call a day ahead so that he'd know an arranged time to greet them. "They pretty much knew what they were going to buy when they came in. In some cases, the store already knew what color and size the customer was interested in, and the items had been pulled out ahead of time." The salespeople would hand display them, and the customer would tell him which piece she liked by saying, "Let's hold that one for now." Then Tom basically repeated the statement, saying, "Could we hold that one for now?" or "We're reserving that one." The customer would

then say, "Thank you, sir." "All this was said right in front of the salesperson. Actually the sales manager was also involved—so I was addressing the sales manager who, in turn, was addressing the saleslady." The customer and the salesperson never talked directly. "It was unique. Almost all of these customers were elderly and the sweetest of people," he added. "When they were finished shopping, tired and ready to leave the store, they would say, 'I'm rather taxed.' That was the cue that it was time to inform the chauffeur that they were ready to go home."

When the Carew Tower was constructed in 1930, the Pogue family leased floor space and connected it to their existing building. The store was beautiful, with its lovely interior structure, brass clocks and the copper and brass ornamentation—the match of anything seen in New York City. In 1962, when Mabley & Carew moved out of Carew Tower, the Pogue family expanded the store further by moving into adjoining space on the opposite side of the arcade, creating both Fourth and Fifth Street storefronts.

Research uncovered that, for many years, Pogue's remarkably provided a very accommodating dining room for its employees (as in, at no charge, and special diets and such were taken into consideration). During the early 1960s, a new system was initiated in which they paid cost for their meals, still at a huge discount. There was also a small Quick-Snack bar opened in the lower budget level that served sandwiches and Kahn's hot dogs, fountain treats and other beverages.

In July 1964, the company opened the Ice Cream Bridge, which spanned the arcade above two pillars covered with Rookwood Pottery floral tiles, connecting the second-floor levels of the Fourth and Fifth Street sections of the store. The eatery was designed along the lines of the nostalgic Gay Nineties (1890s), decorated with pink-and-white-striped walls and an antique chandelier and equipped with period chairs and a white marble soda fountain. The waitresses' uniforms and the menu covers carried out the pink-and-white color scheme. Along with Graeter's ice cream served in sundaes and sodas, the shop offered sandwiches, soups and soft drinks as well. Chef James Gregory, the executive chef hired to manage Pogue's restaurants, shared that when they opened the Ice Cream Bridge, they expected to serve about one hundred people per day, but instead they had many hundreds. "There was a constant line of people. The poor kids who had been hired were overwhelmed—dipping all that ice cream was major exercise!" "A Conversation Stopper," made with meringues, chocolate, vanilla and coffee ice cream and topped with

The Ice Cream Bridge, which spanned the arcade connecting the second-floor levels of the Fourth and Fifth Street sections of the Pogue's store, was a striking and popular addition in 1964. *Found in the Cincinnati Museum Center, Cincinnati History Library & Archives clipping collection. The photo was also found in the archives of the Emery family and is used with permission.*

brandied chestnuts, chocolate sauce, whipped cream, cherries and nuts, was one of the special items made to serve five people.

Next to open was the Soup Bar, on the sixth floor, which offered a signature Scotch broth, a barley-based soup and an optional daily soup; a chef salad; and a deep-dish apple pie with cheese or hard sauce, along with coffee and cokes. Later, a Men's Grille was added next to the Soup Bar.

In September of that same year, the Camargo Room opened, and according to the *Cincinnati Enquirer*, it became "the 'star' of Pogue's new and unique dining areas…rapidly becoming a Cincinnati favorite." Luncheons cost $1.35, and suppers, during the evening hours when the store was open, cost $1.65.

Whether the restaurant was named for the road and club in the affluent Indian Hill neighborhood or for eighteenth-century French ballerina Marie Anne de Camargo, the Camargo Room opened with an innovative style for that period of time. The menus were advertised as having special food and beverage items, including beers, ales, wines and champagnes.

The Camargo Room originally followed a service model based on the Birdcage Restaurant at Lord & Taylor in New York. Customers paid the flat rate of $1.25 for a meal ticket as they entered the tea room and then chose their seats from the randomly placed old-school chairs with attached wraparound desktops that could be arranged to fit the size of each group. After orders were placed from a five-entrée menu that included a salad,

This illustration of the Ice Cream Bridge appeared in a Pogue's ad in the *Cincinnati Enquirer* on August 3, 1964. *Courtesy of Bruce Kopytek, the Department Store Museum/Blog Archive. Pogue's is a trademark of Macy's Inc. The author thanks Macy's for allowing the use of the Pogue's name as well as the copyrighted image seen here.*

wouldn't you know Pogue's would have the smartest little spot to eat...

It's called the *Camargo Room* . . . and it's delightful! First of all, the setting's different; individual swing-arm chairs, but so easy to get into, and comfortable. The menu is different, too. One price, five suggestions for lunch. 1.35 or supper, 1.65 . . . each with a little something extra that sets it apart from the ordinary. And then, that pastry cart! It's real *Viennese* pastry . . . simply luscious! The service? Actually, you don't have time to smoke a cigarette before your meals in front of you. And you wouldn't believe such delicious food could be so inexpensive. Something else unique: wine with your meal, if you choose. Leave it to Pogue's: when they do something, they do it right!

Camargo Room, Sixth Floor

This Pogue's ad appeared in the *Cincinnati Enquirer* on December 14, 1964. *Courtesy of Bruce Kopytek, the Department Store Museum/Blog Archive. Pogue's is a trademark of Macy's Inc. The author thanks Macy's for allowing the use of the Pogue's name as well as the copyrighted image seen here.*

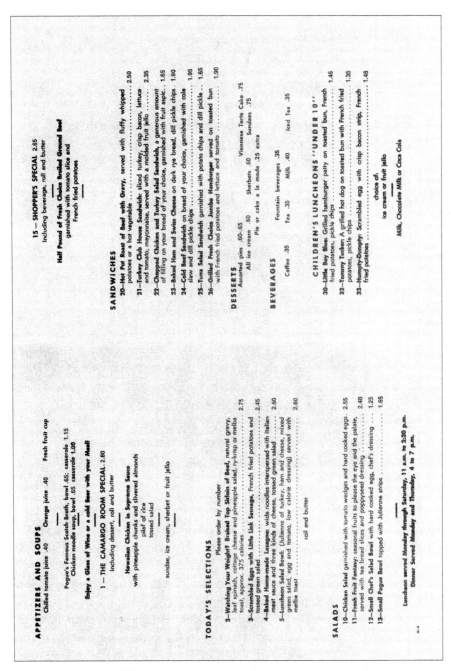

The Pogue's Camargo Room offered a wide variety of menu items, ranging from appetizers, soup and salads to hearty meals or some aimed at those watching their weight, as well as selections for children. *Courtesy of Nellie Goodridge.*

From Pogue's menu:

The Legend of Camargo... dancer extraordinaire! Born in Brussels in 1710, Camargo proved something of a child prodigy. Her Paris debut in 1726 met with great acclaim: her cabrioles and entrechats were effortless, and she was considered one of the most brilliant performers of her day.

One of her lasting contributions to the ballet was the shortening of the dancing skirt. Success followed success. Fashions were named for her. Would-be protectors, among them the Comte de Clermont, vied for her favor.

It is believed by some that Camargo held title to property in what is now northern Cincinnati. To strengthen the legend, the name for the adjacent area, Clermont County, is presumed taken from Clermont in France—possibly the earldom of the Comte de Clermont mentioned above. Her biographer confirms that she owned deeds to "considerable landed property" at her death in 1770—undoubtedly gifts from admirers.

Other sources believe that the name Camargo was brought to Cincinnati by one Charles Brennemen in fond memory of his Mexican War associates [who may have served in Camargo, Mexico, during the 1846–48 war]. *So—did the dancing feet of Camargo carry her across the seas and years to our place and time, or not? Romantics favor one version; realists, another. What do you think?*

dessert and beverage, the food was served on lovely little white trays with small, beautifully arranged dishes. As Chef Gregory explained, "The food was fairly simple but very nicely done." Within less than a year, the service was changed to a more sophisticated theme. The desk chairs were replaced by chairs at tables covered with table linens and cloth napkins in a lovely shade of gray, topped with bright-white dishes manufactured by the famous Syracuse China Corporation, which supplied the same china pattern to the Four Seasons in New York. The waitresses wore caps made of imported French lace that stood up on their heads.

The Camargo Room, situated in a corner of the sixth floor, was expanded in 1977 to hold 196 seats, rather than the 148 it had previously

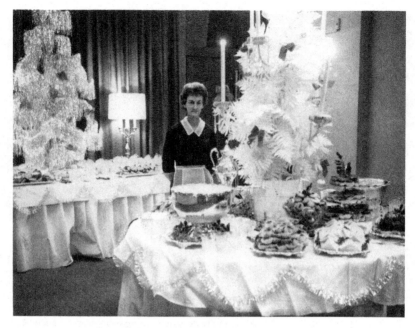

The Camargo Room staff in the mid-1960s prepared a lovely array of finger sandwiches, cookies, punch and tea for a holiday spread. *Courtesy of Chef James Gregory.*

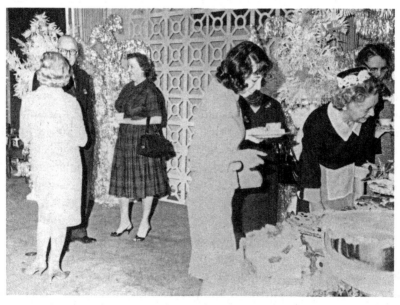

The occasional gentleman also partook. *Courtesy of Chef James Gregory.*

Left: The Camargo Room's stately and tastefully designed dining room was enhanced by the stylish etched-glass panels located on each side of the room's entrance, announcing the tea room's name. *Photo by Roy Davis and Audrey Ann Photography; courtesy of David Conzett, Curator, Historical Objects & Fine Art, Geier Collections & Research Center (Cincinnati Museum Center). Pogue's is a trademark of Macy's Inc. The author thanks Macy's for allowing the use of the Pogue's name as well as the copyrighted image included here.*

Right: Florentine Backhus and Mrs. Edward Brockhaus must have been good bridge players. *Courtesy of Susan Heil.*

accommodated. This popular spot had a stylish décor—a very nicely designed environment with a tasteful pale gray-green color scheme that complemented the Camargo portrait. The back wall had a strong graphic style. The combination of mirrors, back lighting and faux panels made the room appear deeper than it actually was, and a stately architectural grid gave the illusion of a big window, thus making customers feel as if they were in a more open space.

Women reported playing card games, especially on Thursday afternoons, in Pogue's Camargo Room. In the years before the restaurant was opened, they also met for bridge—perhaps in an activity room, as evidenced by a little silver cup that was won at a Pogue's Bridge Club in April 1936.

Beyond the room's physical atmosphere, customers who loved the tea room went for the experience of the gracious care given by its staff and the quality of the food, which was outstanding for the price charged. Nellie

Goodridge, a former manager of the dining room, proudly believes the Camargo Room was "the best restaurant in downtown Cincinnati."

Many people mentioned large crowds of people who lined up through the china department waiting to get into the Camargo Room. As shared by Henry Vittetoe, who was a regular weekday customer for twenty years, if there was a long line of customers waiting, it was not uncommon for the stylish hostess to ask if you minded sharing a table. Some people said they'd rather not, but many others said that would be fine. She would then "waltz you up to a table and say, 'I have a delightful guest who would love to join you,' and most people would say, 'Well, sure.' The hostess would seat you, hand you your menu, turn and say, 'You meet the most lovely people at Pogue's,' and then she would walk away. It was an interesting way for people to really meet strangers. Most immediately engaged in conversation. Some great friendships developed that way."

True friendships also developed between the regular customers and their waitresses. In at least one case, customers attended a retirement party for a waitress of whom they'd become very fond.

Camargo Room waitresses from June 1983 had more "modern" uniforms. *Courtesy of Nellie Goodridge.*

Similar to Wayne Martin's shows at McAlpin's, Pogue's also offered Breakfast with Santa events every Saturday morning during the Christmas seasons. For several years, Skip Fenker, a local puppeteer during the early 1970s, entertained children with shows using rod puppets performing stories such as "The Littlest Snowman" and "The Nutcracker." In different years, television personalities Uncle Al and Captain Wendy made appearances.

Many women recalled that Pogue's had "a lovely little place" imbued with a wonderful ambiance. Some women described the Camargo Room as a place to go not just for luncheon but often as the spot just to sit, have some tea, see who was there and be seen. As described by many, being a customer there was considered to be "better" than being in the other department stores, because they believed if someone was seen in the tea room at Pogue's, that meant they had some money. That's apparently just the way it was—they made no bones about that. When the store stayed open later on Mondays and Thursdays, an elaborate dinner buffet was served, which was exactly what one would expect from a "prim and proper," stylish and sophisticated emporium.

3
Times Changed

Over time, shopping centers and malls sprang up in multiple areas and certainly influenced the decline of downtown shopping. These venues offered convenience for suburbanites, as well as easier parking. The whole concept of "going downtown" changed. People no longer saw it as a destination. The era of getting dressed up for a day of shopping in department stores and eating in tea rooms was coming to a close. As people moved their more casual shopping trips to the suburban malls and no longer invested as much time in sitting down to dine at lunchtime, there was no reason the keep the tea rooms open—they were no longer viable moneymakers.

If you've enjoyed stepping back in time through the recollections above, there's one more way to conjure the past—use the recipes that follow to create gustatory memories through the taste and aromas of the food enjoyed in the tea rooms. While you're at it, see if you can encourage your guests to dress up for the meal!

4
Beverages

The predominant beverage offered in the tea rooms was, of course, hot tea—served in a pot with dainty little cups. Hot coffee and hot chocolate were also available. Many people ordered iced tea and, in some cases, iced coffee to drink. Others preferred Vichy, a naturally effervescent sparkling water beverage. A cold glass of buttermilk was also a menu choice.

Children visiting a tea room in the 1940s and early 1950s often chose chocolate milk as a special treat, while others were allowed to buy a Coca-Cola, 7 Up or root beer (probably either Hire's or Barq's). People did not stock soft drinks in their homes back then like they do today. Most children drank milk, juice and water at home, so a fountain drink was a real treat for them. When flavored soft drinks became popular, many customers ordered chocolate cokes, "heavy on the chocolate," and cherry cokes. Some people requested cherry flavoring added to their orange soda drinks. Part of the fun was watching the cherry color go down the glass, so when a server occasionally stirred the mixture before bringing it to the table, the young customers were greatly disappointed. Many youngsters felt very fancy and sophisticated when ordering Shirley Temples that were served in real champagne glasses decorated with little cocktail umbrellas. Other people remembered ordering tangy fruit (usually cherry or lemon) flavored phosphate drinks that were originally created as medicinal drinks but later became popular as soda fountain beverages. Lemonade, orangeade or pineappleade—often with lemon sherbet added—were also popular choices.

A year or so after Pogue's opened the Camargo Room in 1964, wine was an option with lunch, once again underscoring the store's upscale atmosphere and sensibility. Beer was also on the menu. As indicated on a menu cover showing a salad bowl, teacup and wineglass, by the time Shillito's had renamed its restaurant The Dining Room, it, too, served wine, along with popular classic cocktails and bottled beers.

Now that we know what we could drink, let's look at the food on the menu!

5
Soups

When selecting from a tea room's menu, starting with soup was always a good idea. You could usually choose from at least two soups daily—either a signature soup or the chef's daily feature.

The more than 250 people interviewed for this book generally agreed that McAlpin's was famous for its homemade soups. Each day of the week, a different variety was offered in addition to the standard vegetable. On Monday, for example, you could also get beef barley; Wednesday was mock turtle, a big seller; on another day, the soup du jour might have been chicken noodle, navy bean or perhaps a spinach cheese soup.

The other tea rooms also had fans of their soups. Shillito's served a vegetable soup that was described as phenomenal, and many people looked forward to the days lentil soup with "frankfurter dots," broccoli mushroom chowder or French onion au gratin soup was on the menu. Both Shillito's and Pogue's served a mulligatawny that many customers enjoyed. Though Pogue's popular signature soup was a Scotch broth, other favorites included minestrone, vegetarian vegetable, cream of mushroom and a chicken velvet soup that was "heavenly" and "to die for." Pogue's customers had a choice of soup served in a bowl or a larger terra-cotta tureen with a handle, referred to as a casserole on some menus. The Woman's Exchange was also known for delicious soups, such as creamy vegetable, pea and chicken noodle.

Enjoy the warm comfort of these traditional flavors!

BEAN SOUP

1 pound dry navy beans
1 ham hock
2 cups chopped onion
1 cup chopped celery and leaves
2 cloves garlic, pressed
¼ cup chopped parsley
1 cup mashed potatoes
1 dash Tabasco
1 teaspoon salt
⅛ teaspoon white pepper

Soak beans overnight in water to cover. Place ham hock and drained beans in 3 quarts of water in Dutch oven. Bring to boil, reduce heat and simmer covered for 2 hours. Add remainder of ingredients, simmer covered another hour. Remove ham hock, dice meat, return meat to pot. Adjust seasoning. For a complete meal, serve with hot French bread and a tart green salad.

Yield: 4 servings for a one-dish supper; 6 to 8 otherwise

This recipe is from *Woman's Exchange Cook Book Volume I* (published in 1964, revised copyright 1967) and has been kindly provided by The Woman's Exchange of Memphis, 88 Racine Street, Memphis, TN 38111.

HEARTY CHICKEN NOODLE SOUP

3 quarts chicken broth, homemade or canned
1 cup cooked chicken, diced
⅓ cup diced onion
1 cup sliced carrots
1 cup diced celery
2 teaspoons dried parsley flakes
¼ teaspoon black pepper
¼ teaspoon curry powder
1 bay leaf
12 ounces frozen egg noodles

Put all ingredients except noodles in a 4-quart saucepan. Bring to a boil. Add noodles and return soup to a boil. Cook for 45 minutes or until noodles are tender. Remove bay leaf before serving.

Yield: 3 quarts

Recipe from *Recipes from Our Kitchens, Café Lazarus*. Written and distributed by Lazarus Department Store (published in approximately 1995).

> Elizabeth Kelly, a former employee in the Shillito's kitchen, shared that she taught the staff how to make good chicken soup and that "Mr. Fred Lazarus loved my chicken noodle soup." When asked if she still had the recipe, the answer was no, but she added that there wasn't anything to it. "You just have some diced chicken and then some celery, carrot and onions—I sautéed them—add salt and white pepper, then some broth from the stewed chicken, and put in some fine flat noodles." Spoken like someone for whom cooking is second nature and knowing precise recipe measurements is not needed!

Chicken Velvet Soup

¾ cup butter
¾ cup flour
1 cup warm milk
1 pint hot chicken stock
1 cup warm cream
1 quart chicken stock
1½ cups chopped, cooked chicken
¼ tablespoon (¾ teaspoon) salt
1 dash pepper

In a stockpot over medium heat, melt butter and then whisk in flour, blending well. Add warm milk, pint of hot chicken stock and warm cream. After cooking well, add remaining ingredients.

Yield: 2 quarts

Recipe from *L.S. Ayres Tea Room, Recipes & Recollections*, compiled by Indiana State Museum, Indianapolis, IN (copyright 1998). It has been provided through the generosity of the Ayres Foundation Inc. and the Indiana State Museum Foundation.

Author's Note: I interpreted "cooking well" to mean that all the ingredients had been thoroughly blended and the mixture had reached a warm temperature.

Lentil Soup

2 onions, sliced thin
4 strips bacon, diced
2 cups dried lentils, rinsed
2 carrots, sliced
2 ribs celery, chopped
½ teaspoon oregano
½ teaspoon salt
¼ teaspoon pepper
½ cup tomatoes, or 1 tablespoon of tomato paste
2 cloves garlic, minced
½ teaspoon sweet basil

Sauté onions and bacon (½ cup olive oil may be used in place of bacon) until brown. Add remaining ingredients plus 2½ quarts water. Simmer covered until lentils are tender, about 2¼ hours.

Yield: 2 quarts

This recipe is from *Woman's Exchange Cook Book Volume I* (published in 1964, revised copyright 1967) and has been kindly provided by The Woman's Exchange of Memphis, 88 Racine Street, Memphis, TN 38111.

Minestrone Soup

¼ cup olive oil
1½ medium onions, chopped, not diced
1 cup diced white celery
1 cup diced carrots
1 cup diced zucchini
1 cup curly endive, cut up
1 cup shredded cabbage
Four Friends* (1 teaspoon garlic salt, 1 teaspoon Acćent, 1 teaspoon liquid Maggi and 1 drop
Tabasco sauce)
2 teaspoons oregano
1 tablespoon basil
1 teaspoon paprika
1 cup tomato puree
1 (14½-ounce) can diced tomatoes
1½ cups canned garbanzo beans with juice
4 to 6 cups beef or chicken stock
1 cup elbow macaroni or seashells

Place all ingredients in soup pot, except pasta, and bring to the boiling point. When boiling, add elbow macaroni or seashells. Simmer 45 minutes. Can be served as a main dish with green salad, crusty bread and cheese.

Yield: Serves 8 to 10

Recipe from *The Chef Gregory Cookbook with Lois Rosenthal,* published by F&W Publishing Corporation, Cincinnati, OH, in 1972. All rights reserved; reprinted with permission of the chef/author.

*Author's Note: *Chef Gregory often referred to four ingredients that he used so often and found so valuable that he called them his "Four Friends." For those concerned about MSG, the main ingredient in Acćent, studies suggest that in small amounts, this gluten-free, low-sodium ingredient is safe to use for adding depth to savory foods.*

Mulligatawny Soup
Lazarus Version

1 cup diced onion
1 cup diced carrots
1 cup diced celery
⅓ cup butter or margarine
⅓ cup flour
2 quarts chicken broth, homemade or canned
½ cup diced apples
18 ounces canned diced tomatoes
2 teaspoons salt
½ teaspoon black pepper
1½ teaspoons curry powder
1 cup diced cooked chicken

Sauté onions, carrots and celery in butter or margarine until tender, but not browned. Add flour and stir well. Add chicken broth a cup at a time and continue to stir. Add apples. Cook 15 minutes. Add remaining ingredients and simmer 10 to 15 minutes longer.

Cook's Note: This is a hearty soup; you can add more chicken broth if you prefer and adjust the amount of curry to suit your taste.

Yield: 2 quarts

Recipe from *Recipes from Our Kitchens, Café Lazarus.* Written and distributed by Lazarus Department Store (published in approximately 1995).

Mulligatawny Soup
Pogue's Version

½ cup diced onion
1 carrot, diced
2 stalks of celery, diced
¼ cup butter or olive oil
1½ tablespoons flour
2 teaspoons curry powder

1 quart chicken stock, homemade or canned
½ cup diced tart apples
½ cup boiled rice
½ cup diced cooked chicken
1 teaspoon salt
¼ teaspoon pepper
⅛ teaspoon thyme
½ cup hot cream

Sauté the vegetables lightly in ¼ cup butter or olive oil, but do not brown. Then add the flour and curry powder; stir and cook for approximately 3 minutes. Pour in the chicken stock and simmer for 30 minutes.

Add all of the remaining ingredients except the cream and simmer 15 minutes longer.

Yield: This recipe makes approximately 4 cups.

This mulligatawny recipe is compliments of Chef James Gregory, the former executive chef at the Camargo Room in Pogue's department store. All rights reserved; reprinted with permission of the chef/author.

CREAM OF MUSHROOM

¼ cup butter
1 medium onion, chopped
1½ pounds mushrooms, washed and trimmed
1 cup dry white wine
Juice of a lemon
Four Friends* (1 teaspoon garlic salt, 1 teaspoon Accent, 1 teaspoon liquid Maggi and 1 drop Tabasco sauce)
2 cups light cream
2 tablespoons chicken base
1 pinch of grated nutmeg
1 or 2 tablespoons arrowroot
½ cup dry sherry
½ cup chopped parsley

In a saucepan, melt butter and sauté onion until transparent. Then add mushrooms, wine, lemon juice and Four Friends. Bring to a boil and add cream, chicken base and nutmeg. Simmer for 20 minutes. Blend in small batches on medium speed. Add remaining ingredients, return to the heat until thickened and taste for seasoning. This may also be done using all chicken stock.

Yield: 8 servings

Recipe from *The Chef Gregory Cookbook with Lois Rosenthal*, published by F&W Publishing Corporation, Cincinnati, OH, in 1972. All rights reserved; reprinted with permission of the author.

*Author's Note: *See additional information about Four Friends on page 73.*

Onion Soup

5 medium onions, sliced
3 tablespoons butter
2 scant teaspoons prepared mustard
1 tablespoon Worcestershire sauce
2/3 tablespoon flour
1/3 cup white wine
5 cups good beef stock
1 teaspoon salt
1/8 teaspoon pepper
Croutons
Fresh Parmesan cheese

Sauté onions in butter until brown, about 30 minutes. Add mustard and Worcestershire sauce, cook for 2 minutes. Add flour, mix, then add wine, cook for 2 minutes. Add 1 cup stock, cook 2 or 3 minutes, add remainder of stock, salt and pepper. Cook slowly, covered, for 2 hours. Serve with cheese croutons and Parmesan cheese.

Yield: 6 servings

This recipe is from *Woman's Exchange Cook Book Volume I* (published in 1964, revised copyright 1967) and has been kindly provided by The Woman's Exchange of Memphis, 88 Racine Street, Memphis, TN 38111.

Split Green Pea Soup

2 quarts water
2 cups dried green split peas
1 whole ham hock, split
10 peppercorns
3 carrots, sliced
½ cup chopped onion
2 cups chopped celery
2 tablespoons chopped parsley
2 kosher-style frankfurters
1 cup milk
1 cup beef bouillon
Salt to taste
Paprika and additional chopped parsley as garnish

Rinse and soak peas in 2 quarts of water overnight. Bring to boil in same water. Reduce heat, add ham hock and peppercorns; simmer covered for 1 hour. Press peas and liquid through a coarse sieve. To this mixture add carrots, onion, celery and parsley; cook until vegetables are tender. Add sliced frankfurters, ham (removed from bone and shredded), milk and bouillon. Simmer 20 minutes. Add salt to taste. Serve with chopped parsley and paprika.

Yield: 3½ quarts

This recipe is from *Woman's Exchange Cook Book Volume I* (published in 1964, revised copyright 1967) and has been kindly provided by The Woman's Exchange of Memphis, 88 Racine Street, Memphis, TN 38111.

Scotch Broth

½ cup pearl barley
3 pounds mutton or lamb, with bones
10 cups chicken stock

1 rib of celery, finely diced
1 small carrot, finely diced
½ small turnip, finely diced
½ small onion, finely diced
1 tablespoon heated butter

Rinse barley and then soak in 2 cups of water for 12 hours.

After soaking, drain off the liquid and add the barley to meat and chicken stock. Simmer, covered, for 2 hours or until the meat is tender.

Gently sauté the vegetables in 1 tablespoon of heated butter—allowing enough time to let the vegetables absorb the butter but not get brown. (A dash of curry is optional.) During the last half hour, add sautéed vegetables. Remove the meat and bones from the soup; dice the meat, return it to the soup and reheat. If desired, you can use a flour thickener to bind the soup:

Allow 1½ teaspoons flour for 1 cup of soup. Make a paste of the flour with about twice as much cold stock or water, and then slowly pour the paste into the boiling soup, while stirring. Simmer and stir 15 to 20 minutes. Season to taste.

Suggested seasoning:

Garlic salt—depending on saltiness of chicken stock, start with ¼ to
 ½ teaspoon of salt
1 teaspoon liquid Maggi seasoning
1 drop Tabasco sauce

Serve garnished with chopped parsley.

Yield: This recipe makes approximately 10 to 12 cups.

This Scotch broth recipe is compliments of Chef James Gregory, the former executive chef at the Camargo Room in Pogue's department store. All rights reserved; reprinted with permission of the chef/author.

Cream of Spinach Soup

1 pound spinach, fresh or frozen
8 ounces (1 cup) butter or margarine
1 cup flour, sifted
1 quart chicken stock
1 quart half-and-half
1 teaspoon salt
¼ teaspoon white pepper

Clean spinach, remove stems, cut into ½-inch pieces. Steam in ½ cup of water until tender or follow microwave directions for frozen spinach. Do not drain. Set aside.

Melt butter in saucepan over medium heat. Add flour to make a roux. Cook for 2 to 4 minutes. Add chicken stock, stirring with wire whisk, and bring to boil. Turn heat to low. Add spinach, half-and-half, salt and pepper. Heat, but do not boil.

Cook's Note: This recipe was a favorite in the Lazarus 6th Floor Café.

Yield: 6 to 8 servings

Recipe from *Selected Lazarus Restaurant Recipes*. Written and distributed by Lazarus Food Service Division of Federated Department Stores, Columbus, OH (published in 1981).

Tomato Soup

2 tablespoons diced onion
2 tablespoons carrot
2 tablespoons celery
2 tablespoons raw ham
2 tablespoons butter
2 tablespoons flour
⅛ teaspoon pepper
½ bay leaf

1 pinch of ground cloves
⅛ teaspoon tarragon
⅛ teaspoon thyme
⅛ teaspoon sweet basil
2 cups stock or consommé
2 cups canned or fresh tomatoes
½ teaspoon salt
2 tablespoons sugar
Additional pepper to taste

Cook onion, carrot, celery and ham in butter for 5 minutes. Add flour and seasonings; cook 3 minutes. Add stock and tomatoes; cover, cook slowly for 1 hour. Remove bay leaf; put in blender, blend until smooth. Season to taste with salt, pepper and sugar. Serve with whipped or sour cream.

Yield: 1 quart. Serves 5 to 6 (cup servings)

This recipe is from the *Woman's Exchange Cook Book Volume I* (published in 1964, revised copyright 1967) and has been kindly provided by The Woman's Exchange of Memphis, 88 Racine Street, Memphis, TN 38111

Author's Notes: Not being familiar with the term "raw ham," I did a little research and found that raw ham is pork that has been dry-cured with salt and air, such as prosciutto. Although the word "chicken" was not mentioned in regard to the stock or consommé, tomato soup recipes generally use chicken stock, not beef.

MOCK TURTLE SOUP

Mock Turtle Soup used to be the free lunch at old-time saloons. It was made of calves' heads, meat trimmings from Cincinnati's several local slaughterhouses and other low-cost (or free) ingredients. Today we make it with ground beef, but the mysteriously subtle flavor persists. The light thickening used to be browned flour—a time-consuming pain in the schedule of any busy cook. Gingersnaps accomplish the same thing, with improved flavor.

2 carrots
1 large onion
2 ribs of celery with some of the leaves and scrappy pieces

1 pound (or slightly more) lean ground beef (preferably chuck)
1 tablespoon vegetable oil
1½ cups ketchup
1 teaspoon salt (more later if needed)
1 tablespoon beef stock granules or 4 teaspoons beef broth base
1 tablespoon packed brown sugar
2 teaspoons Worcestershire sauce
1 tablespoon vinegar
A generous grinding of black pepper
1½ quarts hot water
1 dozen each whole cloves and whole allspice
2 bay leaves
12 gingersnaps (1½ inch—fewer if larger)
½ cup cold water
A scant tablespoon sherry wine to each bowl, optional
3 to 4 hard-cooked eggs, diced (use about ½ egg for each bowl of soup)
8 thin lemon slices
Finely snipped parsley

Use: a heavy 3½- to 4-quart stainless Dutch oven

Dice the carrots, onion and celery. If using your food processor, cut the peeled carrots in about ½-inch chunks and process them with 2 or 3 quick "on-off" power pulses, then add the coarsely cut onions and celery to the carrots and process for a second or less until all are medium-finely chopped. Set aside.

Cook the ground beef and oil in the Dutch oven on large range surface unit, medium-high heat, about 5 minutes, stirring often. After a couple of minutes, if the meat is clumping together, use a pastry blender to break it up into small particles.

Meanwhile, in a quart measure combine the ketchup, salt, beef granules, brown sugar, Worcestershire sauce, vinegar and pepper. Add these to the meat along with the hot water. Add the cloves and allspice (in a tea ball or tied in cheesecloth) and bay leaves. Bring to boiling, then adjust heat to a medium-low setting so soup simmers gently. At this time soften the gingersnaps in the cold water and stir into the simmering soup. Cook, uncovered, stirring frequently with a straight-end stirrer (a wooden paddle is good for this). Watch carefully, as the lightly thickened mass can stick and scorch. Cook

I to I½ hours for flavors to blend. If soup is becoming too thick, add a cup of hot water, but be cautious—a diluted soup tastes like a diluted soup. Taste and add salt if needed.

Serve in large soup bowls, add the scant tablespoon of sherry to each (optional but traditional and good). Add the diced half egg and float a lemon slice on each, sprinkle the lemon with parsley. Serve with oven-crisped crackers.

Like other soups, this one is even better if cooled, uncovered, then refrigerated overnight. It keeps well in the refrigerator for a week; for longer storage, freeze in units you'll need for a meal. Use within a couple of weeks—freezing is not kind to spicy foods.

Yield: about 2 quarts, 8 servings

Recipe and historical background from *Recipes Remembered: A Collection of Modernized Nostalgia*, by Fern Storer. Published by Highland House Books, Covington, KY, in June 1989. Permission for use of this recipe was granted by the Kansas State University Foundation.

Author's Note: Adding the sherry is highly suggested, as it creates a very enjoyable tweak to the flavor.

Copper Kettle Vegetable Soup

4 pounds soup meat: foreshank
½ cup diced potatoes
½ cup diced carrots
¾ cup diced cabbage
¼ cup whole kernel corn
⅓ cup diced celery
2 tablespoons onions
¾ cup green beans
¾ cup green peas
2 cups tomato juice

1 tablespoon beef base
1 teaspoon salt
2 quarts beef broth—from foreshank

Cook meat, debone and dice. Add all ingredients and cook until tender.

Cook's Note: So hearty it is almost a meal.

Yield: 1 gallon

Recipe from *A Treasury of Favorite Recipes from Lazarus*. Written and distributed by Lazarus Department Store, Columbus, OH (published approximately between 1970 and 1985).

Author's Note: I interpreted the recipe to mean that I should simmer the soup meat, covered in 2 quarts of water, without any additional seasonings or ingredients for about 2 hours until the meat was tender. After discarding the bones, I added the cut-up meat to all the other ingredients in the resulting broth. The foreshank comes from the upper part of a cow's front legs and creates a great, beefy flavor.

6
Salads and Dressings

S alads were always popular with ladies who ventured downtown for luncheon, and the tea rooms offered a wide selection ranging from home-style comfort to gourmet.

While a number of people mentioned eating a tasty chicken salad as they sat in Pogue's Bridge restaurant, The Woman's Exchange and Shillito's were two spots famous for their chicken salads, whether served on a plate with lettuce underneath or between slices of bread as a sandwich. Comments such as "just delicious" and "a lot of chicken" convey the popularity of Shillito's version. According to interviewees, everybody loved The Woman's Exchange's fabulous white-meat chicken salad served with freshly baked small pecan rolls or butter bits, including men who would go there just for that delectable dish. McAlpin's also offered a salmon salad on its menu.

In the category of complete meal salads, Shillito's Tea Room served the Manhattan, a chef's salad presented with the items laid out in sections versus being tossed together, one ingredient of which was beef tongue chopped into little cubes. The Maurice Salad was considered a special treat by many people because it was different from the kinds of salad that they ate at home. This salad was a well-tossed mixture of julienned ham, turkey, Swiss cheese, crisp greens, egg slices, tomato wedges and sweet gherkins served with a vegetable bread that was spread with strawberry cream cheese. Fresh strawberries also played a role in a refreshing Bibb lettuce salad topped with Shillito's own celery seed dressing. Many customers were introduced to the French-inspired Salad Niçoise at both

McAlpin's and Shillito's; it was a signature item in both tea rooms. Chef Callaway described it as a mixture of shredded lettuce, tuna, redskin baby potatoes that had been steamed and quartered, lightly steamed green beans, julienned sweet gherkins and black olives. At Shillito's, "this mixture was packed into a cone shaped container and then turned over onto a leaf lettuce liner on the plate, so that it maintained the cone shape, and then egg and tomato wedges were arranged around the plate as garnish. A dressing that looked similar to a creamy Caesar, but was actually mayonnaise based, was ladled over the salad and a black olive was placed on top. When served, the salad resembled a snow-topped mountain. It was always one of the most popular items in the dining room." Another favorite remembered from McAlpin's was the Seven Layer Salad, which combined spinach, tossed greens, chicken, peas, American cheese, bacon and hardboiled eggs with a choice of dressings. McAlpin's also offered the Stadium Salad, composed of julienned slices of Swiss cheese, ham and turkey on a bed of crisp lettuce and topped with tomato quarters and bacon pieces. Mabley & Carew's Fountain Room had a similar salad that, with the addition of anchovies, was called the Queen City Salad Bowl. According to the menu, its Waverly Salad was "as colorful as the Famous Fair, a mélange of assorted Fruits with your choice of Cottage Cheese or Fruit Sherbet."

Smaller side salads were also available, sometimes presented on interesting china like a plate shaped like a large lettuce leaf. If a customer expressed interest, the waitresses at Shillito's were prepared to kindly inform the customer that the plates were available in the nearby china department. All of the Shillito's dressings, such as a Roquefort blue cheese, thousand island, the house vinaigrette and celery seed dressing, were made in the store's kitchen; and customers were very pleased that the dressings, along with over a dozen more take-home items, were also available downstairs in the main-floor deli.

Speaking of dressings, Pogue's featured a fabulous French salad dressing; many a patron of the Camargo Room enjoyed a large salad bowl of assorted mixed greens, julienned turkey, ham and Swiss cheese and egg and tomato wedges, topped with the flavorful, tart-sweet mixture. Pogue's salad bowl, served with petite rolls, was an adaptation of the famous (in Cincinnati) Netherland Salad, a luncheon meal with well-chilled iceberg lettuce, chicken, ham, eggs and tomatoes, served with tiny Boston brown bread and cream cheese sandwiches. Another enormous salad, nicknamed the Julie by some employees and considered elegant by many, was covered with little thin

shreds of Swiss cheese and its own wonderful dressing, an Italian blue cheese mix. Typically, iceberg dominated the lettuce choices for the first six decades of the twentieth century and is now a cornerstone of retro salads.

Many of the menu items served in The Woman's Exchange tea room were reported by Frances Schloss to have been supplied from the recipe boxes of families who lived in Hyde Park, Indian Hill and North Avondale and adapted for commercial use. Among the praised dishes were a salad made with iceberg lettuce, crumbled blue cheese, pickled beets and a delectable oil and vinegar dressing; the shrimp salad; and aspics. How many of you have seen an aspic in the last few decades? For those of you who don't remember them or have never even heard of them, this type of fancy salad was molded in a gelatin base and prepared in a variety of flavors. Sandwiches were often garnished with fruit aspic. Tomato aspic, usually topped with a dollop of mayonnaise, was very common as a side dish, but chicken aspic made with chopped chicken and olives was popular as a meal salad, as were salmon, tuna, ham and shrimp.

In general, all the tea rooms offered a similar variety of popular salads that people enjoyed ordering. The basics included plates with cottage cheese attractively surrounded by fresh fruit, Waldorf salad, fruit mixtures in gelatins and slaws. Other salads enjoyed by many customers were stuffed tomatoes filled with either cottage cheese, tuna salad or egg salad and Trio Plates made up of a variety of individual scoops of three of the following: cottage cheese, chicken salad, tuna salad or egg salad. A really special-occasion treat for many (or even an incentive to be persuaded into going shopping as reported by others) was a shrimp cocktail.

Enjoy the fresh flavors, textures and colors!

SIDE SALADS AND MEAL SALADS

Ambrosia

1 quart orange sections (sliced out from pulp)
1 cup sliced bananas
½ cup pineapple bits
½ cup coconut
½ cup maraschino cherries
½ cup chopped pecans
1 cup sugar

Mix all ingredients thoroughly. Chill.

Yield: 6 to 8 servings

This recipe is from *Miss Daisy Entertains* (published in 1980) and has been kindly provided by Miss Daisy King of Franklin, TN.

Author's Note: This is a very sweet mixture. If you are watching your sugar intake, you might want to either use unsweetened coconut or cut back on the sugar by ¼ cup.

Cottage Cheese Ambrosia

1 (15-ounce) can pineapple chunks or tidbits, drained
1 (11-ounce) can mandarin oranges, drained
1 pound (2 cups) creamed small curd cottage cheese
1 (3-ounce) package orange gelatin
1 (4-ounce) carton frozen whipped topping, thawed

Optional additional ingredients:
1 cup small marshmallows or quartered large size
½ cup flaked coconut

Turn the fruits into a colander to drain, reserving juice to use in place of water in your youngster's favorite fruit gelatin. In a 2-quart mixing bowl combine cottage cheese and dry orange gelatin; toss gently with fork.

Add the drained fruits and topping, folding gently to mix. Cover and refrigerate 4 to 6 hours.

To serve, turn the mixture into an attractive serving bowl or spoon into individual serving dishes with as little stirring as possible. If serving as a salad, garnish with small, crisp leaves of Bibb lettuce; if using as a dessert, garnish with a few bits of colorful fruit.

Yield: 6 to 8 servings

Recipe from *Recipes Remembered: A Collection of Modernized Nostalgia,* by Fern Storer. Published by Highland House Books, Covington, KY, in June 1989. Permission for use of this recipe was granted by the Kansas State University Foundation.

BEET SALAD MOLD

1 cup boiling water
1 (3-ounce) package lemon gelatin
1 cup chopped beets (canned are easier)
¾ cup chopped celery
1 tablespoon (or less) grated onion
1 tablespoon horseradish
3 tablespoons vinegar
¾ cup beet juice
Salt to taste

Dissolve gelatin in boiling water. Add other ingredients. Mold as desired.

Yield: 6 servings

This recipe is from *The Cincinnati Cook Book,* with recipes collected by the Co-Operative Society of the Children's Hospital, Cincinnati, OH (published in 1976—original copyright in 1966), and has been kindly provided by Children's Hospital and the Co-Operative Society.

LEMON-LIME CONGEALED SALAD

1 (3-ounce) package lime gelatin
1 (3-ounce) package lemon-flavored gelatin
2 cups water, boiling
1 (16-ounce) can crushed pineapple in its own juice, not drained
½ cup mayonnaise
1 cup small-curd cottage cheese, mashed with fork

½ cup sweetened condensed milk
1 cup pecans, chopped

Add gelatins to 2 cups boiling water. Combine with crushed pineapple and juice. Then add the mashed cottage cheese, sweetened condensed milk and mayonnaise. Blend well. Add the chopped nuts.

Pour into a 13 x 9 x 2-inch pan, cover tightly, chill until firm. Serve on lettuce leaves.

Yield: 12 servings

This recipe is from *Tea Room Treasures* (second printing, May 1996) and has been kindly provided by The Woman's Exchange of Memphis, 88 Racine Street, Memphis, TN 38111.

Tomato Aspic

Basic lemon mix:
1 package of gelatin
⅓ cup sugar
¼ cup lemon juice

1½ cups tomato juice
⅛ bay leaf
2 tablespoons chopped onion
¼ cup celery tops
2 tablespoons vinegar
Pinch salt

Mix together basic lemon mix ingredients. Heat tomato juice with bay leaf, onion and celery tops. Strain over basic lemon mix. Add vinegar and salt. Chill until firm.

Yield: 6 (individual) molds

Recipe from *L.S. Ayres Tea Room, Recipes & Recollections*, compiled by Indiana State Museum, Indianapolis, IN (Copyright 1998). It has been provided through the generosity of the Ayres Foundation Inc. and the Indiana State Museum Foundation.

Author's Note: I got the best results when I heated the tomato juice mixture to a boil and then let it simmer for about 3 to 5 minutes. After straining it over the lemon mix, I stirred until gelatin was dissolved before adding the vinegar and salt. Then I let it cool slightly before pouring into the mold for chilling in the refrigerator. Wiping the molds with a small amount of vegetable oil before filling will help with the unmolding process.

CHICKEN ASPIC

3 cups chicken stock
½ tablespoon chicken base stock or 2 chicken bouillon cubes
Salt and white pepper to taste
2 tablespoons gelatin
¼ cup cold water
2 hard-boiled eggs
12 stuffed olives, sliced
¼ cup finely minced celery hearts
4 cups cubed chicken
1 cup tart mayonnaise
2 tablespoons chopped chives

Bring 3 cups stock to boil; add chicken base stock, salt and pepper. Soak gelatin in water 5 minutes, add to hot stock; stir until dissolved. Refrigerate until it begins to thicken.

Rinse 6-cup mold in cold water, do not dry. Fill with half an inch of jellied stock; arrange sliced eggs and olives in an attractive pattern in stock. Mix celery and chicken in remaining stock, then carefully fill mold.

Chill until firm. Unmold. Serve with 1 cup tart mayonnaise to which 2 tablespoons chopped chives have been added.

Yield: 8 to 10 servings

This recipe is from *Woman's Exchange Cook Book Volume I* (published in 1964, revised copyright 1967) and has been kindly provided by The Woman's Exchange of Memphis, 88 Racine Street, Memphis, TN 38111.

Author's Note: I wasn't sure what "tart mayonnaise" meant, because in general mayonnaise can be considered tart due to the combination of vinegar and lemon juice found in most recipes. However, to produce a mayonnaise that is tarter, try the directions in the creamy cole slaw recipe (see page 94), in which lemon juice and Tabasco are added.

SHRIMP ASPIC

3 cups chopped boiled shrimp
½ cup finely chopped celery
½ cup finely chopped sweet gherkins
1 (8-ounce) bottle catsup
Juice of 3 lemons
Salt and pepper to taste
1 dash Tabasco
2 envelopes gelatin
½ cup cold water
2 cups boiling water
Bibb lettuce, hard-boiled eggs and whole shrimp for garnish
Remoulade sauce (see recipe on next page)

Mix first 5 ingredients, seasoning to taste with salt, pepper and Tabasco. Soften gelatin in cold water, dissolve in boiling water and add to shrimp mixture. Pour into wet ring mold, chill.

Unmold on platter lined with Bibb lettuce. Fill center with remoulade sauce; garnish with quartered hard-boiled eggs and whole shrimp.

Yield: 8 to 10 servings

REMOULADE SAUCE

1 pint Hellmann's mayonnaise
2 hard-boiled eggs, chopped fine
1 cup finely chopped celery hearts
3 cloves garlic, mashed
3 tablespoons dry mustard
2 tablespoons red wine vinegar
8 tablespoons horseradish mustard
1 teaspoon Worcestershire
1 teaspoon sugar
½ teaspoon white pepper
1 teaspoon salt

Combine all ingredients and mix thoroughly. Store in refrigerator in tightly covered jar. Keeps indefinitely.

Cook's Note: Simply delicious for shrimp, asparagus or as a fresh vegetable dip.

Yield: I quart

This recipe is from *Woman's Exchange Cook Book Volume I* (published in 1964, revised copyright 1967) and has been kindly provided by The Woman's Exchange of Memphis, 88 Racine Street, Memphis, TN 38111.

Author's Note: I enjoyed the remoulade sauce on the chicken aspic also.

CREAMY COLE SLAW

*1½ cups mayonnaise**
1 tablespoon minced celery
1 tablespoon minced pimento
1 tablespoon minced green onion, top and bottom
1 tablespoon minced chervil
1 teaspoon seasoned salt
⅛ teaspoon white pepper
½ cup sour cream
4 cups shredded cabbage
2 tomatoes, peeled, seeded and chopped

Mix first seven ingredients. Stir in sour cream. Pour over slaw and tomatoes, folding carefully until well mixed. Chill several hours before using.

Yield: 1½ quarts

Cook's Note: *If commercial mayonnaise is used, add 1 tablespoon lemon juice and 3 drops Tabasco.

This recipe is from *Woman's Exchange Cook Book Volume I* (published in 1964, revised copyright 1967) and has been kindly provided by The Woman's Exchange of Memphis, 88 Racine Street, Memphis, TN 38111.

SWEET-SOUR SLAW

2 green cabbages
1 large onion
⅞ cup sugar
1 cup vinegar
1 tablespoon salt
1 teaspoon dry mustard
1 teaspoon celery seed
¼ cup oil
1 teaspoon sugar

Shred cabbage very thinly. Slice onions paper-thin; separate into rings. Sprinkle sugar over cabbage and onion. In small sauce pan, combine the remaining ingredients, bring to boil.

Pour over cabbage.

Cook's Note: Will keep in refrigerator 10 days to 2 weeks and improves each day.

Yield: 12 to 14 servings

This recipe is from *Woman's Exchange Cook Book Volume II* (published in 1976) and has been kindly provided by The Woman's Exchange of Memphis, 88 Racine Street, Memphis, TN 38111.

Raisin Slaw

1½ pounds cabbage, shredded
1 pound Mandarin orange sections
4 ounces raisins
8 ounces celery seed dressing [see page 108]

Drain orange sections. Combine ingredients. Toss with dressing.

Yield: 10 to 12 servings

Recipe from *Selected Lazarus Restaurant Recipes*. Written and distributed by Lazarus Food Service Division of Federated Department Stores, Columbus, OH (published in 1981).

Waldorf Salad

8 cups chopped Red Delicious apples
2 cups celery
1 cup English walnuts
½ cup mayonnaise
½ cup sour cream

Mix all ingredients together.

Yield: 12 servings

This recipe is from *Recipes from Miss Daisy's (at Carter's Court)* (published in 1978) and has been kindly provided by Miss Daisy King of Franklin, TN.

Pineapple Waldorf Salad

1½ pounds unpeeled apples, diced
8 ounces celery, diced
4 ounces pecans, toasted
1 pound can pineapple tidbits, drained
Celery seed dressing [see page 108]

Combine ingredients and toss with dressing.

Cook's Note: You can prevent apples from turning brown by sprinkling them with lemon juice.

Yield: 10 to 12 servings

Recipe from *Selected Lazarus Restaurant Recipes*. Written and distributed by Lazarus Food Service Division of Federated Department Stores, Columbus, OH (published in 1981).

Herb Egg Salad

6 hard-boiled eggs
⅓ bunch watercress, finely chopped
1 green onion, finely chopped with green part included
Tarragon, crushed (approximately 1 teaspoon)
Mayonnaise

Chop egg well and season liberally with crushed tarragon. Mix with chopped watercress and onion. Add real mayonnaise (about ⅓ cup) until desired consistency is achieved.

Serve on thick slices of tomato as salad, on crackers as hors d'oeuvre or on bread as a sandwich.

Yield: 4 to 6 servings

Recipe from *Greens and Tureens*. Compiled for Easy Riders Inc., member of United Appeal, Cincinnati, OH (copyright for revised edition 1978), Betsy Sittenfeld, editor.

EGG SALAD WITH OLIVES

5 eggs, boiled and chopped
¼ cup green olives, chopped
2 tablespoons mayonnaise
1 dash Tabasco
1 dash sugar

Combine and spread on thinly sliced white bread.

Yield: 10 sandwiches

This recipe is from *Tea Room Treasures* (second printing, May 1996) and has been kindly provided by The Woman's Exchange of Memphis, 88 Racine Street, Memphis, TN 38111.

TEA ROOM TUNA SALAD

1 (7-ounce) can albacore water-packed tuna, drained
½ cup mayonnaise
2 tablespoons lemon juice
½ cup chopped celery
⅓ cup sweet pickle relish
2 hard-boiled eggs, chopped

Mix all ingredients and serve in a tomato or avocado wedge.

Yield: 6 servings

This recipe is from *Miss Daisy Entertains* (published in 1980) and has been kindly provided by Miss Daisy King of Franklin, TN.

Author's Note: I've also enjoyed this recipe made with dill pickle relish.

Tuna Salad

1 (6-ounce) can tuna in water, drained
½ cup peeled and finely chopped apple
6 stuffed green olives, sliced
6 green onions, minced
¼ teaspoon dill weed
¼ cup chopped celery
½ lime, juiced
3 drops Tabasco sauce
Mayonnaise

Mix together, using just enough mayonnaise to bind the salad together.

Yield: Enough filling for approximately 4 sandwiches

This recipe is from *Tea Room Treasures* (second printing, May 1996) and has been kindly provided by The Woman's Exchange of Memphis, 88 Racine Street, Memphis, TN 38111.

Summer Savory Tuna Salad

⅓ cup minced onion
2 ribs celery, sliced thin
2 tablespoons minced fresh parsley
1½ teaspoons dill weed
12 ounces tuna, packed in water, drained
½ cup small curd cottage cheese
½ cup mayonnaise
1 tablespoon Dijon mustard
1 tablespoon small capers, drained

In a bowl, toss together onion, celery, parsley and dill. Add tuna and toss until coated well. Coarsely chop capers by flattening with side of a large knife and then chopping. Add rest of ingredients and salt and pepper to taste. Toss until well combined.

Cook's Note: This is a great twist on classic tuna salad. To reduce the fat content of the salad, substitute low-fat cottage cheese and a low-fat or fat-free mayonnaise in the same quantities.

Yield: 3 cups

Recipe from *Recipes from Our Kitchens, Café Lazarus*. Written and distributed by Lazarus Department Store (published in approximately 1995).

Ham Salad

2 cups cubed cooked ham
1 cup diced celery
½ cup diced apples
½ cup mayonnaise
¼ cup light cream

Combine ingredients and serve in lettuce cup or pastry shells.

Yield: 3 to 4 servings

This recipe is from *Recipes from Miss Daisy's (at Carter's Court)* (published in 1978) and has been kindly provided by Miss Daisy King of Franklin, TN.

Lazarus Chicken Salad

1 quart cubed cooked chicken breast
1 quart medium diced celery
1 pint pecans, roasted and salted
1 pint Lazarus Chicken Salad Dressing [see page 110]

Mix chicken, celery and pecans together and add Lazarus Chicken Salad Dressing. Toss gently. Do not over mix. Chill thoroughly. Can be served in a lettuce cup with additional salad dressing on top.

Cook's Note: "It's a Lazarus exclusive! Developed in 1935..." The single biggest selling item on the menu.

Yield: 12 large salads

Recipe from *Specialties of the House, Cincinnati Dining Guide with Recipes,* by Ralph and Martha Johnston (copyright 1996). Published by McClanahan Publishing House, Kuttawa, KY.

Elizabeth Kelly, who was one hundred years old at the time she was interviewed, made the chicken salad during the years she worked at Shillito's. When asked about the recipe, she said that the chicken salad she made was similar to the one that all the Federated Stores shared, but she didn't bother following the store's recipe. She made a slightly different version—one that she'd gotten from her mother, who was an excellent cook and had taught her culinary skills. While not using the official Lazarus dressing, she sometimes, along with the celery and pecans, added pineapple and occasionally green grapes. She made her own mayonnaise and her own dressing from scratch. "It can curdle easily." She explained that she didn't use any vinegar, as the recipe called for, but instead used lemon juice and olive oil. "And I didn't like using some of the spices (like Worcestershire and Tabasco sauce) in the Lazarus recipe, but I did use the paprika and mustard."

While still reminiscing, Elizabeth added, "Mr. Fred also loved my boiled shrimp with cocktail sauce."

CINCINNATI WOMAN'S EXCHANGE CHICKEN SALAD

1- to 2-pound stewing chicken (Or allow a little more than ½-pound chicken breasts, including
bones, per person.)
Fresh lemon juice from a large lemon
4 hard-boiled eggs, finely chopped
2 stalks celery, finely chopped

Boil the stewing chicken until firm but tender. When cool, take
meat and cut into large pieces. Marinate in fresh lemon juice for
a while (minimum 1 hour, several hours preferred). Then add
hardboiled eggs and celery.

Mix a dressing:
1 pint of mayonnaise (use homemade or pure)
1 cup sour cream
1 teaspoon dry mustard
1 tablespoon tarragon vinegar
1 tablespoon lemon juice

Toss dressing with the other ingredients.

Yield: 4 servings

Recipe from *Greens and Tureens*. Compiled for Easy Riders Inc., member of
United Appeal, Cincinnati, OH (copyright for revised edition 1978), Betsy
Sittenfeld, editor.

Author's Note: The amount of dressing made from the recipe above was a generous amount
for a 2-plus-pound chicken. I think the use of the phrase "pure mayonnaise" was in
reference to using a true mayonnaise, like Hellmann's, versus the similar sandwich spread
alternatives, such as Miracle Whip, that have a sweeter taste and more ingredients/spices
in them.

HOT CHICKEN SALAD

2 cups diced cooked chicken
2 cups thinly sliced celery
½ cup grated cheese
½ cup toasted sliced almonds
½ teaspoon salt
2 teaspoons grated onion
1 cup mayonnaise
2 tablespoons lemon juice
1 cup crushed potato chips for topping

Mix all ingredients except potato chips. Butter baking shells and sprinkle with some of the crushed potato chips. Fill with chicken salad mixture. Top with potato chips. Bake at 350° about 10 to 15 minutes or just until hot.

Yield: 6 servings

Recipe from *The Cincinnati Woman's Club Cookbook*, compiled as the President's Project and developed and produced under the leadership of the Gourmet Class of The Cincinnati Woman's Club, Cincinnati, OH (copyright 1984).

Author's Note: Chef Mark Bowers of The Cincinnati Woman's Club said, "It is important to use fresh lemon juice and sharp finely shredded cheddar cheese. In addition, we bake our chicken breasts the day before assembling so that when we dice the breasts they are COLD to retain as much juiciness as possible." The baking shells are ramekins or soufflé cups.

POGUE'S CURRIED CHICKEN SALAD

2½-pound cooked chicken, diced (3 cups)
1 (8-ounce) can sliced water chestnuts
1 pound seedless green grapes
1 cup pecans, coarsely chopped
1 (20-ounce) can pineapple chunks, drained

Dressing

2 cups mayonnaise
1 tablespoon curry powder
1 tablespoon soy sauce
2 tablespoons lemon juice

Combine all ingredients with dressing and refrigerate to meld flavors before serving.

Cook's Note: A rotisserie chicken would do. This is more of a salad than a spread for sandwiches.

Yield: 6 servings

Author's Note: This recipe, which is reported to have been served at Pogue's, was provided by Barbara Ruh, who received it from Lanee Philippe in the early 1980s. If by chance it is not authentic to the Camargo Room, "then just enjoy it!"

CURRIED TURKEY SALAD

½ pound cooked turkey breast
1 cup finely diced celery
1 cup raisins
½ cup pecans
2 green onions, sliced
¼ cup chopped fresh parsley

Curry Dressing:
½ teaspoon curry powder
1 tablespoon tarragon vinegar
1½ tablespoons olive oil
¼ teaspoon salt
1 dash of onion juice
1½ teaspoons honey
¼ cup mayonnaise

Cut turkey into ½-inch, thin julienned strips. Combine turkey, celery, raisins, pecans, onions and parsley. Combine all of the ingredients for the dressing and lightly toss with the turkey mixture.

Yield: 4 servings

Recipe from *Recipes from Our Kitchens: Café Lazarus*. Written and distributed by Lazarus Department Store (published in approximately 1995).

Maurice Salad

4 ounces Swiss cheese, julienned
4 ounces ham, julienned
4 ounces turkey, julienned
2 ounces sweet gherkins, julienned
1 large head of iceberg lettuce, shredded
2 cups fresh spinach, chopped
Hard-cooked egg wedges
Tomato wedges
Ripe olives for garnish
Maurice Salad Dressing (see recipe on next page)

Toss the greens, cheese, ham, turkey and gherkins with Maurice Salad Dressing to coat the ingredients lightly. Serve chilled on lettuce leaves. Garnish each salad with three egg slices and three tomato wedges plus ripe olives.

Yield: 4 large salads

Author's Note: Julienne means to cut ingredients in slender strips.

MAURICE SALAD DRESSING

3 tablespoons cider vinegar
1½ tablespoons wine vinegar
¼ cup salad oil
¾ teaspoon Worcestershire sauce
½ ounce onion, chopped
⅓ teaspoon salt
1½ eggs, hard-cooked and chopped
8 cups Hellmann's mayonnaise
⅓ teaspoons garlic powder
½ cup dill relish

Combine all ingredients and mix well. Refrigerate.

Yield: 2 quarts

Recipe from *Recipes from Our Kitchen: Lazarus Celebrating 100 Years of Fine Food.* Written and distributed by Lazarus Department Store, Columbus, OH (believed to have been published in 1991).

NETHERLAND SALAD DRESSING

3 tablespoons mayonnaise (not salad dressing)
3 tablespoons olive oil
2 tablespoons vinegar
1 teaspoon Worcestershire sauce
1 chopped hard-boiled egg
1 teaspoon finely chopped chives

Stir together the mayonnaise, olive oil, vinegar and Worcestershire sauce; add the egg and chives.

Salad
¾ head of crisp lettuce, julienned
½ cup julienned chicken
½ cup julienned ham
⅓ cup julienned tomatoes (seeds discarded)
1 tablespoon chopped pickle
4 tomato quarters and hard-boiled egg slices for garnish

In a 1½-quart salad bowl, combine the lettuce, chicken, ham, tomatoes and pickle. Immediately before serving, add the dressing and toss to mix.

Mound on 2 chilled dinner plates. "Do not use lettuce leaves to serve on—put directly on plate," cautioned Peter A. Maurice, onetime maître d' of the Netherland Plaza.

Garnish each with 2 tomato quarters and 2 slices of hard-boiled egg.

Yield: 2 luncheon salads

Recipe from *Recipes Remembered: A Collection of Modernized Nostalgia*, by Fern Storer. Published by Highland House Books, Covington, KY, in June 1989. Permission for use of this recipe was granted by the Kansas State University Foundation.

The Netherland Hotel Salad has been included because so many people remembered it fondly, and other restaurants, such as the Camargo Room, were known to make their own interpretations of it. According to Joyce Rosencrans, a former food editor for the *Cincinnati Post*, one of the most requested recipes during the period from 1951 to 1976 when Fern Storer was the columnist was the one for the Netherland Salad. Some folks still consider it the best salad they have ever eaten.

SALAD DRESSINGS

HOT BACON DRESSING

¼ cup flour
1¼ cups sugar
¼ teaspoon salt
2 cups water
¼ pound bacon, diced
1½ teaspoons fat from bacon
1 cup cider vinegar

Combine flour, sugar and salt. Mix well with part of water (about ½ cup). Heat vinegar and remaining water. Add flour mixture stirring well. Fry bacon until crisp and drain, reserving a small amount (1½ teaspoons) of bacon fat. Add bacon and bacon fat to mixture and cook to desired consistency.

Yield: About 1 quart

Recipe from *A Treasury of Favorite Recipes from Lazarus*. Written and distributed by Lazarus Department Store, Columbus, OH (published approximately between 1970 and 1985).

Author's Note: While this could be served over lettuce for a "wilted lettuce salad," I thought it was good over finely shredded cabbage.

LAZARUS BLEU CHEESE DRESSING

1½ quarts mayonnaise
5 tablespoons port wine
5 tablespoons buttermilk
¼ teaspoon tarragon
2 teaspoons minced fresh garlic
10 ounces bleu cheese, crumbled

Combine all ingredients and blend gently with a spoon. Chill.

Cook's Note: The dressing is best if made a day ahead, giving all the flavors a chance to blend. An easy way to mince garlic is to put it in a blender with port wine for liquid. The mayonnaise, tarragon and buttermilk can be added in the blender on low speed, but fold in the bleu cheese.

Yield: 1¾ quarts

Recipe from *Recipes from Our Kitchens: Café Lazarus*. Written and distributed by Lazarus Department Store (published in approximately 1995).

CELERY SEED DRESSING

1½ ounces onion
½ cup lemon juice
3 pounds sugar (approximately 6½ cups)
½ ounce dry mustard (2 tablespoons)
½ ounce salt (scant tablespoon)
2 cups cider vinegar
4 cups vegetable oil
1 tablespoon celery seeds

Puree onion in blender with lemon juice. Set aside.

Combine sugar, dry mustard, salt and vinegar in a double boiler. Bring to a boil for 1 minute. Cool until lukewarm, then blend on low with mixer for 5 minutes. Add oil, onion mixture and celery seeds and blend at medium speed for 10 minutes.

Bottle and store in refrigerator. Serve at room temperature.

Yield: Approximately 2 quarts

Recipe from *Selected Lazarus Restaurant Recipes*. Written and distributed by Lazarus Food Service Division of Federated Department Stores, Columbus, OH (published in 1981).

ORANGE-CELERY SEED DRESSING

A great variation on the previous recipe

¼ medium onion
½ cup lemon juice
3 pounds granulated sugar
2½ tablespoons dry mustard
1 tablespoon salt
2 cups cider vinegar
4 cups vegetable oil
1 tablespoon celery seeds
½ cup finely chopped orange, peel and pulp

Puree the onion in a blender with lemon juice. Set aside. Combine sugar, dry mustard, salt and vinegar in a double boiler. Bring to boil for 1 minute. Cool until lukewarm, then blend on low speed with mixer for 5 minutes.

Add the oil, onion mixture, celery seeds and chopped orange and blend at medium speed for 10 minutes.

Bottle and store in refrigerator. Serve at room temperature.

Cook's Note: This dressing is great on a spinach salad. Add toasted almonds, mandarin orange slices and thinly sliced red onion—fantastic!

Yield: 2 quarts

Recipe from *Recipes from Our Kitchen: Lazarus Celebrating 100 Years of Fine Food*. Written and distributed by Lazarus Department Store, Columbus, OH (believed to have been published in 1991).

Author's Note: This orange-celery dressing is also really tasty on a salad that contains chopped ham.

Chicken Salad Dressing

Blend of 1 part boiled dressing and 3 parts mayonnaise

Boiled Dressing:
½ cup flour
½ cup sugar
2 teaspoons dry mustard
1 tablespoon salt
1 teaspoon paprika
2 cups milk
1 cup heated vinegar
¼ cup egg yolks

Thoroughly mix dry ingredients, add to milk and cook in double boiler until flour is thoroughly cooked.

Add heated vinegar and continue to cook for 10 minutes. Beat egg yolks and add a little of the mixture to the yolks to keep them from curdling. Return the yolks to hot mixture and cook for 10 minutes longer. Chill.

Yield: 1 quart

Mayonnaise

1 teaspoon salt
1 teaspoon paprika
1 teaspoon dry mustard
1 pinch white pepper
1 tablespoon sugar
4 teaspoons cider vinegar
1 tablespoon tarragon vinegar
4 teaspoons lemon juice
1 teaspoon Worcestershire sauce
1 drop Tabasco sauce
⅓ cup egg yolks
3⅓ cups oil

Combine dry ingredients with liquid ingredients, except oil and egg yolks. Beat egg yolks until light and creamy. Add vinegar mixture and oil alternately to beaten egg yolks, very slowly at first, until an emulsion is started. Beat until a thick, creamy consistency is achieved.

Cook's Note: It is this dressing that makes Lazarus Chicken Salad so special.

Yield: 1 quart

Recipe from *Specialties of the House: Cincinnati Dining Guide with Recipes*, by Ralph and Martha Johnston (copyright 1996). Published by McClanahan Publishing House, Kuttawa, KY.

POGUE'S FRENCH SALAD DRESSING

½ cup ketchup
½ cup sugar
⅓ cup vegetable oil
⅓ cup wine vinegar
2 ½ tablespoons grated onions
½ teaspoon paprika
½ teaspoon chili powder
½ teaspoon salt
½ teaspoon dry mustard
½ teaspoon celery seed

Combine all of the above ingredients and blend well.
To make dressing thicker: add more ketchup
To make thinner: add more vinegar and/or oil

Yield: About 2 cups

Recipe from *Cincinnati and Soup: Recipes from the Queen City and Great Soup*. Cheri Brinkman, Mac Guffin Productions, 2010. All rights reserved; reprinted with permission of the author.

Author's Note: This dressing was very popular and often requested, as evidenced by the fact that between Rita Heikenfeld's column in the Community Press Newspapers, the Cincinnati Enquirer's food section and Marilyn Harris's weekly food column, Recipe Exchange, it appeared in various newspapers at least five times over the years.

Country French Dressing

½ cup red wine vinegar
Four Friends* (1 teaspoon garlic salt, 1 teaspoon Accent, 1 teaspoon liquid Maggi and 1 drop
Tabasco sauce)
1 teaspoon dry mustard
1 teaspoon kosher salt
Ground black pepper
Juice of one lemon
½ to ⅔ cup olive oil

Place ingredients in blender to mix or shake together in a glass jar.

Yield: A generous cup

Recipe from *The Chef Gregory Cookbook with Lois Rosenthal*. Published by F&W Publishing Corporation, Cincinnati, OH, in 1972. All rights reserved; reprinted with permission of the author.

*Author's Note: This lemon vinaigrette-style French salad dressing was introduced in Pogue's when Chef Gregory set up food operations for the Camargo Room. *See additional information about Four Friends on page 73.*

HONEY LIME FRENCH DRESSING

1/3 cup sugar
1 teaspoon salt
1 1/2 teaspoons paprika
1/4 teaspoon black pepper
1/2 cup fresh lime juice
3/4 cup salad oil
1/3 cup honey
1 teaspoon prepared mustard
1 teaspoon celery seed

Combine all in a blender or food processor.

Cook's Note: This is great tossed with fresh fruits for a quick and easy fruit salad.

Yield: 2 cups

Recipe from *Recipes from Our Kitchens: Café Lazarus*. Written and distributed by Lazarus Department Store (published in approximately 1995).

RASPBERRY FRENCH DRESSING

2 teaspoons cornstarch
1 1/2 cups cider vinegar
3 cups granulated sugar
2 cups raspberry vinegar
*1 egg**
2 1/2 tablespoons salt
2 1/2 tablespoons dry mustard
1/2 teaspoon cayenne pepper
1/2 teaspoon white pepper
1 1/2 quarts salad oil

Combine cider vinegar and cornstarch over medium heat; stirring constantly, bring to a boil. Remove from heat to cool. Combine sugar and raspberry vinegar. Set aside.

Beat the egg until light and frothy. Add cooled cider vinegar mixture to the egg. Add the salt, dry mustard, cayenne and white pepper. Add salad oil and blend. Add the sugar–raspberry vinegar mixture and blend. Refrigerate.

Cook's Note: This dressing, not too sweet and not too tart, is great on mixed greens or spinach salad. Try it as a marinade for chicken breasts before grilling.

Yield: 3 quarts

Recipe from *Recipes from Our Kitchens: Café Lazarus*. Written and distributed by Lazarus Department Store (published in approximately 1995)

Author's Note: Because of current concerns about salmonella when eating uncooked eggs, this dressing was tested without the egg, and it was delicious!

When asked about the raw egg, Chef Bud Callaway explained that in this recipe, the egg was used as an emulsion to bind together ingredients that normally would not mix. It is not a taste enhancer. Without it, the oil separates and comes to the top, so it needs to be stirred or shaken before each use, but that is necessary with several dressings.

Although not tested, I've read that a refrigerated or thawed frozen egg product that is equal to a one-egg serving can be used safely.

LAZARUS ITALIAN HOUSE DRESSING

½ cup fresh parsley
4 cloves fresh garlic
1 cup red wine vinegar
1 cup cider vinegar
1 cup olive oil
3 cups vegetable oil
2 tablespoons salt
1 tablespoon dry mustard

Chop parsley and garlic in blender using part of the oil. Add all the other ingredients, and blend 3 to 5 minutes.

Store in refrigerator. Keeps 3 to 4 weeks. Shake well before using.

Yield: 6 cups

Recipe from *Selected Lazarus Restaurant Recipes*. Written and distributed by Lazarus Food Service Division of Federated Department Stores, Columbus, OH (published in 1981).

RUSSIAN DRESSING

1 quart Hellmann's mayonnaise
2 tablespoons grated onion
2 tablespoons chopped green pepper
½ cup chili sauce
⅛ teaspoon Worcestershire sauce
⅛ teaspoon red wine vinegar
1 teaspoon salt
1 tablespoon sweet relish

Combine all ingredients and blend well. Refrigerate.

Yield: Approximately 5 cups

Recipe from *Recipes from Our Kitchen: Lazarus Celebrating 100 Years of Fine Food*. Written and distributed by Lazarus Department Store, Columbus, OH (believed to have been published in 1991).

THOUSAND ISLAND DRESSING

1 pint mayonnaise
¾ (12-ounce) bottle chili sauce
1 teaspoon chopped chives or onion juice
3 hard-boiled eggs
1 green pepper
1 (4-ounce) can pimentos, washed and drained
Salt to taste

Mix all ingredients together. Be sure eggs, pepper and pimento are finely minced. Store in jar in refrigerator.

Yield: 1 quart

This recipe is from *Woman's Exchange Cook Book Volume I* (published in 1964, revised copyright 1967) and has been kindly provided by The Woman's Exchange of Memphis, 88 Racine Street, Memphis, TN 38111.

7
Sandwiches

The perfect accompaniment for a soup or a salad was a delectable sandwich. Mabley & Carew addressed this combination in its "Shoppers Special," an assortment of little sandwiches, a small fruit salad with the store's special dressing and a cup of soup. Many people were delighted with delicate sandwiches, reminiscent of an elegant afternoon high tea, such as cucumber and watercress, salmon and cucumber or pimento cheese spread. Others preferred cream cheese, either with chopped dates or jam, on crust-trimmed white bread triangles; plain cream cheese on freshly baked nut breads; or cream cheese topped with sliced pimento-filled green olives on Boston brown bread. Some people enjoyed peanut butter and banana sandwiches at Mullane's. Sandwich sampler plates were also available. Mabley & Carew created a combination of four small soft rolls, filled with ham, turkey breast, tuna salad and egg salad. In comparison, for someone looking for a much lighter meal, a 1943 Mullane's tea room menu actually shows that lettuce sandwiches were offered for fifteen cents. If something heartier than finger sandwiches was desired, sandwiches equivalent to full meals were available.

At Shillito's, many of its sandwiches were named for Cincinnati's neighborhoods, such as the Price Hill or the Mariemont. The Queen City Club, a closed sandwich made with turkey breast, baked ham, Swiss cheese and lettuce on three slices of pumpernickel rye bread, served with the store's own Russian dressing on the side (with the option of anchovies), was a "big" hit. It was reported to be so big that most adults couldn't eat it all. There was

also the Triple Crown, composed of oven-roasted breast of turkey, sliced ripe tomatoes, grilled lean bacon and a club dressing on lightly toasted bread. The same sandwich ingredients topped with a hot cheese sauce instead of the club dressing was called a Devonshire. The Salmon 'n' Bermuda was a grilled salmon patty topped with a large slice of a Bermuda onion and Shillito's special dill sauce on a toasted cheese bun. The Hidden Sandwich was sometimes considered a salad. Layers of turkey, ham and Swiss cheese on a piece of marble rye bread were "hidden" beneath shredded lettuce, tomatoes, egg, bacon and Russian dressing.

"The busiest section of the kitchen was the sandwich area. It was a shame toward the end," shared Chef Callaway. "A lot of the traditional items we'd served for years got cut. We'd had a whole club section made up of different combinations: one had a layer of egg salad and a layer of tuna salad, another ham and cheese and another example was turkey and bacon. The company had merged so many times with different divisions. When Lazarus went with Macy's, they did not realize that a lot of these items had a nostalgic importance to the Cincinnati patrons. So they came in and dropped a lot of them, and as they did, it just kept pushing the business down and we lost these key items, like the Queen City Club."

Standard sandwiches, like tuna, ham and chicken salad, were available in all the tea rooms, and sometimes beef tongue, braunschweiger and chicken liver were also available. In general, club sandwiches and double-deckers filled with ham, different kinds of cheeses, tomatoes, lettuce and so forth and served with potato chips and pickles were popular menu selections everywhere. In addition to the McAlpin's Club with bacon, turkey, lettuce and tomato, McAlpin's also served the Plaza Queen, a layered sandwich with ham, beef and cheese on pumpernickel rye, and the Plaza King, with a mixture of ham, turkey and Swiss cheese. The Swiss Chicken double-decker included beef tongue along with the chicken and Swiss cheese. Turkey was featured in a hot sandwich with tomato slices and a "supreme sauce au gratin," as well as in a traditional hot turkey with giblet gravy sandwich that came with a side of mashed potatoes and cranberry sauce. Also served was a Grilled Triple Cheese sandwich that combined American, Swiss and mozzarella cheeses on sourdough bread.

Some people mentioned that The Woman's Exchange had really good egg salad sandwiches. Others thought Pogue's egg salad sandwiches were the best in town, mentioning the texture of the eggs and the fact that they had been very thinly sliced versus crumbled, almost layered atop the lettuce on bread. Chef Gregory explained that the eggs were prepared in a commercial

steamer under a watchful eye—never overcooked! Other popular items at Pogue's were "a beautiful sandwich" hamburger, described as almost like a big steak, served on a dark rye bun with lettuce and tomato; a great BLT on white toast; and a corned beef sandwich served with slaw. Along the same line, interviewee Susan Ditmire shared that she had her first grilled Reuben in a tea room, "although you would not necessarily think of it as a tea room sandwich. It was Cincinnati." McAlpin's offered its popular Monte Cristo with ham, white-meat chicken and cheese sauce as a main dish sandwich. Pogue's occasionally served a rendition of the Monte Cristo also. The Kentucky Hot Brown, with breast of turkey on toast with a savory cheddar cheese sauce topped with tomato slices, bacon strips and sprinkled with Parmesan cheese, was prepared under a broiler. Chef Callaway said at Shillito's that sandwich was one of the biggest sellers. "We made and put those out like crazy." Polk Laffoon IV, in a restaurant column article titled "A Shade of Difference" for the September 1977 *Cincinnati Magazine*, described his pleasure with the Welsh rarebit that was "thick and uncompromisingly cheddared, with an egg on top and tomato soufflé…steaming modestly at its side."

What's the best thing since sliced bread? Sandwiches! Using the recipes that follow, you can make beautiful memories and taste the celebration.

CUCUMBER SANDWICHES

1 (3-ounce) package cream cheese
1 tablespoon heavy cream
1 teaspoon grated onion
1 dash of Tabasco sauce
½ teaspoon Worcestershire sauce
1 teaspoon lemon juice
3 medium cucumbers, peeled and thinly sliced
Bread
Parsley, finely chopped for garnish

Mash cream cheese and blend together with heavy cream in a mixing bowl. Add the onion, Tabasco, Worcestershire and lemon juice, stirring to blend. Cut bread in small rounds (the size of your cucumber slices). Spread the bread rounds with the cream cheese mixture, place a cucumber slice on top and sprinkle lightly with parsley.

Yield: About 3 dozen small sandwiches

119

This recipe is from *Tea Room Treasures* (second printing, May 1996) and has been kindly provided by The Woman's Exchange of Memphis, 88 Racine Street, Memphis, TN 38111.

Author's Note: The cream cheese is easier to work with at room temperature. White bread was the classic choice for these sandwiches.

COLONIAL CHEESE FILLING

2 pounds American cheese
¼ cup diced green pepper
¼ cup sweet pickle relish
2 tablespoons diced pimento
2 tablespoons diced onion
3 cups Lazarus Chicken Salad Dressing [see page 110]

For this recipe, long strands of American cheese are needed. A food grinder was used in the Lazarus kitchens. To substitute at home, use the largest hole on a food grater or meat grinder.

Combine the grated cheese with all other ingredients and blend together. Refrigerate.

Cook's Notes: Lazarus made this favorite for over 40 years... customers loved it as a spread with crackers or on small tea sandwiches.

Yield: 2 pounds

Recipe from *Recipes from Our Kitchens: Café Lazarus*. Written and distributed by Lazarus Department Store (published in approximately 1995).

PIMENTO CHEESE FILLING

1 pound sharp cheddar cheese, grated
4 ounces minced pimento and juice
1 cup mayonnaise, or less
½ teaspoon sugar
⅛ cup minced onion
½ teaspoon Tabasco sauce
½ teaspoon black pepper

Mix all ingredients and chill.

Yield: 1½ pounds

This recipe is from *Tea Room Treasures* (second printing, May 1996) and has been kindly provided by The Woman's Exchange of Memphis, 88 Racine Street, Memphis, TN 38111.

LAZARUS HIDDEN SANDWICH

1 slice rye bread
1 ounce chicken breast
1 ounce baked ham
½ ounce Swiss cheese
1 hard-boiled egg, sliced
1 tomato slice
1 cup shredded lettuce
¼ cup Russian dressing

Place baked ham, Swiss cheese, then breast of chicken on the slice of rye bread. Mound the shredded lettuce on top of this. Cover the entire sandwich with Russian dressing and top with egg slices and a tomato slice.

Cook's Note: Is it a sandwich…or a salad? A delicious conundrum!

Yield: 1 sandwich

Recipe from *A Treasury of Favorite Recipes from Lazarus*. Written and distributed by Lazarus Department Store, Columbus, OH (published approximately between 1970 and 1985).

Welsh Rabbit

1 pound sharp processed cheddar cheese
1½ cups heavy cream
2 teaspoons Worcestershire sauce
½ teaspoon (dry) mustard
¼ teaspoon cayenne
¼ teaspoon paprika
8 English muffins, halved and toasted
16 slices fried bacon
16 tomato slices
Parsley flakes

Melt cheese in double boiler. Add cream, Worcestershire sauce, mustard, cayenne and paprika. Heat.

To assemble:
Place hot muffin halves on each plate and lay a tomato on each muffin half, 2 strips of bacon over the tomatoes, cheese sauce, then parsley flakes. Serve.

Yield: 8 servings

This recipe is from *Recipes from Miss Daisy's (at Carter's Court)* (published in 1978) and has been kindly provided by Miss Daisy King of Franklin, TN.

Author's Note: Welsh Rabbit is also known as Welsh Rarebit.

BAKED SANDWICHES

8 slices of bread
4 slices of ham
4 slices of mild cheddar cheese
1 teaspoon dry mustard
3 eggs, slightly beaten
2 cups milk
1 teaspoon grated onion
1 teaspoon salt
1 teaspoon pepper
1 dash Worcestershire sauce
1 dash cayenne pepper

Trim crusts from bread and butter both sides well. Place 4 slices in a buttered baking pan; spread with ham and cover with cheese. Top cheese with remaining bread slices. Combine remaining ingredients and pour over bread. Refrigerate overnight.

Preheat oven to 350°.
Spoon liquid that has gathered in the bottom of the pan overnight over bread and bake for 1 hour.

Yield: 4 servings

This recipe is from *Miss Daisy Entertains* (published in 1980) and has been kindly provided by Miss Daisy King of Franklin, TN.

CHEESE MUFFIN SANDWICH

1 cup ripe olives, sliced
1 cup grated sharp cheddar cheese
½ medium onion, chopped
½ cup Hellmann's mayonnaise
½ teaspoon cayenne pepper
Paprika
3 English muffins

Preheat oven to 350°. Combine ingredients except muffins. Split muffins in half and spread generously with mixture. Bake 5 to 10 minutes until puffy.

Yield: 6 servings

This recipe is from *Miss Daisy Entertains* (published in 1980) and has been kindly provided by Miss Daisy King of Franklin, TN.

Author's Note: The cayenne pepper adds a pretty good kick to the flavor. The first time you make these, you might want to cut back a little and test the flavor.

CREAMED DRIED BEEF

¼ pound dried beef
2 tablespoons butter
1 to 2 tablespoons flour
1 cup milk
Hot buttered toast

Pick meat in small pieces, brown in butter. Sprinkle on flour and stir. Slowly add milk; cook until slightly thickened. When it boils, pour it over a platter of toast and serve at once.

Yield: 2 servings

This recipe is from *Depression Era Recipes* (copyright September 1989) and kindly provided by Patricia R. Wagner. Published by Adventure Publications Inc., Cambridge, MN.

Author's Note: I initially wondered about the fact that the recipe did not list any seasoning. Turns out the recipe produced a very tasty dish—the shaved dried beef from the butcher shop turned out to be well seasoned, no salt needed.

KENTUCKY HOT BROWN

Kentucky Hot Brown is a luncheon or supper entrée. Toast triangles are heaped with sliced chicken or turkey, then blanketed with sherry-tanged, grated Parmesan–flavored sauce. Two strips of bacon crisscross the top of each serving. You'll need shallow, generous individual oven-proof servers.

¼ cup (½ stick) butter or margarine
1 small onion, finely chopped (about ¼ to ⅓ cup)
¼ cup (4 tablespoons) flour
2 cups milk, or 1 cup each of milk and half-and-half
½ teaspoon salt
¼ teaspoon pepper
2 to 4 tablespoons grated Parmesan cheese
1 egg yolk, optional
2 tablespoons dry sherry
4 slices bread (white or whole wheat), toasted and buttered
4 generous servings of sliced cooked chicken or turkey
Additional Parmesan for tops
8 slices half-cooked bacon
Cherry tomatoes or tomato wedges and parsley for garnish

Ahead of time cook the bacon, until about half done; wrap in a paper towel and set aside.

Slice the cooked chicken or turkey and return it to the refrigerator.

Making the sauce (in a microwave): In a quart oven-glass measure, cook the butter and onion (high) about 3 minutes. Stir in the flour, mixing until no trace of flour remains, then stir in the milk or half-and-half, whisking smooth. Cook (high) until boiling and smooth, whisking every 1½ minutes for about 6 minutes. Stir in the Parmesan cheese (or shredded cheddar or Monterey Jack if you prefer). Stir briefly until cheese melts; season as needed with salt and pepper.

Beat the egg yolk in a 1-cup measure; slowly stir in about ¼ cup of the hot sauce. When smoothly mixed, stir this into the rest of the hot sauce, whisking smooth. Cook (high) 30 seconds; take from oven immediately. Whisk again and add the sherry. Cover with wax paper and set aside if not completing the dish at this time. Gently

warm the sauce on 30 percent power (medium-low)—do not boil—when ready to complete the Hot Browns.

Use: 4 generous, shallow individual oven-proof servers

To assemble Hot Browns: Start oven preheating to 350° F. Place 2 triangles of buttered toast in each server. Top each with a generous layer of chicken. Spoon ¼ of sauce over each; sprinkle with a bit more Parmesan and top with 2 strips of the half-cooked bacon, crisscrossed.

Place servers on a metal tray or cookie sheet for easy handling. Bake on middle oven rack 10 to 12 minutes or until heated through and bacon is crisp. Garnish with halved cherry tomatoes or with wedges of large tomatoes and parsley.

Yield: 4 servings

Recipe from *Recipes Remembered: A Collection of Modernized Nostalgia*, by Fern Storer. Published by Highland House Books, Covington, KY, in June 1989. Permission for use of this recipe was granted by the Kansas State University Foundation.

MONTE CRISTO SANDWICH

3 slices white bread
Mayonnaise
1 slice ham, large enough to cover the bread
1 slice Swiss cheese, large enough to cover the bread
Sliced turkey, large enough to cover the bread
Egg batter (recipe below)
Oil for frying
Mustard sauce (recipe below)

Spread mayonnaise on three slices of bread. Place ham and cheese on one slice. Place turkey on the second slice. Top third slice of bread to make a 3-tier sandwich. Dip sandwich completely in egg batter. Fry in oil at 350° until golden brown. Cut into quarters and serve with mustard sauce.

Yield: 1 sandwich

Egg Batter
1 1/3 cups milk
1 1/3 cups flour
1 egg
1/4 teaspoon salt
1/4 teaspoon baking powder

Beat together all ingredients until smooth.

Mustard Sauce
1/2 cup sugar
4 1/2 tablespoons cornstarch
1/3 cup + 1 tablespoon egg yolks
12 ounces fruit juice
1 1/2 teaspoons lemon juice
1 cup mayonnaise
1/4 cup prepared mustard

Mix together sugar, cornstarch and egg yolks. Heat fruit juice and lemon juice. Add a small amount of the heated juice to the egg yolk mixture; stir yolk mixture into juice mixture. Cook over medium heat until thick, stirring constantly. Combine with mayonnaise and mustard and beat until thoroughly mixed.

Recipe from *L.S. Ayres Tea Room: Recipes & Recollections*, compiled by Indiana State Museum, Indianapolis, IN (copyright 1998). It has been provided through the generosity of the Ayres Foundation Inc. and the Indiana State Museum Foundation.

Author's Note: Cutting off the crusts allowed me to pinch the bread edges together, creating a better seal before dipping the sandwich in the egg batter.

Toothpicks can also be used to hold the sandwich together while frying—remove before serving.

To remove excess oil, place the hot sandwich on a paper towel. Cranberry, strawberry, raspberry or pomegranate juices are good choices for the mustard sauce.

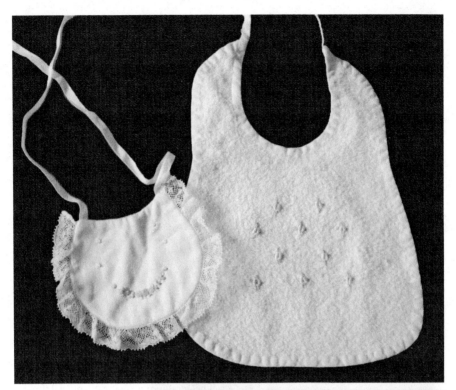

Above: These baby bibs featuring hand-sewn appliqué work display some of what was available in The Woman's Exchange shop. *Items photographed courtesy of Eunice Abel.*

Right: This menu cover spotlights McAlpin's among all the neighboring stores located on Fourth Street. *Menu provided by Dan Howell, former manager of McAlpin's Tea Room. McAlpin's is a trademark of Dillard's Inc. The author thanks Dillard's for granting permission to use the McAlpin's name as well as the copyrighted image included here.*

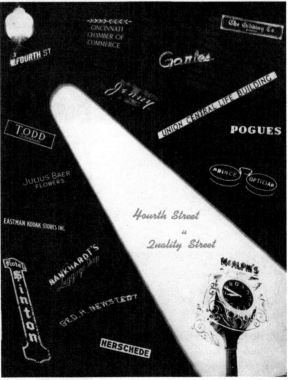

The geranium, Cincinnati's official flower, graces the cover of this tea room menu. *Courtesy of the Public Library of Cincinnati and Hamilton County.*

Caroline Williams was very well known for her scenes of Cincinnati, including this one depicting the McAlpin's clock on the menu cover. *Courtesy of the Public Library of Cincinnati and Hamilton County.*

This menu from 1939 offers a budget luncheon of beef short ribs, mashed potatoes and grilled tomatoes for forty cents. *Menu provided by Dan Howell, former manager of McAlpin's Tea Room. McAlpin's is a trademark of Dillard's Inc. The author thanks Dillard's for granting permission to use the McAlpin's name as well as the copyrighted image included here.*

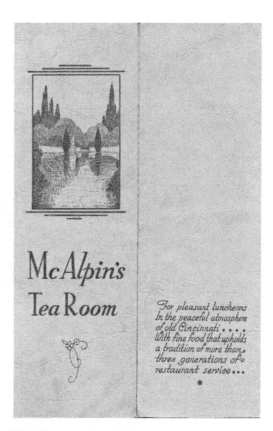

McAlpin's
Tea Room

For pleasant luncheons In the peaceful atmosphere of old Cincinnati With fine food that upholds a tradition of more than three generations of restaurant service . . .

Over the years, McAlpin's had a variety of menus, each sporting different cover designs and offerings. *Menu provided by Dan Howell, former manager of McAlpin's Tea Room. McAlpin's is a trademark of Dillard's Inc. The author thanks Dillard's for granting permission to use the McAlpin's name as well as the copyrighted image included here.*

McAlpin's Miniature Menus, such as this one featuring Tom Turkey, were created and copyrighted in 1945. *Menu provided by Dan Howell, former manager of McAlpin's Tea Room. McAlpin's is a trademark of Dillard's Inc. The author thanks Dillard's for granting permission to use the McAlpin's name as well as the copyrighted image included here.*

The children's Easter menu was presented alongside an Easter tale about Mack Alpin Rabbit, who encouraged reading books. *Menu provided by Dan Howell, former manager of McAlpin's Tea Room. McAlpin's is a trademark of Dillard's Inc. The author thanks Dillard's for granting permission to use the McAlpin's name as well as the copyrighted image included here.*

The Halloween menu offered a soup or fruit cup, a miniature chicken pot pie and, of course, pumpkin pie. *Menu provided by Dan Howell, former manager of McAlpin's Tea Room. McAlpin's is a trademark of Dillard's Inc. The author thanks Dillard's for granting permission to use the McAlpin's name as well as the copyrighted image included here.*

The Christmas menu announced that Santa was coming and suggested that boys and girls should drink all their milk and eat every bit of their food. *Menu provided by Dan Howell, former manager of McAlpin's Tea Room. McAlpin's is a trademark of Dillard's Inc. The author thanks Dillard's for granting permission to use the McAlpin's name as well as the copyrighted image included here.*

Above are some of the original equipment pieces used by the John Mullane Company. The candy press and nineteen sets of interchangeable candy rollers that were manufactured between 1860 and 1890 make up one of the largest sets of surviving rollers anywhere in the country, perhaps even the world. *Photo provided by Ron Case.*

The cover of the Mullane's menu advertised its downtown tea room and Hyde Park locations. *Menu provided by Ron Case.*

Left: This Shillito's Tea Room menu, thought to be from the 1950s, stated the daily operating hours from 11:00 a.m. to 2:30 p.m., with additional evening hours of 4:30 p.m. to 7:00 p.m. on Mondays and Thursdays. *Courtesy of the Public Library of Cincinnati and Hamilton County. Shillito's is a trademark of Macy's Inc. The author thanks Macy's for allowing the use of the Shillito's name as well as the copyrighted image included here.*

Below: The cover of this Shillito's menu depicts some of the items, including wine, available in the restaurant, renamed The Dining Room. *Menu provided by Chef Glenn "Bud" Callaway. Shillito's is a trademark of Macy's Inc. The author thanks Macy's for allowing the use of the Shillito's name as well as the copyrighted image included here.*

The Camargo Room

Pogue's bright red menu cover welcomed guests in the 1980s to the tasty choices from which they would choose their meal. *Image of menu cover provided courtesy of Nellie Goodridge. Pogue's is a trademark of Macy's Inc. The author thanks Macy's for allowing the use of the Pogue's name as well as the copyrighted image included here.*

This painting of Lady Camargo adorned the Camargo Room. *Photographed courtesy of Nellie Goodridge, a former manager of the dining room.*

The Fountain Room

Mabley & Carew's Fountain Room menu carried out the store's well-known blue color scheme. *Courtesy of the Collection of the Public Library of Cincinnati and Hamilton County. Mabley & Carew is a trademark of Bon-Ton Stores Inc. The author thanks Bon-Ton Stores Inc. for granting permission to use the Mabley & Carew name as well as the copyrighted image included here.*

Lentil soup with "frankfurter dots" was well liked at Shillito's. *Photo by Kristin Ungerecht.*

French onion soup au gratin was a popular choice on many tea room menus. *Photo by Kristin Ungerecht.*

A warm bowl of tomato soup is a traditional favorite with salads and sandwiches. *Photo by Kristin Ungerecht.*

Right: Mrs. John C. Pogue thought that this beet salad was "very pretty in a ring with cottage cheese in the center." *Photo by Kristin Ungerecht.*

Below: The Maurice Salad was a popular, hearty staple. *Photo by Kristin Ungerecht.*

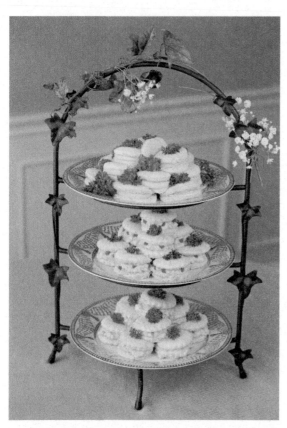

Left: Finger sandwiches, such as these filled with cucumbers and cream cheese, colonial cheese filling and pimento cheese, were very popular in tea rooms. *Photo by Kristin Ungerecht.*

Below: This sandwich can fool you—it looks like a salad! *Photo by Kristin Ungerecht.*

Popular with all ages—a warm chicken pot pie. *Photo by Kristin Ungerecht.*

Chicken broccoli casserole was a signature entrée on Lazarus menus. *Photo by Kristin Ungerecht.*

Above: Chicken à la king brings back many fond memories. *Photo by Kristin Ungerecht.*

Left: This carrot and apple scallop side dish could also be served as a dessert. *Photo by Kristin Ungerecht.*

The pecan and wild rice pilaf is a great accompaniment for chicken and fish. *Photo by Kristin Ungerecht.*

So many delicious choices: apricot, spinach-orange, date nut, carrot-lemon and banana breads. *Photo by Kristin Ungerecht.*

Left: This cheesecake was served in the Shillito's Tea Room and also sold in the Shillito's Bakery. *Photo by Kristin Ungerecht.*

Below: Years ago, this white chocolate cake recipe was handed out at Shillito's candy counter. *Photo by Kristin Ungerecht.*

8
Main Dishes

In addition to soup, salads and sandwiches, full, hearty meals were also available.

Chicken dishes were popular. Options included country chicken casseroles cooked in a rich cream sauce with peas and carrots or chicken à la king with mushrooms and pimientos, both usually served in a vol-au-vent, puff-pastry shell. Fried chicken with creamy gravy, stewed chicken with homemade noodles, chicken croquettes, chicken tetrazzini, chicken broccoli casserole and, in later years, chow mein with crisp noodles piled high were among the possible choices. Another favorite chicken offering among children at many of the tea rooms until the mid-1980s was presented in special china or glass dishes that had hen-shaped lids that sat on top of the "nests," served with warm biscuits on the side. At Shillito's, the dish consisted of mashed potatoes in the base of the hen's nest bowl with creamed chicken on top. Also popular among all ages were chicken pot pies with chunks of white meat, mushrooms and garden vegetables in a fricassee gravy or cream sauce topped with or sealed in a pastry shell. The Woman's Exchange sold individual chicken pot pies in small glass bowls as takeout purchases to be rewarmed at home. (There are still a few kitchen cabinets that have these dishes stacked on the shelves and being used for cereal!) McAlpin's version delighted children when their meals were served in Beatrix Potter bowls. Eating every bite to find out which character was at the bottom of the bowl added excitement to the meal, with some youngsters always hopeful they would uncover Peter Rabbit.

Pogue's offered children under ten years of age the opportunity to choose from their own special menus: Little Boy Blue (grilled hamburger patty on a toasted bun, French fried potatoes and pickle chips), Tommy Tucker (grilled hot dog on a toasted bun, French fried potatoes and pickle chips) and Humpty-Dumpty (scrambled egg with crisp bacon strip and French fried potatoes). All of those were accompanied by a choice of ice cream or fruit gelatin and milk, chocolate milk or cola. Seems it was just the boys in nursery rhymes being represented. I suppose it's just as well—no one would want to order Mary and her little lamb!

While discussing memories interviewees had of eating in the tea rooms as children, one quite charming theme came up several times. Several ladies remembered small stoves or ovens sized for children that appeared in the Shillito's Tea Room during the holiday seasons in the late 1930s and early 1940s, and each person expressed that they were the highlight of their dining experience. The waitresses brought out children's orders in Peter Rabbit ovens that were white with red trim accents, from which they opened the oven doors and served the dish. Others remembered miniature appliances set up along a higher level from where one sat to eat, separated by a small railing. Children were able to pretend that they were cooking on them while they waited for their luncheons to be served.

Fish was a menu item often mentioned. Mabley & Carew advertised a Friday's special of baked tuna fish and noodles au gratin with a side of tossed salad. In addition to the ordinary dishes in the region, such as sole, cod, halibut, haddock and shrimp, tea room menus also offered clams, scallops, oysters (fried, stewed and raw) and soft-shell crab in season.

In particular, McAlpin's was noted for its fish, and as a result, crowds showed up on Fridays, lined up almost to the elevator. Some people went downtown specifically on Fridays so they could partake of the big, delicious two- or three-piece dinners that were priced a little less expensively on that day to attract customers. According to head hostess Martha Hinkel, "We had the best fish in Cincinnati. It was an Icelandic cod, and one of the cooks would cut the fish into logs and bread it every morning. It was our big seller. The menu stated that you could have seconds on that meal for no additional charge. Young men loved that deal!" She went on to say that some people thought that meant it was an all-you-could-eat arrangement, but it was only for second servings. However, the deal also included seconds on the macaroni and cheese and coleslaw that came with the fish as well. "Fridays during Lent were

unbelievable," she added. "I remember one Friday we served 1,150 people in three hours' time, and most of them ordered the fish. I needed eighteen waitresses on Fridays during Lent."

The grill sections of the various kitchens were also busy, because businessmen liked broiled sirloin steaks, pork chops and lamb chops with mint jelly. Other items mentioned as favorites were tomato sauce–covered meatloaf meals that included large scoops of fluffy mashed potatoes or potato au gratin and green vegetables, casseroles of tender beef stew with vegetables in gravy, beef stroganoff, beef hash, Salisbury and Swiss steaks and pot roasts with brown gravy. Additional beef dishes included steamship round of beef at the Fountain Room, tenderloin steaks served with mushroom sauce, filet mignon on toast and broiled calf liver with bacon curls. If pork was your preference, you could order cold slices of boiled ham or warm ham steaks served with either raisin sauce or a glazed pineapple ring topping; a dish with green asparagus on Canadian bacon covered with rarebit sauce; or roast pork loin with gravy, sauerkraut, potato pancakes and applesauce. It didn't have to be Thanksgiving to enjoy a good turkey meal. In addition to the traditional meal with stuffing and cranberry sauce, poulettes were served with roasted turkey breast on toasted bread, topped with asparagus spears, egg slices and cheddar cheese sauce, and then broiled until bubbling. Peter Glaubitz, the head of Shillito's food services, said in an interview with *Cincinnati Magazine* in 1977 that "the turkey poulet…'a unique Cincinnati, Shillito's, hot-brown thing,' is the daily best-seller." Crepes poulette consisted of turkey wrapped in the crepes along with chopped spinach and finished with a light cheese and mushroom sauce.

If you preferred a less filling meal, there was always the choice of eggs cooked to order, such as shirred eggs served with sausage and sliced tomatoes; omelets filled with options such as onions, peppers, diced ham, mushroom slices, cheese and bacon bits; or, in the more modern years, quiche with fruit garnish.

Are you hungry yet? Enjoy a satisfying meal as you gather your family for a sit-down dinner and share both the meal and memories from the past.

SHILLITO'S CHICKEN POT PIE

⅛ cup frozen peas
¼ cup sliced frozen carrots
6 cooked pearl onions
3 ounces or ½ cup diced cooked chicken (½ to ¾ inch chunks)
¾ cup sauce (recipe below)
1 (2-ounce) prebaked pastry to cover pie

Cook frozen peas and carrots. Drain. Place chicken chunks into small casserole and add vegetables.

Pour sauce over and bake at 350° until sauce bubbles. Serve with pastry top over casserole dish.

Pot Pie Sauce
3 tablespoons margarine
1 cup chicken stock
1½ tablespoons flour
1 dash pepper

Melt margarine, add flour and mix well. Add stock, cook and stir until creamy. Add pepper.

[The mixture cooks down to the required ¾ cup amount as you stir.]

Yield: 1 individual pie

Recipe from *Cincinnati and Soup: A Second Helping: More Recipes from the Queen City*. Cheri Brinkman, Mac Guffin Productions, 2011. All rights reserved; reprinted with permission of the author.

Author's Note: Butter works just as well as margarine—in my mind, it's even better. Refrigerated pie crust, cut out in a circle slightly smaller than the rim of your individual casserole and baked separately on a cookie sheet ahead of time, works well to top the baked chicken pot pie. Another option is to use a 2-ounce split baking powder or buttermilk biscuit for covering the pie.

Bacon Wrapped Stuffed Chicken Breasts

6 boneless, skinless chicken breasts
8 ounces cream cheese, softened
6 green onions, chopped fine (including tops)
½ cup walnut pieces
12 strips bacon, raw

Combine cream cheese, green onions and walnut pieces in a small bowl. Divide into 6 equal portions, rolling each portion into a ball and set aside.

Lay 2 strips of bacon in the shape of an X. Place the top side of the breast down on top of the bacon.

Place a portion of the cream cheese mixture on top of the chicken breast.

Wrap the chicken breast and bacon up around the cream cheese and secure with toothpicks if necessary.

Place the X side up and bake in a shallow pan at 375°, uncovered for 45 to 55 minutes.

Cook's Note: Serve this entrée on a bed of long grain and wild rice. Accompany with steamed squash or carrots.

Yield: 6 servings

Recipe from *Specialties of the House, Cincinnati Dining Guide with Recipes,* by Ralph and Martha Johnston (copyright 1996). Published by McClanahan Publishing House, Kuttawa, KY.

Author's Note: Although not mentioned in the recipe, I found that flattening the chicken breasts to a uniform thickness with a mallet made it easier to cover the cheese balls and produced better baking results. Remove toothpicks before serving.

CHICKEN BROCCOLI CASSEROLE

1 pound fresh broccoli
¼ pound butter
2 cups diced celery
1 cup diced onion
1 medium green pepper, diced
2 cups fresh mushrooms, sliced
1 tablespoon salt
1 teaspoon pepper
¼ teaspoon garlic salt
1¼ pounds chicken breast, boneless and skinless, cooked and cubed
2 (8-ounce) packages of cream cheese, softened

Cut the buds from the broccoli stems. Peel the stems using a potato peeler and cut the stems into ½-inch pieces. Steam the stems and buds until tender-crisp. Drain.

Melt butter in frying pan. Sauté celery, onion, green pepper and mushrooms until all are tender. Add steamed broccoli. Add the chicken and seasonings. Add cream cheese to the mixture and blend over low heat until the cream cheese is melted.

Pour the mixture into a buttered 9 x 13 x 2-inch casserole and heat in the oven at 350° until the top is golden brown.

Cook's Note: Chicken broccoli casserole was a signature entrée on Lazarus menus.

Yield: 4 to 6 servings

Recipe from *Recipes II from Our Restaurant Associates: Lazarus Celebrating 100 Years of Fine Food*. Written and distributed by Lazarus Department Store, Columbus, OH (believed to have been published in 1991).

CREAMED CHICKEN

2 tablespoons fat
2 tablespoons flour
¼ teaspoon salt
1 cup chicken stock
1 cup milk
2 cups chicken, cooked
2 egg yolks
¼ cup cream
½ teaspoon lemon juice
2 teaspoons parsley

Melt fat, stir in flour and seasonings and cook until bubbly. Slowly add chicken stock and milk; cook until thick and smooth, stirring often. Dice up chicken and add to sauce. Beat the egg yolks a bit and add the cream. Just before serving, add this to the chicken mixture and cook 2 minutes. Add lemon juice and parsley, and serve immediately.

Cook's Notes: This is even better when served over hot popovers. It makes it a bit fancier.

Yield: 4 to 6 servings

This recipe is from *Depression Era Recipes* (copyright September 1989) and has been kindly provided by Patricia R. Wagner. Published by Adventure Publications Inc., Cambridge, MN.

Author's Note: Creamed chicken is also good over a "nest" of mashed potatoes.

CHICKEN À LA KING

¼ cup chopped green pepper
1 cup sliced mushrooms
¼ cup butter
3 tablespoons flour
2 cups milk
Salt and pepper
1 egg yolk, beaten
2 ½ cups diced, cooked chicken
2 tablespoons finely cut pimentos

Lightly brown green pepper and mushrooms in butter. Blend in flour. Add milk and seasonings. Cook until thick, stirring constantly. Stir part of the hot mixture into egg yolk; return to remaining hot mixture. Cook 10 minutes. Add chicken and pimentos. Serve on hot biscuits, toast, chow mein noodles or potato chips.

Yield: 6 servings

This recipe is from *Miss Daisy Entertains* (published in 1980) and has been kindly provided by Miss Daisy King of Franklin, TN.

Author's Note: For the salt and pepper, ½ teaspoon of salt and ¼ teaspoon of pepper worked well for me.

LAZARUS NEW ENGLAND STYLE HAM LOAF

2 pounds ground ham
1 pound ground pork
1 cup graham cracker crumbs
¾ cup milk
2 eggs

Preheat oven to 350°. Mix pork and ham until well blended. Add the graham cracker crumbs, milk and eggs. Mix all ingredients until thoroughly blended. Place into two greased loaf pans and bake for 1 hour.

Slice and serve with pineapple sauce.

Cook's Notes: Add sweet potatoes and green beans to this meal and you have comfort food at its best.

Yield: 10 to 12 servings.

Pineapple Sauce
1 (20-ounce) can crushed pineapple
¼ cup sugar
1 cup water
1 tablespoon cornstarch
1 pinch ground cloves

Combine the pineapple, sugar and ¾ cup of water in a saucepan. Over medium heat, heat to boiling. Mix the cornstarch with remaining ¼ cup of water. Add cornstarch mixture to the hot pineapple mixture and cook until sauce is slightly thickened and becomes clear.

Recipes from *Recipes from Our Kitchens: Café Lazarus*. Written and distributed by Lazarus Department Store (published in approximately 1995).

Author's Note: Many butchers will grind the ham and pork together for you so that they are well blended.

Cherry Sauce
Optional sauce that is also good over ham loaf and pork.

1 (12-ounce) jar cherry preserves
2 tablespoons light corn syrup
¼ cup red wine vinegar
½ teaspoon salt
¼ teaspoon cinnamon
½ teaspoon nutmeg
½ teaspoon ground cloves
¼ cup sliced almonds

Mix together in a small saucepan and simmer for 20 minutes.

This recipe is from *Tea Room Treasures* (second printing, May 1996) and has been kindly provided by The Woman's Exchange of Memphis, 88 Racine Street, Memphis, TN 38111.

Meat Loaf

2 ½ cups canned tomatoes
⅛ teaspoon celery salt
⅛ teaspoon garlic
⅛ teaspoon onion salt
1 pinch paprika
1 teaspoon salt
⅛ teaspoon pepper
2 pounds ground chuck
2 eggs, beaten
8 soda crackers [Saltines], crushed
1 rib celery, chopped
¼ green pepper, chopped
1 onion, finely chopped
2 tablespoons catsup
3 strips bacon
1 teaspoon sugar
½ cup catsup

Break up tomatoes, mix well with seasonings; strain, save juice. Mix tomato pulp, meat, eggs, cracker crumbs, vegetables and 2 tablespoons catsup. Shape into loaf; lay strips of bacon on top, bake uncovered at 350° for 1 hour.

Simmer reserved tomato juice mixture, sugar and ½ cup catsup while loaf cooks.
Pour sauce over loaf when serving.

Yield: Approximately 8 servings

This recipe is from *Woman's Exchange Cook Book Volume I* (published in 1964, revised copyright 1967) and has been kindly provided by The Woman's Exchange of Memphis, 88 Racine Street, Memphis, TN 38111.

PORK CHOPS IN SOUR CREAM SAUCE

6 pork chops, ¾ inch thick
1 medium onion, chopped
1 clove garlic, minced
2 cups chicken stock
1 bay leaf
1 cup sour cream
2 teaspoons paprika
3 tablespoons butter
Flour seasoned with salt and pepper

Melt butter in a large skillet and sauté the onion and garlic until golden brown. Remove the onion and garlic from the skillet and set aside. Lightly flour pork chops in seasoned flour, place in the skillet and brown on both sides. Remove from skillet and pour off excess fat, return skillet to medium heat and add chicken stock and deglaze the skillet.

Add the pork chops, bay leaf, and cooked onion and garlic to the skillet; cover and simmer for I hour. Remove pork chops to a heated serving platter. Turn the heat up and reduce the liquid by one half. Remove skillet from heat and add the sour cream and paprika.

Yield: 6 servings

Recipe from *Recipes from Our Kitchens: Café Lazarus*. Written and distributed by Lazarus Department Store (published in approximately 1995).

Author's Note: This recipe, a favorite on the Marketplace Buffet in the Lazarus 6ᵗʰ Floor Café, was provided by Chef Bud Callaway. Suggestion: Pour a little of the sauce over the pork chops and serve the rest in a gravy boat with seasoned rice or home-style mashed potatoes on the side. Option for seasoned flour: 1 cup flour mixed with 1½ teaspoons salt and ½ teaspoon pepper.

Salmon Croquettes

1 (14-ounce) can salmon, drained (save juice)
1¼ cups corn flake crumbs, divided (¼ cup and 1 cup)
1 tablespoon lemon juice
1 tablespoon margarine
1 tablespoon onion, minced
1⅓ tablespoons flour
3 tablespoons milk
¼ teaspoon dry dill weed

In a mixing bowl, combine the drained salmon, ¼ cup of the cornflake crumbs and lemon juice. Melt the margarine in a saucepan. Stir in the onion and flour, and sauté until soft, but not brown. Add salmon liquid, milk and dill weed. Cook until thick. Combine salmon mixture with sauce and refrigerate for 1 to 2 hours.

Preheat oven to 350°. Make into desired shape and roll in approximately 1 cup crushed cornflakes. Bake in a greased glass baking dish for approximately 35 minutes or until brown. Do not let sides of croquettes touch.

Serving Ideas: Serve with cucumber sauce [next page]. Mixture can be made into a loaf by omitting crushed cornflake coating and refrigeration. Place in a greased loaf pan and bake 30 minutes at 350°.

Yield: 6 croquettes

Cucumber Sauce

1 cup mayonnaise
1 cup cucumber, chopped
½ teaspoon salt
2 teaspoons vinegar
½ teaspoon Worcestershire sauce
2 teaspoons onion, grated
½ cup sour cream

Combine and chill.

Yield: Makes approximately 2½ cups

These recipes are from *Tea Room Treasures* (second printing, May 1996) and have been kindly provided by The Woman's Exchange of Memphis, 88 Racine Street, Memphis, TN 38111.

Author's Note: I substituted butter for margarine in the croquettes and peeled the cucumber used in the sauce.

Swiss Steak

1 teaspoon salt
½ cup flour
2-pound tenderized round steak, cut in pieces
2 tablespoons melted fat
2 cups canned tomatoes
1 green pepper, chopped
2 carrots, sliced
Tomato juice

Mix salt with flour; pound into steak. Sear steak in hot fat in a large skillet or pan. Add vegetables.

Cover; simmer for 2 hours or until meat is tender. Add tomato juice, if necessary.

Yield: 6 servings

This recipe is from *Miss Daisy Entertains* (published in 1980) and has been kindly provided by Miss Daisy King of Franklin, TN.

Author's Note: Your butcher can tenderize the meat with a Jaccard tool, making a dish so tender a knife is optional.

TEA ROOM TUNA FLORENTINE

1 (8-ounce) package of noodles
2 packages frozen chopped spinach
2 (6-ounce) cans tuna
2 (4-ounce) cans mushrooms, drained
1 onion, chopped
4 ribs celery, chopped
1 green pepper, chopped
¾ stick butter
3 cups medium cream sauce (see recipe below)
Parmesan cheese

Cook noodles and spinach according to package directions. Spread drained noodles over the bottom of greased casserole, cover with tuna and mushrooms. Next, layer drained spinach. Sauté vegetables in butter, add to cream sauce. Cover casserole with sauce, sprinkle with Parmesan. Bake at 325° until bubbly, about 20 minutes.

Cook's Note: Chicken or ham may be substituted for tuna.

Yield: 8 to 10 servings

Medium Cream Sauce:
6 tablespoons butter
6 tablespoons flour
1½ teaspoons salt
3/8 teaspoon pepper
3 cups milk

Melt butter over low heat; remove from fire; add flour, salt and pepper. Stir until smooth. Return to heat and slowly add milk, stirring constantly until thick and smooth.

Yield: 3 cups

These recipes are from *Woman's Exchange Cook Book Volume II* (published in 1976) and have been kindly provided by The Woman's Exchange of Memphis, 88 Racine Street, Memphis, TN 38111.

9
Accompaniments

For many years, meals in the McAlpin's tea room began with mouthwatering dill pickles that were placed on each table. Pickled watermelon rinds, although not given away freely, were a popular treat with certain dishes on the menu at Shillito's for a number of years. Such items, along with a variety of relishes, could also be found and purchased in the "edible department" of The Woman's Exchange. Of course, in addition to condiments, all the restaurants offered delicious side dishes of vegetables, fruits and breads to accompany the entrées.

Almost everybody enjoyed a scoop of mashed potatoes or macaroni and cheese with meatloaf or steamed celery dressing topped with hot gravy on the side of turkey slices. Glazed carrots or the carrots and apple scallop dish at Shillito's were popular with baked ham slices. Other people mentioned ordering baked potatoes slathered with butter, sour cream and chives or sometimes with additional ingredients like cheddar cheese and chopped bacon pieces. In some cases, vegetables were prepared in ways that actually opened the door to new tastes. Brussels sprouts, for instance, prepared in the tea room and served with cheese sauce, purportedly could turn dislike into love for the tiny cabbage buds.

Breads came in a variety of forms. There were teacakes with currants, butter rolls, biscuits, corn bread, cheese rolls, bran muffins, pecan rolls, nut breads, fruit and vegetable breads and brown breads. The beaten biscuits sold at The Woman's Exchange were the traditional southern product often served with ham. Reportedly, they were difficult to chew, sometimes

compared to the hardtack Civil War soldiers ate, but enjoyed by many people. Mullane's small open-faced rolls with melted cheddar cheese were served with chicken salad. Other tea rooms offered delicious Parker House rolls that had cheese mixed in the dough and delectable cheese bread triangles made from home-style bread that was heavily coated with butter, rolled in Parmesan cheese and then grilled.

Find the perfect match to pair with and complement your favorite main dish from the sides below. Or make a meal out of them!

SIDE DISHES

CARROT AND APPLE SCALLOP

3 cups sliced cooked carrots
1½ cups sliced cooked apples
1½ teaspoons salt
2 tablespoons flour
1 cup brown sugar
2 tablespoons lemon juice
1 teaspoon grated lemon rind
3 tablespoons butter, softened

Mix salt, flour, brown sugar, lemon juice, grated lemon rind and softened butter with a fork. In a baking casserole, begin to arrange either the carrots or apples in a single layer. Sprinkle layer with sugar mixture. Alternate layers of apples and carrots, sprinkling each layer with the sugar mixture. Bake at 350° for 30 minutes or until well heated through and the mixture is dissolved thoroughly with the apples and carrots.

Cook's Note: This carrot and apple scallop side dish may also be served as a dessert. For a faster version of this recipe, use canned carrots and apples.

Yield: 8 to 10 servings

Recipe from *A Treasury of Favorite Recipes from Lazarus*. Written and distributed by Lazarus Department Store, Columbus, OH (published approximately between 1970 and 1985).

Author's Note: A square baking pan (8x8x2) is a good size for this dish.

STEAMED CELERY DRESSING

1 pound fresh bread, unsliced
2 small onions, finely chopped
⅓ cup finely chopped celery
⅓ teaspoon sage
1 teaspoon salt
2 tablespoons chicken fat
1 extra-large egg
½ cup milk

Grind or tear bread rather coarsely. Place in a pressure cooker. Add onions, celery, sage and salt. Combine well. Melt fat and add to the dry mixture. Beat egg. Add milk, and combine with other ingredients. Steam in a pressure cooker for 10 minutes: do not pack. Serve with chicken, turkey or beef gravy.

Cook's Note: Steaming is the secret. Best results are in a pressure cooker; however, an alternate method is to pile the mixture lightly in a pan, cover and steam* in oven at 350° for 30 minutes. This type of dressing does not pack together, so it is not suitable for stuffing. Can be served in place of potatoes.

If you do wish to use it for stuffing, add another beaten egg and poultry seasoning to taste and enough moisture (water, milk or bouillon) to hold together satisfactorily. This amount, making the changes as specified, will stuff a 6- to 8-pound turkey or chicken.

Yield: 6 servings

Recipe from *Recipes II from Our Restaurant Associates: Lazarus Celebrating 100 Years of Fine Food*. Written and distributed by Lazarus Department Store, Columbus, OH (believed to have been published in 1991).

*Author's Note: *To steam without a pressure cooker, place the stuffing pan in a larger pan with a rack (a roasting pan works well) and fill the bottom with approximately a half inch or so of water. Then cover the whole device with a lid or aluminum foil to contain the steam.*

RED SKIN POTATO SALAD

4 pounds (small) red skin potatoes
½ cup fresh parsley
1 teaspoon garlic powder
½ cup Dijon mustard
1 ¼ cups mayonnaise
1 teaspoon salt
½ teaspoon pepper

Place clean potatoes in a saucepan. Cover with water and cook until tender. Remove potatoes from water and cool.

Cut potatoes into quarters and place in a large mixing bowl. Add the parsley and the garlic powder. Toss together. Add the mustard and mayonnaise and season with the salt and pepper. Toss well to mix. Refrigerate.

Cook's Notes: This salad is perfect for any summer picnic or tailgate party. It is best when made a day ahead so the flavors have a chance to blend. Remember to keep all mayonnaise-based salads cold when serving them outdoors.

Yield: 10 to 12 servings

Recipe from *Recipes from Our Kitchens: Café Lazarus*. Written and distributed by Lazarus Department Store (published in approximately 1995).

POTATO SALAD WITH COOKED DRESSING

Potato Salad
2 ½ pounds red potatoes, washed
1 cup diced celery
1 cup chopped onion
Salt and pepper to taste
Cooked dressing (recipe below)

Cover and cook unpeeled potatoes in water 30 to 40 minutes or until tender. Drain and set in cold water to cool. Refrigerate until cold. Peel potatoes and slice or cube. Add celery, onion, salt, pepper and cooked dressing—combine thoroughly.

Cooked Dressing
2 eggs, beaten slightly
⅓ cup apple cider vinegar
⅓ cup sugar
1 teaspoon prepared mustard
1 teaspoon salt
¼ teaspoon pepper
½ cup mayonnaise
1 teaspoon chopped chives

Combine first 6 ingredients in saucepan and cook over low heat until mixture thickens, stirring constantly.

When cool, blend into mayonnaise, stirring until smooth. Add chopped chives.

Yield: 12 servings

This recipe is from *Miss Daisy Entertains* (published in 1980) and has been kindly provided by Miss Daisy King of Franklin, TN.

Pecan and Wild Rice Pilaf

3 cups long grain rice, uncooked
1 cup wild rice, uncooked
2 quarts chicken stock
2 small whole onions
2 whole garlic cloves
1 tablespoon butter or margarine
6 ounces carrots, finely grated
4 green onions, sliced
2 cups large pecan pieces

Place the rice, chicken stock, onions and garlic cloves in large stockpot. Bring mixture to a boil, then turn heat as low as possible. Cover and steam for 50 minutes. Remove from heat and keep covered.

Melt butter or margarine in a large skillet and lightly brown the carrots, green onions and pecans. Remove the onions and garlic cloves from the rice. Toss the rice with the sautéed vegetables and pecans.

Yield: 8 to 10 servings

Recipe from *Recipes II from Our Restaurant Associates: Lazarus Celebrating 100 Years of Fine Food*. Written and distributed by Lazarus Department Store, Columbus, OH (believed to have been published in 1991).

Author's Note: This recipe created an interesting dilemma because of the listing of 2 whole cloves. Initially, I took the recipe at face value, and the dish was prepared as written, using 2 whole cloves, the spice. During the editing stage of the book, the question arose as to whether there might have been a typo and that it should have read 2 whole cloves of garlic. I've made it both ways—I preferred the garlic version. The choice is yours! If you're concerned about finding the cloves in the cooked wild rice, you can wrap them in cheesecloth.

Sweet Potato Soufflé

1 ¼ cups canned sweet potatoes, drained
½ cup brown sugar
¼ teaspoon nutmeg
2 eggs, separated

Mash the sweet potatoes with the brown sugar and nutmeg. Beat the egg yolks and add to the sweet potato mixture. In a clean, dry bowl, beat egg whites until stiff peaks form. Fold egg whites into the sweet potato mixture.

Pour sweet potato mixture into a greased 1-quart casserole dish.

Bake at 375° for 30 to 40 minutes or until a knife inserted into the center comes out dry.

Yield: 4 servings

Recipe from *Specialties of the House: Cincinnati Dining Guide with Recipes*, by Ralph and Martha Johnston (copyright 1996). Published by McClanahan Publishing House, Kuttawa, KY.

BREADS

Apricot Bread

1 ½ cups dried apricots
2 ¾ cups flour
5 teaspoons baking powder
½ teaspoon salt
½ teaspoon soda
¾ cup sugar
1 cup buttermilk
1 beaten egg
3 tablespoons butter, melted
½ cup pecans, chopped

Cook apricots according to directions on package, cut in thin strips and dredge with flour. Sift dry ingredients together; add buttermilk mixed with egg. Add butter; fold in pecans and apricots.

Bake in a 9½ x 5½ x 2¼ greased loaf pan for 1 hour in a 350° oven.

Cook's Note: Good sliced thin, buttered and toasted or for thin sandwiches made with cream cheese or watercress, for tea and luncheon.

Yield: 1 loaf

This recipe is from *Woman's Exchange Cook Book Volume I* (published in 1964, revised copyright 1967) and has been kindly provided by The Woman's Exchange of Memphis, 88 Racine Street, Memphis, TN 38111.

Author's Note: Some apricots are sold without cooking directions. An option other than stewing: place the dried apricots in a bowl and cover with boiling water. Allow them to sit for 20 to 30 minutes and then strain.

BANANA BREAD

1½ cups sugar
½ cup shortening
2 eggs
¼ teaspoon salt
1 teaspoon soda
1½ cups sifted flour
⅓ cup buttermilk
3 ripe bananas, mashed well
1 teaspoon vanilla
1 cup nuts, chopped and rolled in a small amount of flour

Cream sugar and shortening. Add eggs; mix well. Mix salt and soda with flour; add alternately with milk to mixture. Then add bananas and vanilla, and fold in nuts. Sides and bottom of loaf pan must be lined first with brown paper and then waxed paper. Be sure the oven is well regulated, as this bread will scorch easily.

Bake at 350° for 1 hour, then at 250° for 20 minutes.

This recipe is from *Woman's Exchange Cook Book Volume I* (published in 1964, revised copyright 1967) and has been kindly provided by The Woman's Exchange of Memphis, 88 Racine Street, Memphis, TN 38111.

Carrot Lemon Bread

½ medium-size lemon (seeds removed)
3 extra-large eggs
1 cup vegetable oil
1¾ cups granulated sugar
2 cups carrots, shredded
3 cups all-purpose flour
1 teaspoon salt
1 teaspoon baking soda
½ teaspoon baking powder

Grind lemon (peel and pulp) in a meat grinder or blender. Beat eggs in mixing bowl. Add oil and sugar. Mix well. Add carrots and lemon and blend. Sift together dry ingredients, add to liquid ingredients and lightly blend.

Pour into two greased 9 x 5 x 3-inch loaf pans and bake at 350° for 45 to 50 minutes or until a cake tester inserted into the center of the loaf comes out clean.

Cook's Note: The carrots and lemon combine for a very colorful bread. Served plain or spread with strawberry cream cheese, this bread adds a plus to any breakfast, brunch or snack.

Yield: 2 loaves

Recipe from *Recipes from Our Kitchen: Lazarus Celebrating 100 Years of Fine Food.* Written and distributed by Lazarus Department Store, Columbus, OH (believed to have been published in 1991).

DATE NUT BREAD

½ package dates, cut in half
1 teaspoon soda
¾ cup boiling water
1 egg, beaten
1 teaspoon vanilla
1 teaspoon salt
¾ cup sugar
2 tablespoons melted butter
1¾ cups flour
¾ cup chopped nuts

Sprinkle soda over dates, and pour boiling water over them. Let stand 5 minutes. In another bowl, beat egg, vanilla, salt, sugar, butter and flour. Add the water from the dates, then nuts and lastly the dates. Pour in a well-greased loaf pan.

Bake 1 hour in a 300° oven.

Yield: 1 loaf

This recipe is from *Woman's Exchange Cook Book Volume I* (published in 1964, revised copyright 1967) and has been kindly provided by The Woman's Exchange of Memphis, 88 Racine Street, Memphis, TN 38111.

Author's Note: The choice of nuts used in this recipe is a personal preference. Walnuts are probably most common, but pecans and even almonds have been used successfully.

SPINACH ORANGE BREAD

2 cups fresh spinach
½ medium-size orange, unpeeled
3 extra-large eggs
1 cup vegetable oil
1¾ cups granulated sugar
3 cups all-purpose flour
1 teaspoon salt
1 teaspoon baking soda
¼ teaspoon nutmeg
¼ teaspoon cinnamon
½ teaspoon baking powder

Wash spinach; remove stems. Drain well. Chop into ¼-inch pieces. Quarter orange and remove seeds.

Grind orange (peel and pulp) in a meat grinder or blender. In mixing bowl, beat eggs. Add oil and sugar. Mix well. Add prepared spinach and orange to this mixture and blend lightly.

Sift together dry ingredients; add these to the spinach mixture and lightly blend together.

Pour into two greased loaf pans and bake at 350° for 45 to 50 minutes or until cake tester comes out clean when inserted into the center of the loaf.

Yield: 2 loaves

Recipe from *Recipes II from Our Restaurant Associates: Lazarus Celebrating 100 Years of Fine Food.* Written and distributed by Lazarus Department Store, Columbus, OH (believed to have been published in 1991).

Boston Brown Bread

2 tablespoons brown sugar
2 tablespoons shortening
½ cup dark molasses
1 cup buttermilk
1 cup coarse wheat flour
½ cup rye flour
½ cup cornmeal
½ teaspoon baking soda
½ teaspoon salt
½ cup soaked raisins (optional)

Combine brown sugar and shortening. Add molasses, then buttermilk. Combine the next five dry ingredients separately. Add the dry ingredients to the wet ingredients to create the batter. Fold in raisins if using them.

Grease mold* and fill with the pudding. Cover with aluminum foil and seal with a rubber band.

*If you have a one-pound pudding mold (brown bread is actually a hard-steamed pudding) use that; or to make a simple steamer, you can use the "can inside a can" method: Place a one-pound *rimless* coffee can in a larger lidded pot (or 3-pound can) with a rack that sits over 1 inch of water. You can crumple aluminum foil to create a "rack." The smaller mold-can should be sitting over the water, not in it. If the larger pot does not have a lid, cover the large can with foil and seal tightly.

Preheat oven to 350°. Bake the whole device in the oven for at least one hour.

To know when it's finished baking, similar to a coffee cake, press on it. If it feels firm and solid, it's ready to remove from the oven. Let the bread cool slightly, but unmold while still warm.

Yield: 1 loaf

Recipe kindly provided by Tom Thie, fifth-generation baker and last owner of Virginia Bakery, which was located in the historical Gaslight District of Clifton in Cincinnati, OH.

Bran Muffins

1½ cups schnecken goo (see recipe on next page)
2 tablespoons butter
6 tablespoons vegetable shortening
2 cups fine wheat flour
2 cups wheat bran flakes
1 tablespoon baking powder
⅔ cup sugar
⅛ teaspoon salt
2 eggs
2 cups milk (whole milk is best for baking)
1 cup raisins (optional) per dozen

Prepare the pans by greasing 2 dozen muffin molds and spreading 1 tablespoon of schnecken goo in the bottom of each cup. Melt the butter and shortening. Combine the flour, bran and baking powder. In your mixing bowl, combine the sugar, salt and eggs. Add the milk and blend well. Add the flour mix and then mix in the melted fats. Add raisins if you like. Alternatively, fill 1 dozen molds for plain and then add raisins to the batter and make a dozen with raisins. Divide the batter equally between the molds, filling each cup about ⅔ full. Preheat oven to 375°. Place pans in the center of upper rack and bake for about 20 minutes, until centers are set. Turn out onto a baking sheet.

Yield: 2 dozen muffins

Schnecken Goo
1 cup light brown sugar
4 tablespoons vegetable shortening
3 tablespoons butter
⅛ teaspoon salt
1 tablespoon clear corn syrup
½ tablespoon honey
½ tablespoon water

Cream all the ingredients in a bowl.

Yield: Approximately 1½ cups

Recipes from *Virginia Bakery Remembered* by Tom Thie and Cynthia Beischel. Published by The History Press, Charleston, SC (copyright 2010).

Author's Note: McAlpin's bought these bran muffins from Virginia Bakery and served them in the tea room. Unlike many bran muffins that are dry and somewhat tasteless, these muffins had a moister texture that started with a schnecken goo topping down to a somewhat-crispy glazed bottom. These were and still are a favorite of my family. Even though we're eating a sweeter than usual bran muffin, we've convinced ourselves we are eating something healthy because of the bran!

Raisin Biscuits

2 ½ cups flour
1 tablespoon sugar
1 teaspoon salt
4 teaspoons baking powder
1 egg
¾ cup milk
1 cup seedless raisins
⅓ cup shortening

Sift sugar, salt and baking powder with flour. Break egg in small bowl and mix well; add milk and raisins. Mix shortening into dough with milk, egg and raisins, using a spoon. Turn onto a well-floured board and knead until smooth. Roll out to half an inch; cut with tea biscuit cutter. Bake for 10 to 12 minutes in a 400° oven.

Yield: Approximately 3 dozen

This recipe is from *Recipes from Miss Daisy's (at Carter's Court)* (published in 1978) and has been kindly provided by Miss Daisy King of Franklin, TN.

Beaten Biscuits

3 cups all-purpose flour, sifted
½ teaspoon sugar
½ teaspoon salt
3 tablespoons cold butter
3 tablespoons cold lard or vegetable shortening
½ cup cold milk
½ cup cold water

Assemble all ingredients and utensils. Sift flour, sugar and salt into a bowl. Add butter and lard; blend with pastry blender or fork until the mixture looks like coarse corn meal. Add milk and water, tossing mixture with a fork. Knead 15 minutes; then beat with rolling pin

or mallet for 20 minutes or until blistered. Roll dough half an inch thick or less. Cut with small floured biscuit cutter. Prick tops 3 times with a fork. Place on a baking pan. Bake in a 325° oven for 25 to 30 minutes. Biscuits will be a very light brown. Serve cold.

Yield: 34 to 36 biscuits

This recipe is from *Miss Daisy Celebrates Tennessee* by Daisy King, researched and written with James A. Crutchfield and Winette Sparkman (published by Hillsboro Press, an imprint of Providence House Publishers, in 1995) and has been kindly provided by Miss Daisy King of Franklin, TN.

10
Desserts

D id you still have room for dessert? That was the big decision at the end of the meal and actually an easy choice for those who considered dessert "a must" and possibly already knew exactly what they were going to order before they even sat down. Some people were known to place their dessert order before they ate their meal in fear that the kitchen might run out of their favorite if they waited!

The list of choices began with ice cream specialties, such as banana splits and tall strawberry parfaits. Sundaes served in either elegant small dishes or frosted metal bowls kept in the freezer (and sometimes accented with tiny umbrellas) were presented with little pewter pitchers filled with warm chocolate, caramel or butterscotch sauces. Pecan Balls, round scoops of ice cream covered with chopped nuts and topped with hot fudge, or what were known as Snowballs, scoops of vanilla ice cream rolled in coconut flakes and decorated with an edible green "holly leaf" that had a red hot cinnamon "berry," were delicious ways to end the meal. A refreshing sherbet served in an elegant little bowl or silver cup on a doily-covered plate was another popular frozen treat. A number of interviewees pointed out that in the 1940s and '50s, ice cream wasn't available everywhere or in so many flavors as it is today and was definitely considered a treat.

Ice cream was, of course, served in more ways than just in a bowl. A glass would do. Children and adults both enjoyed milkshakes, malts (including egg-malted milk drinks that many people considered a

refreshing, nutritious and easily digestible choice for their breakfast or lunch meal) and sodas, such as black and brown cows. Nectar sodas reportedly originated, according to some sources, at the Mullane's Fourth Street address. A light Mary Ann cake shell provided the perfect "container" for a large scoop of ice cream topped with fresh strawberry sauce. Ice cream à la mode, atop a warm slice of pie, was the favorite dessert of many customers. There were also pies made from ice cream in cookie crusts and topped with chocolate sauce and whipped cream. Peppermint stick ice cream was a good choice for that creation.

No discussion of ice cream can occur without mentioning the clown cone dessert, introduced around 1950, which was very popular with children. The origin is unknown, but the concept was duplicated in several of the restaurants. The design consisted of a scoop of ice cream as the clown's head with a pointed sugar cone placed upside down at a jaunty angle as its hat. The clown's facial features were made with chocolate chips, raisins and a maraschino cherry. Whipped cream depicted either a ruffled collar or hair sticking out from under his hat. The promise of these fun, colorful desserts created genuine excitement that kept children motivated during a long day of shopping. Interviewees who recalled their childhood memories also reported being very fond of cookies. Favorites were sugar cookies cut out and decorated to look like people with hair, facial features and clothes.

Ice cream was certainly not the only item on the dessert menus, however. People often enjoyed a simple dessert of fruit-flavored gelatin topped with whipped cream, baked custard, rice pudding or a bowl of prune whip made of mashed stewed prunes and whipped egg whites folded together. For those looking for something more "substantial," wonderful éclairs and almond paste macaroons were mentioned as having been served at both The Woman's Exchange and Shillito's. Delicious homemade pies, such as fresh blueberry or strawberry, were popular choices. Many people enjoyed ice cream, cheddar cheese or rum sauce on their apple pie slice. Pumpkin, key lime and pecan pies were bestsellers. A variety of cream pies, including coconut, banana, butterscotch and rhubarb cream cheese, were also regarded as favorites in the various tea rooms. Other people mentioned a plethora of marvelous cakes, often with three layers, such as a white cake frosted with peanut brittle icing and Shillito's white chocolate cake filled with chopped pecans and coconut and topped with fluffy marshmallow icing. Strawberry shortcake, carrot cake, Brown Betty and fruit cobbler were among the sweet possibilities. Shillito's was

also famous for sour cream cheesecake. Bob Heyob, who ran the store's multiple bakeries under Henrietta Carnes, his food service director ("she was a legend"), recalled that the gourmet cheesecakes filled with pure cream cheese had to be made so that the slices were a minimum of four inches tall. And they had to have fresh graham cracker crusts that the kitchen staff crushed themselves, versus buying crumbs. They also made the cherry and blueberry toppings for the cheesecakes. Henrietta insisted the items had to look pretty and be made from the best ingredients. Later, Lazarus became as well known for bread pudding with whiskey sauce. Pogue's had great bread pudding, too, that was made with leftover sweet breakfast Danish rolls from morning meetings instead of bread and then covered with a delicious vanilla cream sauce. McAlpin's had huge, melt-in-your-mouth brownies that many families adored. Pogue's also had delicious almond and chocolate-hazelnut butter cream tortes that were made and delivered twice a week by two European women who excelled at making Viennese pastries.

Just as with Snowballs and pumpkin pie, some other desserts were seasonal. In the fall, Shillito's sold large, delicious caramel apples right near the tea room's cash register, which made them hard to ignore or resist and thus a popular treat to take home. Whole fruitcakes were well-liked items to buy from The Woman's Exchange during the Christmas season, and at least some of them ended up being wrapped in brandy-soaked toweling as they further aged at home before the holiday meals.

Occasions throughout the year, such as Valentine's Day, Easter, Mother's Day and birthdays, were cause for buying some of the handmade confections produced by the consignors at The Woman's Exchange and in the kitchens of Mullane's and Shillito's. Many people didn't need a special occasion to buy the fudge and other chocolate-covered pieces, hard candies, opera creams and taffy to take home—the fragrant scent and promise of sweet flavor was enough.

Go ahead, satisfy your sweet tooth and put a smile on your face. Sweeten up your next meal with one of these classic desserts that will be fondly remembered. Take your pick and bake away!

Apple Pie Cake

½ cup shortening
2 cups sugar
2 eggs
2 teaspoons vanilla
2 cups flour
2 teaspoons baking soda
2 teaspoons nutmeg
2 teaspoons cinnamon
1 teaspoon salt
4 tablespoons hot water
5 cups diced apples, peeled and cored
1 cup chopped walnuts

Cream shortening and sugar together. Stir in eggs and vanilla. Sift together flour, baking soda, nutmeg, cinnamon and salt. Stir half of the flour mixture into the shortening mixture. Beat in 2 tablespoons hot water. Stir in remaining flour mixture, then remaining water, beating after each addition. Stir in apples and nuts. Spread in 2 greased 9 x 9 x 2-inch pans. Bake at 350° for 45 to 50 minutes, or until sides pull away from pan.

Yield: 24 servings

This recipe is from *The Cincinnati Cook Book*, with recipes collected by the Co-Operative Society of the Children's Hospital, Cincinnati, OH (published in 1976, original copyright in 1966) and has been kindly provided by Children's Hospital and the Co-Operative Society.

Author's Note: This recipe was contributed by Inez Patterson Drexelius, manager of McAlpin's Tea Room for many years.

Old Fashioned Blackberry Jam Cake

¾ cup butter

1 cup sugar

3 eggs

1 heaping teaspoon soda

1 cup buttermilk

2 cups flour

1 teaspoon cinnamon

½ teaspoon nutmeg

½ teaspoon cloves

½ teaspoon allspice

1 teaspoon baking powder

1 teaspoon vanilla

¾ cup blackberry jam

Cream butter and sugar well, add eggs and continue beating. Add soda to buttermilk.* Sift dry ingredients. Alternately add dry ingredients and buttermilk to the sugar and butter mixture. Add vanilla. Fold in blackberry jam. Pour into a greased and floured 16 x 8 x 1½-inch pan. Bake in a 350° oven 35 or 40 minutes, or until cake springs back when touched. When cool, ice with caramel pecan frosting (see recipe below).

Yield: Approximately 16 servings

*Author's Note: *If you have never added baking soda to buttermilk before, beware! The chemistry involved creates a bubbling and overflowing of the mixture. Be sure to pour the cup of buttermilk into a container that holds at least 2 cups before adding the soda.*

Caramel Pecan Frosting

2 cups sugar

1 cup buttermilk

1 teaspoon soda

⅛ teaspoon salt

1 cup pecans, finely chopped

2 tablespoons butter

Using large pan (as this really bubbles up), combine sugar, buttermilk, soda and salt; cook for 5 minutes, stirring constantly. Add pecans and butter; cook until a soft ball forms in cold water (8 to 10 minutes over a low heat). Set aside to cool; beat well. As you frost the cake, place frosting in a pan of hot water for easy spreading.

Yield: This will frost the top and sides of a layer cake.

Cook's Note: This recipe may be used for pralines by leaving the pecans whole. Drop teaspoonfuls on wax paper.

These recipes are from *Woman's Exchange Cook Book Volume I* (published in 1964, revised copyright 1967) and has been kindly provided by The Woman's Exchange of Memphis, 88 Racine Street, Memphis, TN 38111.

Bread Pudding with Whiskey Sauce

Custard Mix
2 cups granulated sugar
1 teaspoon salt
8 extra-large eggs
5½ cups milk
1 teaspoon vanilla

In a large bowl, blend eggs, salt and sugar lightly with a wire whisk. Add vanilla and milk. Blend and strain. Set aside.

Pudding
½ pound French bread, preferably stale
¼ cup pecans, toasted
4 ounces (½ cup) butter, melted

Break bread into medium pieces. Add pecans and melted butter. Arrange in greased 9 x 13 x 2-inch baking dish. Pour custard mix over bread pieces.

To bake, place the baking dish in a larger pan containing a small amount of water to create a double boiler effect. (For custard to bake properly, you must create this double boiler effect. Plan size of pan accordingly.) Bake at 350° for 50 to 60 minutes or until a knife blade inserted into the center of the pudding comes out clean.

Whiskey Sauce
8 ounces (1 cup) butter, melted
2 cups powdered sugar
2 extra-large eggs
2 tablespoons whiskey

Melt butter. Whip in powdered sugar. Fold in well-beaten eggs. Add whiskey. Serve warm over bread pudding.

Cook's Note: This home-style dessert is a classic New Orleans recipe and was the most requested dessert at Lazarus.

Yield: Approximately 16 servings

Recipe from *Recipes II from Our Restaurant Associates: Lazarus Celebrating 100 Years of Fine Food.* Written and distributed by Lazarus Department Store, Columbus, OH (believed to have been published in 1991).

CLASSIC CARROT CAKE

4 eggs
2 cups sugar
1¼ cups salad oil
2 cups flour
2 teaspoons baking powder
2 scant teaspoons soda
2 teaspoons cinnamon
3 cups finely grated carrots
½ cup nuts

Beat eggs; add sugar, oil and sifted dry ingredients. Add carrots; stir nuts in last. Pour into three greased 9" round cake pans. Bake in 325° oven for 25 minutes.

Frosting
1 (8-ounce) package cream cheese
1 stick butter
1 teaspoon vanilla
1 box confectioner's sugar

Cream all ingredients together. Spread between layers and over cake.

Cook's Note: This cake tastes even better the second day. Keep refrigerated.

Yield: 1 three-layer cake (approximately 12 to 15 servings)

This recipe is from *Woman's Exchange Cook Book Volume I* (published in 1964, revised copyright 1967) and has been kindly provided by The Woman's Exchange of Memphis, 88 Racine Street, Memphis, TN 38111.

CARROT CAKE WITH PINEAPPLE

1¼ cups vegetable oil
1 cup light brown sugar, firmly packed
1 cup granulated sugar
4 large eggs
1 cup all-purpose flour
1 cup whole-wheat flour (less 2 tablespoons)
1 teaspoon salt
2 teaspoons baking soda
2 teaspoons baking powder
2 teaspoons ground cinnamon
3 cups finely shredded raw carrots, packed
1 (8½-ounce can) crushed pineapple, drained
½ cup pecans, finely chopped

Preheat oven to 350°. In a large bowl, blend together oil and sugars. Add eggs one at a time, beating until blended. In a separate bowl, sift together flours, salt, soda, baking powder and cinnamon. Add flour mixture, ⅓ at a time, to oil mixture, beating just enough to blend. Fold carrots, then pineapple, into batter and stir in nuts. Pour batter into a greased and floured 9 x 13 x 2-inch sheet cake pan. Bake 45 minutes or until a toothpick inserted in center comes out clean. Cool cake in pans on rack completely before covering with lemon cream cheese Frosting (see recipe below).

Yield: 12 to 15 servings

Lemon Cream Cheese Frosting

1 (8-ounce) package cream cheese, room temperature
¼ cup unsalted butter, room temperature
2 cups powdered sugar
1½ teaspoons vanilla extract
1 tablespoon grated lemon zest

Cream together the cream cheese and butter until fluffy. Add powdered sugar and beat until well blended. Beat in vanilla and lemon zest.

Yield: This icing will cover the tops only of two cake layers, or one 9 x 13 x 2-inch sheet cake.

These recipes are from *Tea Room Treasures* (second printing, May 1996) and have been kindly provided by The Woman's Exchange of Memphis, 88 Racine Street, Memphis, TN 38111.

SHILLITO'S CHEESECAKE

Crust
18 single graham crackers, crushed
1 tablespoon granulated sugar
3 tablespoons melted butter

Filling
1 cup granulated sugar
24 ounces cream cheese
5 eggs
1½ teaspoons vanilla extract
1 tablespoon fresh lemon juice

Topping
1 pint sour cream
½ cup granulated sugar
1½ teaspoons vanilla extract

Mix the crust ingredients, pressing them into a 10-inch springform pan.

Mix together the sugar and cheese using a mixer. Add the eggs one at a time. Add the vanilla and lemon juice. Bake in preheated oven at 300° from 1 hour to 1 hour 10 minutes. Bake until set and top is puffed.

Mix together topping ingredients.

Remove cake from oven and spread topping on. Return cake to oven for another 10 to 15 minutes Cool and then chill in refrigerator.

Yield: Approximately 12 servings

Recipe from *Cincinnati and Soup: A Second Helping: More Recipes from the Queen City*. Cheri Brinkman, Mac Guffin Productions, 2011. All rights reserved; reprinted with permission of the author.

Author's Note: I interpreted "single graham crackers" as a square, producing 1¼ cups, and my crust turned out well. After you have added the vanilla and lemon juice to the sugar, cheese and eggs, beat the mixture a long time to achieve a creamy consistency—up to 30 minutes. The "30" is not a typo!

LAZARUS SWEET CHOCOLATE CAKE

Cake

3½ ounces German sweet chocolate
½ cup boiling water
1 cup butter or margarine
2 cups sugar
4 eggs, separated
1 teaspoon vanilla
2½ cups cake flour, sifted
1 teaspoon baking soda
½ teaspoon salt
1 cup buttermilk

Melt chocolate in the boiling water and cool. Cream butter and sugar until light and fluffy. Add egg yolks, one at a time, beating well after each addition. Add cooled chocolate and vanilla.

Sift together cake flour, baking soda and salt. Add alternately with buttermilk to the chocolate mixture, beginning and ending with the flour. Beat well after each addition. After all is added, beat until the batter is smooth.

Beat egg whites in a clean, dry bowl until stiff peaks form. Fold egg whites into chocolate batter.

Pour into three 8-inch layer cake pans that have been lined with waxed paper or parchment. Bake at 350° for 35 to 40 minutes. Cool and frost tops of layers with coconut pecan frosting.

Coconut Pecan Frosting

1 cup evaporated milk
1 cup sugar
3 egg yolks
½ cup butter or margarine
1 teaspoon vanilla
1½ cups coconut
1 cup pecans, chopped

Combine evaporated milk, sugar, egg yolks, butter and vanilla in a saucepan. Cook and stir over medium heat until the mixture

thickens, about 12 minutes. Add coconut and pecans. Beat until frosting is cool and thick enough to spread. Makes enough to cover the tops of 3 cake layers.

Cook's Note: Your favorite chocolate frosting recipe may be used to ice the sides of the cake.

Yield: One 3-layer cake (approximately 12 servings)

Recipe from *Recipes from Our Kitchens: Café Lazarus*. Written and distributed by Lazarus Department Store (published in approximately 1995).

POUND CAKE

1 cup butter
½ cup shortening
3 cups sugar
5 eggs
1 cup milk
3 cups all-purpose flour
1 teaspoon vanilla
1 teaspoon lemon extract
½ teaspoon baking powder

Cream butter, shortening and sugar. Add eggs one at a time. Add milk alternately with flour and baking powder mixture. Stir in extracts and pour into 10-inch tube pan. Bake for 1 hour at 350° and then for 15 minutes or until cake tests done at 325°.

Yield: 1 cake

This recipe is from *Recipes from Miss Daisy's (at Carter's Court)* (published in 1978) and has been kindly provided by Miss Daisy King of Franklin, TN.

Lazarus Peach Crisp

3 to 4 cups fresh sliced peaches
1 tablespoon lemon juice
1 cup all-purpose flour
1 cup granulated sugar
½ teaspoon salt
1 egg, beaten
6 tablespoons butter or margarine, melted

Place the sliced peaches in an 8 x 8 x 2-inch baking dish and sprinkle with lemon juice.

Sift together the flour, sugar and salt. Add the beaten egg to the dry ingredients and toss with a fork until the mixture is crumbled. Sprinkle the crumb mixture over the peaches. Drizzle with melted butter or margarine.

Bake at 375° for 35 to 40 minutes.

Serve warm with ice cream.

Cook's Note: When fresh peaches are not in season, substitute frozen or well-drained canned peaches. We love this peach crisp with cinnamon ice cream. To make it at home, blend 1 tablespoon of cinnamon into 1 quart of vanilla ice cream.

Yield: 8 to 9 servings

Recipe from *Recipes from Our Kitchens: Café Lazarus.* Written and distributed by Lazarus Department Store (published in approximately 1995).

Author's Note: I used organic peaches and left the skin on them, creating a very pretty peach color when baked. Although not mentioned, I buttered my pan. Nonstick spray would work as well.

PRUNE WHIP

1½ to 2 cups prunes
¼ to ½ cup powdered sugar
1 teaspoon lemon juice
2 egg whites, beaten until stiff

Cook prunes until soft and run them through a sieve to get 1 cup of pulp. Chill. Fold together pulp, sugar, lemon juice and egg whites. Pile lightly into serving bowls and chill.

Optional: Try some sweetened whipped cream on top.

Yield: 3 to 4 small bowls

This recipe is from *Depression Era Recipes* (copyright September 1989) and has been kindly provided by Patricia R. Wagner. Published by Adventure Publications Inc., Cambridge, MN.

Author's Note: To stew the prunes, barely cover them with water (about 1¼ cups) in a saucepan and, after bringing them to a boil, allow them to simmer for about 20 minutes.

Rather than using a sieve as they did in the past, you can puree the cooked prunes in a blender or food processor until smooth, or almost smooth if you like more texture— probably about 15 to 20 seconds. Reserve some of the liquid in case needed to make a smooth puree.

Yes, this recipe calls for raw egg whites. Although no guarantee against salmonella, if you try this recipe as written above make sure you are using fresh eggs without any cracks and wash them well before using.

Another alternative is to bake the mixture in a buttered baking dish that sits in a pan of water for about 30 to 40 minutes at 350° until browned.

Most people serve this chilled, topped with whipped cream, but it can also be served warm.

CREAM CHEESE RHUBARB PIE

4 cups fresh rhubarb, cut into 1-inch pieces
3 tablespoons cornstarch
¼ teaspoon salt
1½ cups granulated sugar (divided into 1 cup and ½ cup)
1 (9-inch) unbaked pie shell
8 ounces cream cheese, softened
2 extra-large eggs
1 cup sour cream
2 ounces sliced almonds, toasted

Preheat oven to 425°.

In a 2-quart saucepan, combine the rhubarb, cornstarch, salt and 1 cup of the sugar. Cook over medium heat, stirring often, until the mixture boils and thickens.

Pour the rhubarb mixture into the unbaked pie shell. Bake 10 minutes. Remove from oven and set aside. Reduce the oven temperature to 350°.

In a small bowl, combine the cream cheese, eggs and ½ cup of the granulated sugar. Beat at medium speed until smooth. Pour this mixture over the rhubarb.

Bake the pie at 350° for 30 to 35 minutes until filling is set. Cool on wire rack. Chill before serving.

To serve, spread the sour cream on top of the pie. Garnish with toasted, sliced almonds.

Yield: One 9-inch pie

Recipe from *Recipes from Our Kitchen: Lazarus Celebrating 100 Years of Fine Food.* Written and distributed by Lazarus Department Store, Columbus, OH (believed to have been published in 1991).

RICE PUDDING

1 quart milk
½ cup rice
1 tablespoon flour
1 egg
¼ cup milk
Sugar, approximately ⅓ cup
Salt, approximately ¼ to ½ teaspoon

Put milk in the top of a double boiler. Add rice to cold milk, and cook until the rice is tender. Beat together the flour, egg and milk. Stir this into the rice and cook until it thickens. Stir in a little salt and add sugar to taste.

Serve hot or cold.

Yield: Approximately 6 servings

This recipe is from *Depression Era Recipes* (copyright September 1989) and has been kindly provided by Patricia R. Wagner. Published by Adventure Publications Inc., Cambridge, MN.

Author's Note: Whole milk produces a creamier pudding. Try some of these optional additions: ½ teaspoon nutmeg or cinnamon, grated lemon rind, ½ teaspoon vanilla, ½ cup chopped dried apricots, ½ cup raisins.

As typical of many recipes of the time, no measurements were given for the sugar and salt. The approximated measurements worked for me.

TEA CAKES

½ cup butter
½ cup shortening
2 cups sugar
3 eggs
1 cup flour
½ teaspoon soda
2 teaspoons baking powder
½ cup buttermilk
1 teaspoon vanilla
Additional flour sufficient to make a soft dough

Cream butter and shortening, add sugar, then beaten eggs. Into one cup flour, sift soda and baking powder. Add this to the sugar mixture. Add milk and vanilla and enough flour to make a soft dough. Turn onto a floured board, knead until smooth. Roll out to a quarter of an inch. Cut in any shape. Bake about 10 minutes in a 350° oven or until brown.

Yield: 6 dozen

This recipe is from *Recipes from Miss Daisy's (at Carter's Court)* (published in 1978) and has been kindly provided by Miss Daisy King of Franklin, TN.

Author's Note: It takes approximately 3 additional cups of flour added to the original flour-sugar mixture to make a soft dough that is stiff enough that it would hold its shape when rolling and using a biscuit cutter.

I found that I had to bake the tea cakes for about 14 to 15 minutes—ovens vary. I served these with jam and lemon curd (see recipe below).

Lemon Curd

5 egg yolks
1 egg white
¼ cup lemon juice
1 cup sugar
3 tablespoons butter

Mix together well, cook in double boiler until thick and clear, stirring constantly. Store in jar and keep refrigerated. Serve with crumpets, teacakes and gingerbread or use as a filling.

Yield: Approximately 1 cup

This recipe is from *Recipes from Miss Daisy's (at Carter's Court)* (published in 1978) and has been kindly provided by Miss Daisy King of Franklin, TN.

Scotch Tea Tarts

Dough
1 cup softened butter
2 cups sifted flour
6 ounces softened cream cheese
¼ cup finely chopped pecans

Mix butter, flour and cheese; chill half an hour. Place rounded teaspoon of dough in each muffin cup and press dough to bottom and sides with thumb. Sprinkle each cup with pecans.

Filling
2 eggs, slightly beaten
1½ cups brown sugar
½ teaspoon vanilla
2 tablespoons melted butter
¼ teaspoon salt
½ cup finely chopped pecans

Mix eggs, sugar, vanilla, butter and salt together. Spoon into tart shells; sprinkle with pecans. Bake in 325° oven 25 to 30 minutes.

Yield: 18 tarts

This recipe is from *Woman's Exchange Cook Book Volume I* (published in 1964, revised copyright 1967) and has been kindly provided by The Woman's Exchange of Memphis, 88 Racine Street, Memphis, TN 38111.

Author's Note: The recipe created more dough than I expected based on the "rounded teaspoon" measurement. In the past, people often used tableware teaspoons (as opposed to measuring spoons) in their recipes, and my guess is that was the case with this recipe. I divided the dough into 18 equally sized pieces and found that they were actually closer to rounded (measuring) tablespoons.

Shillito's White Chocolate Cake

¼ pound chunk white chocolate
½ cup boiling water
2 cups sugar
2 sticks butter, cut up, room temperature
4 egg yolks, room temperature
1½ teaspoons baking powder
1 teaspoon vanilla
1 cup buttermilk
4 egg whites, beaten until stiff
1 cup finely chopped pecans
1 can angel flake coconut [The cans of Baker's Angel Flake coconut, which are now difficult to find, held 3½ ounces.]
2½ cups cake flour

Preheat oven to 350° F.

Melt chocolate in boiling water and let stand and cool. Cream butter and sugar until fluffy and add yolks, one at a time, beating well. Add melted chocolate and vanilla. Sift flour and baking powder together and add alternately with buttermilk. Fold in whites, then coconut and nuts. Don't overbeat. Bake in three sprayed 9-inch pans for 25 to 30 minutes.

Yield: One 3-layer cake

This recipe appeared in the *Delhi Press* on August 11, 2004, and has been kindly provided by Rita Heikenfeld, columnist for *Rita's Kitchen*.

Rita's Note: This recipe takes some time, but it's worth it.

Use the best chocolate you can find. Don't use white chocolate bark or coating. You can substitute white chocolate chips for the chunk chocolate.

Ice cake with your favorite frosting or the one below that is close to what we called an Italian meringue icing in cooking school.

To avoid having the cakes stick to the pans, line your pans with parchment paper. Try frosting the cake with the Italian meringue-style icing.

ITALIAN MERINGUE–STYLE ICING

1½ cups sugar
½ cup water
¼ teaspoon cream of tartar
1 teaspoon vanilla
2 egg whites, beaten until stiff
11 large marshmallows

Boil sugar, water and cream of tartar until it forms a small ball when dropped into cold water. Take off heat and stir in vanilla and marshmallows until melted. Pour over egg whites and whip until thick. Spread on cooled cake.

This recipe appeared in the *Delhi Press* on August 11, 2004, and has been kindly provided by Rita Heikenfeld, columnist for *Rita's Kitchen*.

WOODLAND GOODIES

2 cups sugar
1 cup corn syrup
½ cup water
1 tablespoon butter
1 teaspoon salt
Mixture of nuts: almonds, pecans, English walnuts, Brazil nuts and hickory nuts (about 2 to 2½ cups)

Cook sugar, corn syrup and water (on a medium-high heat) until the sugar is dissolved. Get all the grain or undissolved sugar from the sides of the kettle before the batch begins to boil, as this is what often makes candy go to sugar. Stir as much as you want to before boiling, but after the mixture boils never stir.

Continue to cook until it commences to turn color, then set off fire and add salt and butter, stirring constantly until it is dissolved. (It will bubble up when you add these ingredients. You should stir until the mixture is dissolved and bubbles recede.) If you are using a candy thermometer, the temperature to reach is 290°.

Then, put in enough nuts to make it very thick and pour out into a pile on greased slab or platter.

Take a table fork in each hand and pull the batch apart in small pieces. (Do this step very quickly or you will find that it has hardened beyond spreadability.)

Flatten them out and push aside to cool. Run a long knife under the batch and double it up occasionally, as this prevents it from hardening in a chunk before you can get it pulled apart.

Confectioner's Note: "Undoubtedly, the greatest convenience for candy making is a marble slab of some description....In greasing the slab for candies, it is far better to use lard than butter....To keep your candy from running off the slab, use four strips of wood about one inch square and the length of slab, or better still, get four iron bars ⅝ by ½ inches if you live in a place where they have a large hardware store. Put these around edge of slab and the candy will not run under them. This is beyond a doubt the swellest piece of nut candy that ever was made."—Martin A. Pease, "The Candy Man"

Recipe from *Pease's Home Candy Maker*. Martin A. Pease, printed by Wilson Press and published in 1913 by Pease Brothers in Elgin, IL.

Author's Note: Dark corn syrup was used for the test batch. I used peanuts and cashews, along with almonds, pecans and English walnuts in the nut mix. The cooking time took approximately 45 minutes. I had trouble locating iron bars but bought hot rolled steel bars that worked.

Another batch was made on a greased 17¼ x 11½ x 2¼-inch nonstick pan with low edges (which eliminated the need for any bars), and instead of using the fork method or a long knife, a spatula was used to run under the brittle and to flatten it out. The brittle was then turned over and the excess lard wiped off with a paper towel before breaking the candy into pieces with a meat cleaver.

NECTAR ICE CREAM SODAS

Nectar Flavoring
1 pint whole milk, cold
1 cup sugar
1 ounce (2 tablespoons) vanilla extract
1 dram (about 1 teaspoon) lemon extract
1 dram (about 1 teaspoon) orange extract
Few drops red coloring

Combine the milk and sugar and agitate [druggist's word for stir] to dissolve. Add the flavorings and agitate again. Add red coloring—you'll have to experiment—a completed soda should have only a delicate rose blush pink. This syrup must be refrigerated—we used to make up a fresh supply about every third day—don't try to store it too long.

Nectar Soda
Into a 12-ounce glass put 2 ounces (¼ cup) of nectar syrup. Add a fine stream of carbonated water to half fill the glass and to break up the syrup into a foam. Add one scoop vanilla ice cream, then enough of a heavy stream of carbonated water to fill the glass to about 2" from the top, stirring as you add. Now add more carbonated water, using a fine stream, to fill and give a fine fluff at the top. Agitate with a long-shank spoon.

Cook's Note: In 1960, Mr. Bettinger wrote to Fern Storer. When he had been a practicing pharmacist at Hauser's Drugstore, at Fifth and Madison in Covington, they regularly made this syrup. Mr. Frank Hauser was a nephew of E.L. Pieck (whose drugstore was long at Sixth and Main in Covington), who is credited by some as having originated the formula. Later, Mr. Pieck found that he could use a can of unsweetened evaporated milk instead of plain whole milk. He thought it even better—it gave the syrup more body and held up a little better.

Today we'd use a bottle of siphon soda water to give the fizz and fluff characteristic of the old-time nectar sodas.

Does anyone remember when soda fountains had silver soda spoons?

Yield: Enough syrup to make approximately 8 sodas

Recipe from *Recipes Remembered: A Collection of Modernized Nostalgia*, by Fern Storer. Published by Highland House Books, Covington, KY, in June 1989. Permission for use of this recipe was granted by the Kansas State University Foundation.

Author's Note: Below the recipe, Fern Storer shared "another sweet memory" from a woman named Edyth Brogan, whose sister had "worked at Mullane's in the early 1920s." She recalled "the nectar syrup for which Mullane's Candy Co. used to be famous... 'It was the best in the world.'"

Not only did many people agree with that assessment, but a piece that appeared in the Enquirer *on February 7, 1948, written by Frank Ruhl stated, "In 1892, the [Mullane] company moved to Fourth Street. It was at this location that the famous Mullane 'nectar' soda was originated. This drink has been often imitated, but never duplicated the company asserts."*

Ron Case, the last owner of Mullane Candies, said the recipe above is "not close" to Mullane's recipe (which is going to remain a family secret for now).

The people who tested the sodas I made liked them; however, having checked the Internet, my guess is that if you want to experiment, you should try substituting almond extract for the lemon and orange.

Afterword and Acknowledgements

The concept of writing about Cincinnati's bygone department store tea rooms was suggested to me by Joe Gartrell, my first contact person at The History Press, when I was working on *Virginia Bakery Remembered* (2010). Though I doubt that I would have ever thought of the idea on my own, it resonated with me because I enjoy local history and perhaps in part because there was a time in my life when I thought I might like to be an archaeologist. This writing adventure did lead me to uncovering "lost" and forgotten photographs and old menus, to holding precious (as in both cute and valuable) silver cups and glass holders that had been "buried away," trying on dainty white gloves and a few hats and seeing old and antique artifacts that had been hidden in modern "tombs" inside family storage spaces, closed buildings and the restricted areas of museums. Thus, the experience (on a very limited scale) of digging up lost treasures and exploring sites that provided information from another layer of time and society has proved to be as close to that vocation as I will ever get.

In the course of my research, I found that the mere mention of tea rooms conjured many different responses in the minds of Cincinnati residents. Some immediately described the tea room experience as the Queen City's equivalent of a British high tea, while others said less posh but warm and quiet little lunchroom venues were appropriate for this topic and still others thought that any place women shoppers chose for a pleasant place to break for lunch and to rest their tired feet for a good length of time should be included.

For the most part, in Cincinnati during the early and mid-twentieth century, "tea room" meant a luncheon spot favored and attended by ladies. There was a genteel quality and décor to the places that appealed to women—although it was not out of the question for men to eat in the establishments also. After all, they, too, enjoyed the relaxed atmosphere and appreciated the delicious food.

I came to realize that I had to set parameters for this project. Yes, there were many tea rooms that had good reputations, but quite a few were in the suburbs. Yes, I understood that many people had wonderful memories of lunching in some of the eateries other than the department stores. Yes, some of Cincinnati's fine hotels served afternoon high teas, and the city had many fine restaurants and cafeterias. As a matter of fact, there was a period of time (mid- to late 1960s and early 1970s) when our city offered the most five-star restaurants anywhere in our country, including New York City. By 1980, the city could boast that it had six four-star restaurants. The original focus of this book, however, was the department store tea rooms, and I have kept mostly true to that. The exceptions are based on how many people said that if I was going to be writing about bygone downtown Cincinnati tea rooms, I must include The Woman's Exchange and Mullane's.

There were additional challenges inherent to this project. Because the subject matter covers decades, many changes occurred during those years in names, environments and purposes. Over time, the places that were once called tea rooms were updated, taking on new incarnations, and were renamed as they became upscale restaurant dining rooms, cafés or something else.

Memories of the food served in the tea rooms played a huge part in the gathered stories, so sharing recipes was important to creating a full offering in this book. Finding the old-time recipes was for the most part very difficult. Luckily, the Lazarus family had published some cookbooks with items made for the Shillito's Tea Room, but no such publications were found or produced for the other establishments. Coming across certain recipes of dishes served in Pogue's, McAlpin's and The Woman's Exchange felt like finding gold. Due to the scarcity, some of the classic recipes shared in this book are what are called "doppelgangers." These taste-alike entries—bygone period recipes that are quite similar to items mentioned in the interviews—have been graciously provided by cookbook authors and tea rooms located in other cities. The concept to offer doppelganger recipes was underscored when I found the exact

recipe for Shillito's white chocolate cake in a Tennessee tea room's cookbook. Many thanks go to those sources for their generosity. Their names appear on the respective recipe pages.

Because I didn't want to include a dish that wasn't reasonably easy and successful to make, I decided that I, or in some cases a family member or friend, would test all the recipes. Needless to say, I was eating better than usual for a few months! Many thanks go to my cooks: Merritt Beischel, Rosemary Beischel, Cece Donovan, Linda Ewing and Dick Monaghan, Melissa and John Feldmeier, Evie and David Foulkes, Denny Grawe, Sue Heppe, Arleen Hoeweler, Cathy McEneny, Jackie Marconet, Lindsay Miklos, Linda Moravec, Jane Petche, Kathy Photos and Tom Dunlap, Jean and Tom Smith and Bet Stephens. Additional thanks go to Kristin Ungerecht for the tasteful photographs of these edible delights.

The research for this book took me down many unexpected paths and led to meeting a multitude of interesting people. To provide as accurate a picture of the tea rooms as possible meant trying to locate individuals who remembered them. Speaking with so many vibrant people in their seventies, eighties, nineties and even a few centenarians was a lucky blessing. They really knew what it had been like to attend the events and shop, eat and work in the establishments about which I was writing—as such, they all helped me develop the distinct *flavor* of the times and restaurants with their stories. You will find their names listed at the end of the book. I also want to acknowledge the kind and diligent staffs of the Genealogy and Local History Department and Cincinnati Room at the Cincinnati & Hamilton County Public Library, the Cincinnati Historical Library & Archives of the Cincinnati Museum Center, the Cincinnati Art Museum, the Blegen Library at the University of Cincinnati and the Intellectual Property Awareness Center of the W. Frank Steely Library at Northern Kentucky University. Research trips to those locations, as well as many others, were made more enjoyable and efficient with the assistance of Kathi Ahern, Merritt Beischel, Denny Grawe, Lindsay Miklos and Jane Mohan. Much appreciation also goes to the individuals who have created and run the Cincinnati TV & Radio History Photostream; Digging Cincinnati History website; H&S Pogue Company of Cincinnati Facebook page; Media Heritage Inc., a group that preserves radio and television history; and the Department Store Museum website.

Additional thanks to Janice Porter Forte for arranging an after-hours photo shoot at the Cincinnati Museum Center and to David Conzett, who went to great lengths to unearth and photograph physical artifacts held in the Cincinnati Museum Center's Geier Collections & Research Center. I

wish to express gratitude to Eunice Abel, Eva Carstens, Ron Case, Bob Castellini, Jean Z. Donaldson, Vicki Everhart, Nellie Goodridge, Susan Heil, Dan Howell, Addison Lanier, Steve Lazarus, Wayne Martin, Gene Planck's family (Jennifer Planck Powers, Joni Davis, Jill Baker, Lorie Gallagher, Kevin Planck and Tammy Clock), Ceci Pogue Sanders and David Tondow for trusting and gifting me with family heirlooms, photos, menus and private papers to help and inspire my research process; and to Kathi Ahern, Glenn "Bud" Callaway, Polly Culp, Jill Gibson, Rita Heikenfeld, Ollie Helm, Sue Heppe, Stewart Shillito Maxwell, Barbara and Michael Streff and Dawn Trammell for loaning me copies of their vintage cookbooks for very long periods of time.

Much gratitude also goes to Glenn "Bud" Callaway, James E. Gregory, Bob Heyob and Elizabeth Kelly for making themselves available to share firsthand information about food preparation in the various tea room kitchens. Thanks also go to Marjorie Allen, Rita Heikenfeld, Frances Schloss, Mary Jane Schmuelling and Betsy and Paul Sittenfeld, who became sources of recipes that were very difficult to uncover. A special nod and tip of the hat goes to Linda Braunwart and Roger Flagler for putting so much effort into connecting with other people and gathering story sources. Appreciation is sent to Rachel Schmid for her patient, expert hand with scanning old photographs and for taking the teacup photo used on the cover and to Lindsay Miklos for my author photo. Additional appreciation goes to Merritt Beischel for modeling 1940s fashion and for more than once providing the word or phrase that was eluding me. Final appreciation goes to Kristina Strom for her "tough love" developmental editing to ensure the quality of this finished product.

May the information shared in this book, along with the recipes, serve as a catalyst to wonderful memories for those who were there and as an intriguing steppingstone to help younger generations understand and learn a little bit about what life was like in the past.

Those Who Shared Memories

Thanks to everyone who spoke with me and shared their memories, loaned items, provided input and helped me uncover the facts. I very much appreciate that many people expressed that they felt it was time well spent.

A
Helen Abbott
Eunie Abel
Gloria Achten
Lee Adams
Sharry Addison
Diane Agricola
Kathi Ahern
Cathy Albers
Marjorie Allen
Carol Allgood
Rob Amend
Cynthia Amneus
Helen Anderson
John Anderson
Janet Fast Andress

Dottie Angst
Rosemary Arbino
Louise Arnett
Carla Austin
Karen Austin

B
Linda Bailey
Joan Baily
Gay Seybolt Bain
Jill Powers Baker
Louisa Barkalow
Nancy Bassett
Margie Bastin
Merritt Beischel
Rosemary Beischel

Sister Lucy Beischel
Jinny Berten
Mary Ellen Betz
Helen Black
Elizabeth Lazarus
 Block
Ellen Bockenstette
Pat Boeddeker
Beth Bolin
Nora Boswell
Mark Bowers
Katie Bramell
Wray Jean Braun
Linda Braunwart
Cheri Brinkman
Nancy Broermann

Karen Brown
Michael Brumm
Robin Buchanan
Jack Buescher
Teresa Buhrlage
Jason Buydos

C

Glenn "Bud" Callaway
Eva Carstens
Ron Case
Shirley Casey
Bob Castellini
Pam Caswell
Alison Chase
Jacquie Chischillie
Fred Cholick
Tammy Clock
Nick Clooney
Gregory Cohen
Michelle Cole
Meredith Comin
David Conzett
Cors & Bassett, LLC
Margaret Lazarus
 Crawford
Bob Craycraft
Catherine Cress
Forrest Cress
Polly Adair Culp
Meghan Cummings
Carol Curless
Harold Curless

D

Ruth Israel Dain
Jim DaMico
Joni Powers Davis
Barbara Dawson

Ellen Everman Deaton
Mary DeCourcy
Charlotte Deupree
Sandra M. de Visé
Helen Dickhoner
Roxann Dieffenbach
Susan Shott Ditmire
Jack Dominque
Jeannie Donaldson
Rick Donaldson
Cece Donovan
Tom Dunlap
Davina Dunn
Jeanne Dwyer

E

Dave Ecker
Margaret Ecker
Jean Elliot
Valerie Elliot
Christine Engels
Carol Euskirchen
Vicki Everhart
Linda Ewing

F

Marta Lake Fales
Mike Fasoldt
Marguerite Feibelman
John Feldmeier
Melissa Feldmeier
Skip Fenker
Shirley Fishel
Mickey Fisher
Roger Flagler
Jim Fornash
Judith Fornash
Janice Porter Forté
David Foulkes

Evie Foulkes
Susan Freidlander
Mike Fremont
Lonnie Frey

G

Lorie Planck Gallagher
Ruth Garchammer
Don Gardner
Joe Gartrell
Dorothy Gavin
Margie Gehringer
Jill Gibson
Kathy Briggs Gire
Martha Goldsmith
Nellie Goodridge
Travis Gortemiller
Marian Gosey
Babette Gotman
Clover Brodhead
 Gowing
Kevin Grace
Denny Mohan Grawe
James Gregory
Mary Gregory
Bob Griffin

H

Marsha Haberer
Evelyn Habermehl
Pat Booth Hagendorn
Audrey Hager
Sandra Hamilton
Evelyn Hance
Bob Hancher
Janet Harding
Barbara Heald
 Harrigan
John Harrison

Lauri Harwood
Dennis Hasty
Mary Heck
Marilyn Heginbotham
Rita Heikenfeld
Susan Heil
Judy Heldman
Ollie Helm
Nathan Heneger
Cindy Shives Henry
Diana Henry
Rachel Henzi
Sue Heppe
Peggy Herr
David Herrlinger
Helen Herrlinger
Bob Heyob
Martha Hinkel
Barb Hite
Lee Hite
Arleen Hoeweler
Patty Hogan
Betsy Whitesides
 Holdsworth
Nancy Holterhoff
Katie Mueller Russell
 Hosmer
Josh Howard
Dan Howell
Irene Howell
Lisa Hubbard
Penny Huber
Geneva Huff
Heather Humphrey
David Hunt
Dan Hurley
Kathy Hurst

I

Leigh Ismael

J

Jeffrey Jakucyk
Peg Jenkinson
Mar Robertson
 Jennings
Mary Ann Jervis
Lois Johannigman
Chris Hiatt Johnson
Judy Smysor Jones
Jeni Junius

K

Tanny Keeler
Elizabeth Kelly
Jean Kemper
M'Lissa Kesterman
Rick Kesterman
John Kiesewetter
Daisy King
Ivan Klebanow
Ken Klosterman
Alan Klug
Sue Koch
Ann Kohstall
Bruce Allen Kopytek
Libby Korosec
Pat Kramer
Debby Borin Kresser
Dottie Hope Kuhn
Barbara Kurtzer

L

Emily Lang
Tim Lanham
Addison Lanier II
Katie Laur

Carol Skinner Lawson
David Lazarus
Steve Lazarus
Jack Leahy
Shirley Leahy
Judie Lee
Pat Lieurance
Mimi LeBlond Liggett
Judith Davis Lindlar
Jean Linne
Nancie Loppnow
Carolyn Ludwig
Mary Ann Luers
Pat Lyons

M

Doug Magee
Mark Magistrelli
June Magrish
Kevin Malloy
Diane Mallstrom
Jackie Marconet
Wayne Martin
Mike Martini
Debbie Matre
Stewart Shillito
 Maxwell
Aja May
Olivia "Libby"
 Maynard
Mara McCormick
Cathy McEneny
Howard McIlvain
Leslie McNeill
Joan Mettey
Jane Meurer
Lindsay Miklos
Maria Mikulic
Marjorie Mocht

Jane Mohan
Marcia Molina
Dick Monaghan
Gene Mooney
Linda Moravec
Jerry Mueller
Dick Murgatroyd
Colleen Sharp Murray
Bill Myers

N
Annie Naberhaus
Freida Nehring
Jim Nienaber
Linda Nienaber
Sylvia Norris

O
Margaret O'Malley
Flo Osterman

P
Micah Paldino
Stella Pardick
Rose Parker
Christine Parks
Nancy Parks
Loueva Parton
Terry Patrick
Sara Pearce
Evelyn Perkins
Peg Peskin
Jane Petche
Agnes Peterson
Deb Colaw Peterson
Mary Peterson
Kathy Photos
Tarrah Pickard
Bonnie Planck

James Planck
Kevin Planck
Ruby Planck
Tom Planck
Michael Pogue
Helen Popolin
Viola Porcello
Jennifer Planck Powers
Mara Proctor

R
Hydie Richardson
 Ralston
Richard Rauh
Joyce Re
Karen Reams
Phyllis Walters
 Rennick
Ruth Reuther
Alene Rice
Patricia Rice
Bev Rieckhoff
Chris Rielag
Dorothy Ries
Anne Rittershofer-
 Neumann
Lynne Martin Roberts
Jean Rohling
Loretta Rokey
Kathleen Romero
Barbara Rosenberg
Joyce Rosencrans
Jane Barnett Royal
Barbara Ruh
Mary Russell

S
Amy Sagola-Bennett
Susan Lynn Saldin

Tom Saldin
Ceci Pogue Sanders
Sarah Sapp
Amanda Schaffer
Betty Schildman
John Schlipp
Ann Lazarus Schloss
Cathy Schloss
Frances Schloss
Stuart Schloss
Rachel Schmid
Mary Jane
 Schmuelling
Nancy Schulhoff
Mary Schultz
Ann Senefeld
Ellen Sewell
Anne Shepherd
Ernie Siders
Christine Pogue
 Simone
Betsy Sittenfeld
Paul Sittenfeld
Connie Smiley
Christopher Smith
Jean Smith
Sara Smith
Tom Smith
Claire Smittle
Mary Snider
Nancy Sorg
Marty Sowders
Tina Spicer
Roberta Sprague
Virginia Stark
Jacob Stein
Judy Stein
Polly Stein
Bet Stephens

Mary Stern
Sugi Stewart
Tom Stewart
Frances Stilwell
Forrest Stivers
Elizabeth Stone
Michelle Stone
Sonja Stratman
Barbara Streff
Michael Streff
Kristina Strom
Jeff Suess
Leslie Sweeney

T
Mary Tallentire
Carolyn Taylor
Tom Thie
Pat Timperman
Rick Toennis
David Tondow
Vicki Townsley
Dawn Trammell

U
Rita Uehlein
Chris Uihlein
Kristin Ungerecht

V
Bill Victor
Henry Vittetoe

W
Akshata Wadekar
Patricia Wagner
Marilyn Waisblum
Harriet Warm
Bev Wedding

Jim Weiner
Jackie Weist
Jennifer Wessel
Donna Wesselman
Ann Westheimer
 Williams
Peg Wimmer
Linda Wohl
Sara Wolf
Dean Worley
Fred Wurzbacher

Y
J. Gregory Yawman
Jenna Yee

Z
Wilbert Ziegler

Bibliography

FLASHBACK: SNAPSHOT OF THE PAST

"Albee Theatre." Cinematreasures.org. http://cinematreasures.org/theaters/1044.

Chase, Robin. "Car-Sharing Offers Convenience, Saves Money and Helps the Environment." http://photos.state.gov/libraries/cambodia/30486/Publications/everyone_in_america_own_a_car.pdf.

Cincinnati Enquirer. "Charga-Plate System Loses Pogue's Stores, Gains Tresler Chain." November 4, 1964.

———. "Department Stores Join in Shorter Work Week." February 4, 1970.

———. "Good Luck! Is Wish of Friends Who Flock to Formal Opening of Pogue's." October 22, 1930.

———. "Great Day! Annual Pogue's Employee Outing." July 27, 1924.

———. "Mabley & Carew to Move to Great Starrett Building; To Occupy First Five Floors." December 8, 1929.

———. "More Time Needed for Night Shopping; Store Makes Move." February 28, 1956.

———. "Shillito's Completes Store Remodeling." June 17, 1962.

———. "Store Has Biggest Day's Sales in History—87th Year Is Marked by Record Advertising." May 2, 1950.

———. "To-Morrow, Labor Day, the McAlpin Store Will Remain Closed All Day." September 3, 1911.

Cincinnati Post. "Pogue's Downtown Gets $1 Million Facelift." August 24, 1977.

———. "Store Opens Thursday Night for Family Shopping." February 28, 1956.

Cincinnati Post & Times-Star. "Charga-Plate Loses Pogue's, Adds Tresler." November 3, 1964.

———. "Stamp-Coin Department." June 19, 1964.

Cincinnati Times-Star. "'Come-As-You-Are' Dress—Shillito's to Open Thursday Nights." February 28, 1956.

———. "Turning Back the Clock." February 17, 1948.

Kopecky, Karen A., and Richard M.H. Suen. "A Quantitative Analysis of Suburbanization and the Diffusion of the Automobile." *International Economic Review* 51, no. 4 (November 2010): 1006. http://www.karenkopecky.net/SandAPaper.pdf.

Kopytek, Bruce Allen. "Pogue's." The Department Store Museum. http://www.thedepartmentstoremuseum.org/2010/07/h-s-pogue-company-cincinnati-ohio.html.

Laur, Katie. "Blue Christmas." *Cincinnati Magazine*, December 1, 2011, 50. http://www.cincinnatimagazine.com/letter-from-katie/letter-from-katie-blue-christmas1/.

Maya. "Gidding-Jenny Department Store Downtown." VisuaLingual. June 5, 2008. https://visualingual.wordpress.com/2008/06/05/gidding-jenny-department-store-downtown/.

"Old Time Cincinnati Department Stores." City-Data.com. http://www.city-data.com/forum/cincinnati/1366004-old-time-cincinnati-department-stores.html.

"Pogue's to Open Stamp Department." Unidentified newspaper. June 19, 1964.

Shillito's Enthusiast. "The Shillito's Story." July 1976.

Smith, Kim. "Cincinnati Netherland Hotel Plaza and Carew Tower." *Kim Smith Designs* (blog). http://kimsmithdesigns.wordpress.com/2011/01/03/hilton-netherland-plaza/.

Stinson, Tamia. "Cincinnati's Shopping History." *A-Line*, July 12, 2011. http://a-linemagazine.com/articles/2011/12/07/cincinnatis_shopping_history.

Wheeler, Lonnie. "Shape Up Fourth Street, Kitty's Watching." *Cincinnati Enquirer.* March 2, 1979.

Wikipedia, s.v. "Charga-Plate." http://en.wikipedia.org/wiki/Credit_card.

PAINTING A PICTURE OF BYGONE TEA ROOMS

Cincinnati Enquirer. "The Geo. W. McAlpin Co's Easter Sale." April 8, 1900.

———. "Special Club Breakfast—Private Tea Rooms." September 17, 1911.

———. "Specific Reasons for Shopping at McAlpin's—Cincinnati's Complete Christmas Store." December 10, 1911.

L.S. Ayres Tea Room: Recipes & Recollections. Indianapolis: Ayres Foundation Inc. and the Indiana State Museum Foundation, 1998.

Marjorie. "Smart Gowning at Tea Hour." *Columbus News Fashions*. November 28, 1909.

Rosen, Steve. "Have Menu…Will Time Travel." *Cincinnati Magazine*, February 27, 2014. http://www.cincinnatimagazine.com/features/2014/02/27/have-menuwill-time-travel.

Shillito's Enthusiast. "Six-Minute Squad Serves Shillito's Tea Room." October 16, 1940.

———. "Teleautograph Makes Debut." January 10, 1942.

A LOOK AT THE HISTORICAL PERSONALITY OF THE TEA ROOMS AND LOCATIONS

The Woman's Exchange

Hoeb, Karen D. "Letter to the Editors." *Ohio Valley History* 1, no. 1 (Winter 2001): 48. http://library.cincymuseum.org/starweb/journals/servlet.starweb?path=journals/journals.web.

New York Times. "Cincinnati Woman's Exchange." March 18, 1883.

Sander, Kathleen Waters. "'Brave Hearts There Were': Woman's Exchange of Cincinnati, 1883–1900." *Queen City Heritage* (Winter 1999): 20–36. http://library.cincymuseum.org/journals/files/qch/v57/n4/qch-v57-n4-bra-020.pdf.

———. *The Business of Charity: The Woman's Exchange Movement, 1832–1900*. Urbana and Chicago: University of Illinois Press, 1998.

Scarborough, Alice. *1883–1908 Woman's Exchange Cincinnati*. Cincinnati Historical Library & Archives at the Cincinnati Museum Center.

———. *1893—The Woman's Exchange of Cincinnati, Ohio—Nos. 184 and 186 Race Street*. Cincinnati Historical Library & Archives at the Cincinnati Museum Center.

———. *Woman's Exchange Hand Book 1897–1898 Containing Bills of Fare, Annual Reports, Etc*. Cincinnati Historical Library & Archives at the Cincinnati Museum Center.

Scarborough, Alice, and Mary B. Corwin. "Eighteenth Anniversary." *The Woman's Exchange Annual Hand Book—Cincinnati, 1901*. Cincinnati Historical Library & Archives at the Cincinnati Museum Center.

Tugman, William, and Alton F. Baker Jr. "Another Observation along the Road." *Register-Guard* (Eugene, OR), April 30, 1954.

McAlpin's

Cincinnati Enquirer. "In Honor of the Opening Monday of Our New Tea Rooms." September 10, 1911.

———. "Our Tea Rooms." April 22, 1900.

———. "Specific Reasons for Shopping at McAlpin's—Cincinnati's Complete Christmas Store." December 10, 1911.

————. "To-Morrow, Labor Day, the McAlpin Store Will Remain Closed All Day." September 3, 1911.

Garratt, Phyllis. "George McAlpin Department Store." OHHAMILT-L Archives, March 12, 2004. http://archiver.rootsweb.ancestry.com/th/read/OHHAMILT/2004-03/1079149373.

"The Good Morning Show." WLW-Radio, November 22,1963. David Von Pein's Old-Time Radio Channel. https://www.youtube.com/watch?v=c8jo5MigiH4.

Hasty, Dennis. Cincinnati TV & Radio History. Photo of Bob Braun tray liner on site. https://www.flickr.com/photos/30457287@N07/page2.

Kopytek, Bruce Allen. "McAlpin's." The Department Store Museum. http://www.thedepartmentstoremuseum.org/2010/06/george-w-mcalpin-co-cincinnati.html.

McAlpin's Kopper Kettle (Information on back cover of menu). March 1979.

McAlpin's postcards illustrating early tea rooms. http://www.cincinnativiews.net/department_stores.htm.

Miller, Mildred. "Answer to a Working Girl's Prayer." *Cincinnati Enquirer*, April 14, 1949.

Miller, Nick. "Tea Room Chef Hangs Up His Apron after 45 Years." *Cincinnati Post*, June 11, 1992.

Radel, Cliff. "McAlpin's Down-Home Style Fit Us." *Cincinnati Enquirer*, May 18, 1998.

Scarborough, Alice. "Geo. W. McAlpin advertisement." Placed in *1893—The Woman's Exchange of Cincinnati, Ohio—Nos. 184 and 186 Race Street.* Cincinnati Historical Library & Archives at the Cincinnati Museum Center.

Stradling, David. *Cincinnati: From River City to Highway Metropolis.* Charleston, SC: Arcadia Publishing, 2003.

Wikipedia, s.v. "McAlpin's." http://en.wikipedia.org/wiki/McAlpin%27s.

Shillito's

Brazes, Jane. "Shillito's Rings Up 150 Years." *Cincinnati Post*, March 20, 1980.

Chapin, Ed. "125th Anniversary Week Planned—Shillito's to Turn Back Clock—Costumes of 1830 in Style." *Cincinnati Times Star*, February 4, 1955.

Cincinnati Daily Gazette. John Shillito & Co. advertisement. March 19, 1880.

Cincinnati Enquirer. "A Bit of History Indicative of the Growth of Cincinnati." December 2, 1921.

————. "Cornerstone of Store Sealed with Golden Trowel by Its Oldest Customer." June 26, 1937.

————. "Instant Postum." July 10, 1912.

————. "New Store Plans Expanded for Huge Service Building." March 9, 1937.

————. "Reconstructed Store to Be Opened Today; Expansion Represents $2,000,000 Outlay." October 26, 1937.

————. "Shillito Early Dry Goods Leader." October 6, 1988.

————. "Shillito's Gives Big Party as 125th Birthday Nears." February 5, 1955.

————. "Shillito's to Open Remodeled Grill." March 24, 1963.

————. "Vast Throng Received at Formal Opening of Remodeled Store; Officials of City and Commercial Leaders Laud Enterprise." October 27, 1937.

The Cincinnati Federal Writers 9 Project of the Works Progress Administration in Ohio. *They Built a City: 150 Years of Industrial Cincinnati*. Cincinnati: Cincinnati Post, 1938.

Cincinnati Post. "$500,000 Improvement Under Way at Shillito's." September 9, 1961.

————. "Shillito Opened His First Store in 1830." April 10, 1987.

————. "Shillito's Rings Up 150 Years." March 20, 1980.

————. "Shillito's Shows Rapid Growth." February 16, 1950.

Cincinnati Post & Times-Star. "Long Ago." September 8, 1961.

Cincinnati Times-Star. "Cornerstone Laying Attended by Group of Leading Citizens." June 25, 1937.

————. "Looking Forward after 50 Years—Store Chain Head Not to Retire." November 11, 1953.

Clubbe, John. *Cincinnati Observed: Architecture and History*. Columbus: Ohio State University Press, 1992.

Findsen, Owen. "Lazarus Store Has a Long, Rich Lineage—Many Remember Retailer as Shillito's." *Cincinnati Enquirer*, October 12, 1997.

Giglierano, Geoffrey J., and Deborah A. Overmyer. *The Bicentennial Guide to Greater Cincinnati: A Portrait of Two Hundred Years*. Cincinnati: Cincinnati Historical Society, 1988.

Hendrickson, Robert. *The Grand Emporiums: The Illustrated History of America's Great Department Stores*. New York: Stein and Day Publishers, 1979.

Hurley, Daniel. *Cincinnati: The Queen City*. Cincinnati: Cincinnati Historical Society, 1982.

Josten, Margaret. "Shillito's at 150 Has Just Begun to Fight." *Cincinnati Enquirer*, April 20, 1980.

King, Moses. *King's Pocket Book of Cincinnati*. Boston: Franklin Press, Rand, Avery & Company, 1909.

Kopytek, Bruce Allen. "Shillito's." The Department Store Museum. http://www.thedepartmentstoremuseum.org/2010/06/shillitos-cincinnati-ohio.html.

Kraft, Joy W. "Shillito's Was a Retail Palace with Panache." *Cincinnati Enquirer*, July 21, 2013.

Langsam, Walter E. *Great Houses of the Queen City: Two Hundred Years of Historic and Contemporary Architecture and Interiors in Cincinnati and Northern Kentucky*. Cincinnati: Cincinnati Historical Society, 1997.

Neil, Edna. *Shillito's Every-Day Cook-Book and Encyclopedia of Practical Recipes for Family Use*. Cincinnati: published expressly for Shillito's, 1905.

"Secrets Worth Telling and Ones You Should Know." Shillito's advertisement placed in *1893—The Woman's Exchange of Cincinnati, Ohio*.

Shillito's Enthusiast. "The Shillito's Story." July 1976.

Shillito's Enthusiast 125th Anniversary Issue, 1830 to 1955.

"Shillito's Spends $500,000 on Downtown Location." Unidentified newspaper. September 9, 1961.

Wikipedia, s.v. "John Shillito Company." https://en.wikipedia.org/wiki/John_Shillito_Company.

Mullane's

Case, Ron. "History of Mullane's When Owned by the Cases." Case Family Notes provided by Ron Case.

Cincinnati Enquirer. "War, Depression Fail to Halt Candy Firm in 102-Year History." February 13, 1950.

Cincinnati Post. "Mullane's to Mark 100th Anniversary." February 7, 1948.

Cincinnati Post Times-Star. "Mr. and Mrs. to Make Taffy." April 23, 1959.

———. "There Is Candy in News." September 19, 1964.

Cincinnati Times-Star. "The John Mullane Candy Co. Will Establish a Second Downtown Store." July 16, 1948.

———. "Mullane's New Confectionery and Tea Room." May 9, 1933.

———. "Presentation of Bronze Plaque by the Cincinnati Chamber of Commerce to the John Mullane Co." February 12, 1948.

———. "Turning Back the Clock." February 17, 1948.

Cutter, William Richard, ed. *American Biography: A New Cyclopedia*, vol. 11. New York: American Historical Society, 1922.

"How to Make Victorian Nectar Drop Candy and Why Are Lemon Drops Called Drops?" Video showing Mullane's antique candy-making equipment being used at Lofty Pursuits Candy Store in Tallahassee, Florida. December 26, 2015. https://www.youtube.com/watch?v=sd90XCvpO1k.

McLean, Gil. "Mullane's 118 Years Old—Radio Team's New Bulletin: They Like Candy Business." *Cincinnati Enquirer*, February 13, 1966.

Mullane. *Book of Mullane's Candies Made with Loving Care in Cincinnati since Eighteen Hundred and Forty Eight.* Cincinnati: John Mullane Company, 1918 and 1921.

"Mullane's Story" (information written on back of menu after the 1970 restaurant opening in the "new Garfield Towers" at 723 Race Street).

Ruhl, Frank J. "Mullane Observes 100th Anniversary." *Cincinnati Enquirer*, February 7, 1948.

"Sweet and Loud: Mullane's Beats Core to Redevelopment." Unidentified newspaper. November 6, 1964.

Weiland, Ed. "Mullane's 100 Years Are Sweetest—Sweet Shop Marks Century Since Founding." *Cincinnati Post*, February 14, 1948.

Wheeler, Lonnie. "Shape Up Fourth Street, Kitty's Watching." *Cincinnati Enquirer*, March 2, 1979.

Mabley & Carew

Cincinnati Enquirer. "C.R. Mabley, the Prince of Western Clothiers." March 25, 1877.

————. "'Fashion Image'—Glimpse Reveals Glitter of New Mabley & Carew." November 9, 1962.

————. "Fashion Is the New Mabley & Carew—Fountain Square." November 17, 1962, 18.

————. "The Mabley & Carew Co.—Greatest Electric Illumination on Any Mercantile Building in the World." April 4, 1923.

————. "Mabley & Carew Signs Long Lease in Starrett Project." December 8, 1929.

————. "Mabley & Carew to Move to Great Starrett Building; To Occupy First Five Floors." December 8, 1929.

————. "Mabley's Steps Out." September 15, 1955.

————. "New Mabley's Open." November 17, 1962.

Cincinnati Post. "Mabley & Carew Celebrates 100th—Mabley and Carew: Canada to Cincinnati." April 20, 1977.

Cincinnati Post & Times-Star. "Emphasis on Fashion at Opening Nov. 19." November 8, 1962.

————. "New Mabley's Store Opens; Called Symbol of Future." November 19, 1962.

Cincinnati Times-Star. "Turning Back the Clock—Mabley's Mammoth Clothing House." February 25, 1947.

"Great Store of the Mabley & Carew Company Fairly Glistens." *Boot and Shoe Recorder* 51, no. 20 (Summer 1907): 95.

"Jottings of Interest." *Light Magazine.* September 1907, 352. https://books.google. com/books?id=EKs6AQAAMAAJ&pg=PA352&lpg=PA352&dq=Mabley+%2 6+Carew+7000+lights&source=bl&ots=1fPUDXaPeU&sig=hDLZ1KSBIEG EhS02rvfFZ-FVr6g&hl=en&sa=X&ei=3_RXVZfcMZPtggSKpoCYDA&ved= 0CCMQ6AEwAg#v=onepage&q=Mabley%20%26%20Carew%207000%20 lights&f=false.

Kopytek, Bruce Allen. "Mabley & Carew." The Department Store Museum. http:// www.thedepartmentstoremuseum.org/2010/11/mabley-carew-cincinnati-ohio. html.

"The Mabley & Carew Illumination." *Men's Wear* 23, no. 6 (July 24, 1907): 93.

Messick, Morris. "Mabley & Carew Is Owned by 48 Employees. It's as Home-Grown as Its Arbor Day Trees." *Cincinnati Enquirer*, November 21, 1950.

Murray, J. Edward. "Mabley & Carew Salutes Founders during 100th—Founders' Days Represent Special Event during Our 100th Anniversary Celebration." *Cincinnati Enquirer*, April 24, 1977.

"New Mabley's to Open Today." Newspaper unidentified. November 19, 1962.

Rosen, Steven. "Have Menu…Will Time Travel." *Cincinnati Magazine*, February 27, 2014. http://www.cincinnatimagazine.com/features/have-menuwill-time-travel/.

"Soda Water?" *Dry Goods Reporter* 42, no. 1 (January 20, 1912).

Pogue's

Cincinnati Enquirer. "Department Stores Join in Shorter Work Week." February 4, 1970.

———. "Formal Opening—Good Luck! Is Wish of Friends." October 22, 1930.

———. "Only at Pogue's." November 26, 1964.

———. "Pogue Plans 10-Story Unit and Modernization of Store with Outlay of $2,000,000." February 3, 1946.

———. "Pogue's Camargo Room, Sixth Floor the 'Star' of Pogue's New and Unique Dining Areas." *Cincinnati Enquirer*, December 14, 1964.

———. "Pogue's Leases Mabley Space—Arcade Bridge to Link Stores in Remodeling." July 22, 1962.

———. "Pogue's to Stay Open on Monday Evenings for Holiday Season." September 16, 1949.

———. "Potato Famine in Erin Partly Responsible for Founding of Pogue's, Now 90 Years Old." May 4, 1953.

———. "Shop Pogue's Late Friday." November 26, 1964.

———. "Store Has Biggest Sales in History—87th Year Is Marked by Record Advertising." May 2, 1950.

———. "Welcome to Pogue's Ice Cream Bridge." August 3, 1964.

———. "Wonderful Eating Adventures at Pogue's." December 13, 1964.

———."Wouldn't You Know Pogue's Would Have the Smartest Little Spot to Eat." December 14, 1964.

Cincinnati Post. "Pogue's Downtown Gets $1 Million Facelift." August 24, 1977.

Cincinnati Post & Times-Star. "Pogue Opens Restaurant." August 27, 1964.

———. "Pogue's May Lease Part of Mabley's." May 17, 1962.

———. "Pogue's Plan to Serve Wine in Restaurant New 6th Floor Shoppers Restaurant the Camargo Room." September 23, 1964.

"H.&S. Pogue Co.'s History One of 'Quality & Friendliness.'" Unidentified newspaper. September 25, 1960.

Kopytek, Bruce Allen. "Pogue's." Department Store Museum. http://www.thedepartmentstoremuseum.org/2010/07/h-s-pogue-company-cincinnati-ohio.html.

Munsen, Rosemary. "Recalling the Name about to Change." *Cincinnati Enquirer*, October 29, 1984.

Oestreicher, Martha Pywen. "Meet Some Men Who Put Cincinnati on the Map." *Cincinnati Post*, April 4, 1978.

Pogue, John Crawford, Jr., and James A. Maxwell. "The Pogue and West Ancestry of Samuel Franklin Pogue, Jr. With Records of the H.&S. Pogue Company and Family History—The First Hundred Years." Pogue family papers. An updated (1994) and bound compilation can be found in the Carl Blegen Library, University of Cincinnati, HF5465.U6 P63 1994 ARB Reference.

"Pogue's Opens Ice Cream Bridge." Unidentified newspaper. July 29, 1964.

Pucci, Carol. "Cincinnati's Department Stores Lay Out Millions of Dollars on Lavish Remodelings." *Cincinnati Enquirer*, August 14, 1977.

Wikipedia, s.v. "H.&S. Pogue Company." http://en.wikipedia.org/wiki/H._%26_S._Pogue_Company.

BEVERAGES

Smith, Andrew F., ed. *The Oxford Encyclopedia of Food and Drink in America*. 2nd ed. Oxford: Oxford University Press, 2013.

SALADS AND DRESSINGS

Block, Stephen, and Stephen Holloway. "The History of Iceberg Lettuce." Food History—The History Project. http://kitchenproject.com/history/Salads_Lettuce/IceburgLettuce.htm.

Cincinnati Enquirer. "Shop Pogue's Late Friday." November 26, 1964.

Pelger, Ron. "In the Trenches: Will Iceberg Lettuce Make a Comeback?" *Produce News*, June 14, 2013. http://www.producenews.com/markets-and-trends/10596-in-the-trenches-will-iceberg-lettuce-make-a-comeback.

Tanimura & Antle. "Iceberg Lettuce—A Cornerstone of American Cuisine." May 24, 2007. http://www.taproduce.com/consumer/press-detail.php?id=23&keywords=Iceberg_Lettuce_%E2%80%93_A_Cornerstone_Of_American_Cuisine.

MAIN DISHES

Cincinnati Enquirer. "Shillito's to Open Remodeled Grill." March 24, 1963.

———. "Shop Pogue's Late Friday." November 26, 1964.

DESSERTS

Frederick, J. George. "What's the Matter with Horlick's?" *Printers' Ink, A Journal for Advertisers* 67, no. 9 (June 2, 1909): 27–29.

"A Letter from 'Frisco. Wanganui Man's Interesting Observations." *Wanganui Chronicle* 74, no. 17693 (October 20, 1919). http://paperspast.natlib.govt.nz/cgi-bin/paperspast?a=d&d=WC19191020.2.13.

Pease, Martin A. *Pease's Home Candy Maker*. Elgin, IL: Pease Brothers, 1913.

AFTERWORD AND ACKNOWLEDGEMENTS

Barnard, Melanie. *Cincinnati à la Carte*. Cincinnati: Cincinnati Magazine, 1980.

Headlee, Celeste. "Ohio's Only Four-Star Restaurant to Close." *Day to Day*, NPR News. http://www.npr.org/templates/story/story.php?storyId=100751261.

Martin, Chuck. "Maisonette Chef Reopening Pigall's." *Cincinnati Enquirer*, May 15, 2001. http://enquirer.com/editions/2001/05/15/tem_maisonette_chef.html.

Simonds, Dawn. "Star Wars." *Cincinnati Magazine*, March 2003, 87.

Index

About the Author

Cynthia Kuhn Beischel grew up in Cincinnati and enjoyed the special trips downtown to shop and enjoy afternoon luncheons in the tea rooms, first with her mother, sister and grandmother and later with high school and college friends. Recalling those occasions, in conjunction with taste-testing all the retro recipes, made this writing endeavor a very enjoyable experience. Her previously published work includes *Virginia Bakery Remembered*, another history/cookbook about an iconic five-generation German bakery in Cincinnati; *Discover the Past*, a storybook about Cincinnati history that encourages children and their families to enjoy learning about the past; and *From Eulogy to Joy*, a heartfelt anthology that explores the grieving process. Her educational background includes a bachelor of science in design at the University of Cincinnati and a master's degree in Montessori education from Xavier University. Cynthia resides with her two dogs in a quiet village north of Cincinnati, Ohio.

CPSIA information can be obtained
at www.ICGtesting.com
Printed in the USA
BVOW07*0520300118

506602BV00002B/11/P